D0854968

The Abelló Collection

A Modern Taste for European Masters

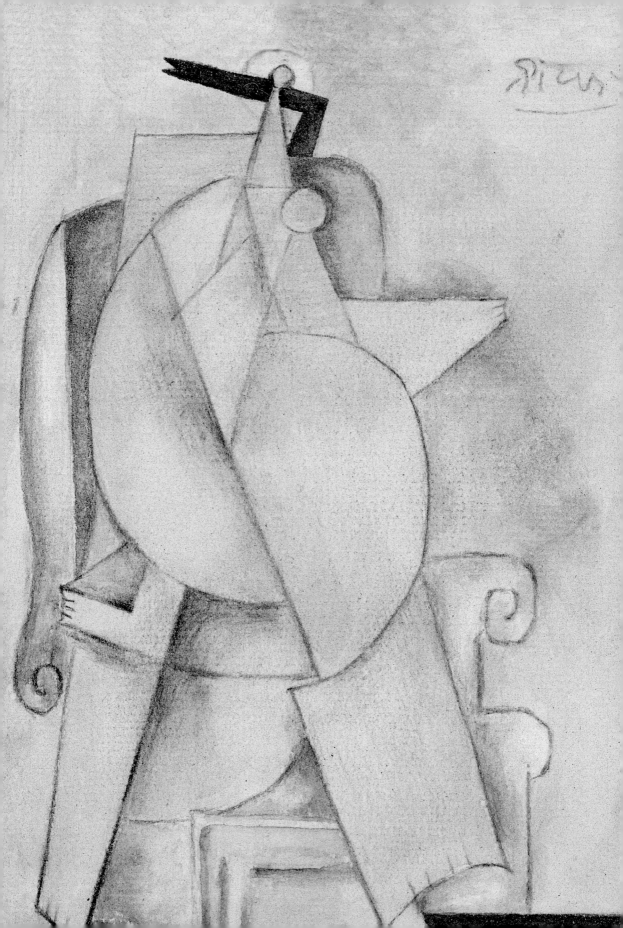

The Abelló Collection

A MODERN TASTE FOR EUROPEAN MASTERS

Almudena Ros de Barbero

April 18, 2015

August 2, 2015

Meadows Museum, Southern Methodist University, Dallas

This catalogue has been published in conjunction with the exhibition *The Abelló Collection: A Modern Taste for European Masters*, on view at the Meadows Museum, Southern Methodist University in Dallas, Texas, from April 18 to August 2, 2015. This exhibition has been organized by the Meadows Museum with works generously loaned to the museum by the Abelló Collection, and has been brought to Dallas by a generous gift from The Meadows Foundation.

The exhibition is part of the Museum's Golden Anniversary, which is sponsored by The Meadows Foundation, The Moody Foundation and the Dallas Tourism Public Improvement District. Media sponsorship has been provide by *The Dallas Morning News*.

The Dallas Morning News

CATALOGUE

PUBLISHED BY
Meadows Museum, Southern Methodist University

TEXTS BY
Almudena Ros de Barbero

COORDINATION
Bridget LaRocque Marx

Ediciones El Viso, Madrid
Félix Andrada

PRODUCTION
Ediciones El Viso, Madrid
Santiago Saavedra
Gonzalo Saavedra
Félix Andrada

DESIGN
Adela Morán
Encarnación F. Lena

TRANSLATIONS
Wade Matthews

COPY EDITOR
Erica Witschey
With the assistance of
Jim Harris
Nicole Atzbach

PHOTOGRAPHS
Collection Abelló Archives (Joaquín Cortés Noriega)

COLOR SEPARATION
Lucam, Madrid
Brizzolis, Madrid

PRINTING
Brizzolis, Madrid

BINDING
Encuadernación Ramos, Madrid

COVER: Pablo Picasso, *Nu assis* (*Seated Nude*),
winter 1922–23

PAGE 2: Pablo Picasso, *Cubist Figure* (detail), *ca.* 1914–15

ISBN: Meadows Museum, Southern Methodist
University, Dallas: 978-0-692-36934-0
ISBN: Ediciones El Viso, Madrid: 978-84-943527-3-7
D.L.: M-4996-2015

EXHIBITION

ORGANIZED BY
Meadows Museum, Southern Methodist University

PROJECT DIRECTED BY
Enrique Gutiérrez de Calderón

CURATED BY
Almudena Ros de Barbero

COORDINATION
Bridget LaRocque Marx (Meadows Museum)
Holly Hutzell (Meadows Museum)
Francisco Ortiz (Abelló Collection)
Nuria Pareja (Abelló Collection)

INSTALLATION
Unified Fine Arts Services

TRANSPORTATION
Masterpiece International Ltd.
SIT Transportes Internacionales

ACKNOWLEDGMENTS

Rafael Alonso, Kenneth Z. Altshuler, Ruth Collins Sharp Altshuler,
Mauricio Álvarez de las Asturias, Melanie Bailey, Pía Barbero,
Robert Bucker, Elizabeth Chapman, Peter Cherry, Odile Delenda,
Alexandra Filippelli, Francesc Fontbona, Felipe Garín, Charlie Guijarro,
Lotta Hanson, Rafael de la Hera, Adelina Illán, Amelia Larbec,
Brenda Laury, David Leggett, Alejandro Martínez, Isabel Mateo,
Quin Mathews, Benito Navarrete, Isabel Pascual Lavilla, Laurey Peat,
María Paz Pérez Piñán, Eulalio Pozo, Artur Ramón, Rafael Romero,
Robert Salmon, Ignacio Sánchez-Fajardo, Eugenio Soria, Kirk Turner,
Susana de Urbina, Cristina Uribe, Jesús Urrea, Lucía Varela,
Paul Ward, Susan Williams

Juan Abelló

It gives me great personal pleasure to be able to present these works of art in the Hamon Galleries of the Meadows Museum at Southern Methodist University. They form part of a collection I have been assembling with enormous interest and care over the past thirty five years and, while it has evolved and taken on its own meaning over the years, my intention has always been to bring together a group of works that are representative of Spanish painting and drawing, and their place in art in an international context.

I have not attempted to be encyclopedic in this endeavor. My choices as a collector reflect personal taste and the opportunities that have arisen over the years to obtain specific pieces that have come to form a coherent core. As much as possible, I have tried to recover from abroad works that are a part of Spain's artistic heritage.

This, the project of a lifetime, would have been impossible without the decisive support and advice of my wife, Anna Gamazo.

My father sparked my interest in art and instilled in me the pleasure of living in its midst. That is something I have always sought to pass on to my children, Juan Claudio, Alejandro, Cristian and Miguel.

My thanks go to the Meadows Museum at Southern Methodist University for giving me the opportunity to share this collection, which has brought me so much pleasure, with other art lovers. I hope they enjoy it as much as I have.

Mark A. Roglán
The Linda P. and William A. Custard Director of the Meadows Museum
and Centennial Chair in the Meadows School of the Arts,
Southern Methodist University

It has been fifty years since the Meadows Museum opened its doors and made its renowned Spanish collection available to the public. Since the death of our generous founder, Algur H. Meadows in 1978, the Museum has followed his vision and continued to grow. The collection has more than doubled in size in the past decades and a grand new building was dedicated in 2001. The institution has also focused on making research and scholarship central to its mission, developing major educational initiatives, including lectures, fellowships and inclusive programming. Actively participating in the academic and educational life of Southern Methodist University, and collaborating with faculty across campus, fertile initiatives have developed through the years, including classes, workshops and other learning opportunities for our students that have often become career-changing experiences. Moreover, the Museum has also organized exhibitions and published insightful catalogues and books to accompany these projects. All of these exciting developments have made the Meadows Museum the center for Spanish art in America.

As the Meadows Museum's collection was assembled with the vision of Algur H. Meadows, we wanted the exhibition programming during the Golden Anniversary year to focus on the idea of taste and collecting. The Abelló Collection perfectly suits this theme; a vast portion of this private Spanish collection is comprised of works by many of Spain's greatest talents. The Abellós also share a passion for modern and contemporary art, which coincidentally, Algur H. Meadows also collected with zest, including works by Jackson Pollock, Alberto Giacometti and Franz Kline. It is truly impressive to see how this successful businessman, Juan Abelló, along with his remarkable wife, Anna Gamazo, have assembled through their lives this outstanding collection.

It is with great pride that we will be the exclusive venue in the United States to feature the treasures of the Abelló Collection, the first time that a major private collection from Spain has ever been shown at the Meadows Museum. While this most distinguished family was previously very generous to our institution in lending 65 drawings for the 2008 exhibition entitled *From Manet to Miró: Modern Drawings from the Abelló Collection*, that was only a small portion of their holdings. Now, with *The Abelló Collection: A Modern Taste for European Masters*, we are presenting the majority of the Collection's highlights: a total of 105 paintings, drawings and one sculpture, all of which attest to the depth and quality of the art in the collection.

My first and deepest thanks go to Juan and Anna, as well as to their family, for being so incredibly generous to the Meadows Museum all these years. It is to their credit that the people in Dallas and our region will have the unique opportunity to

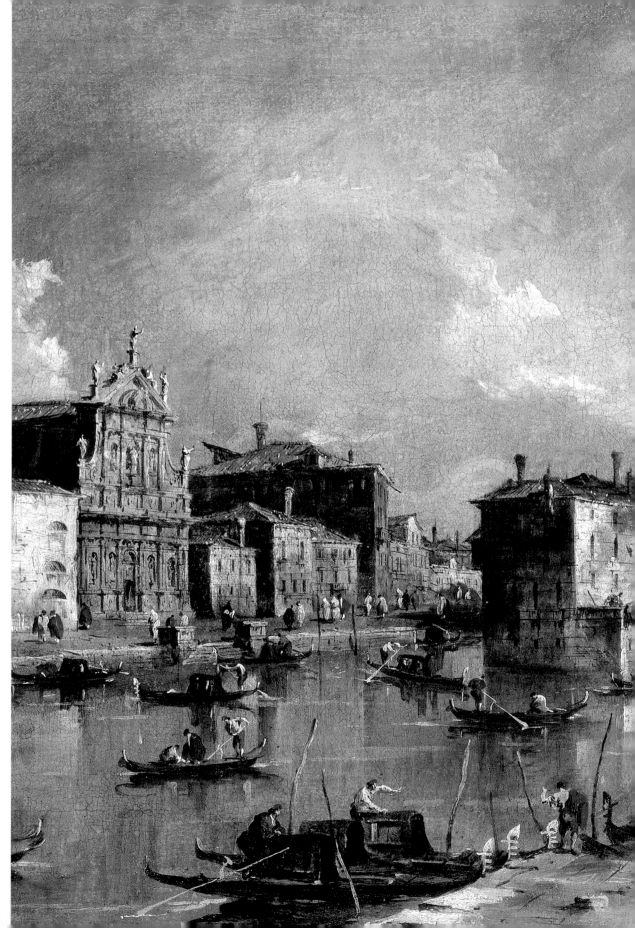

CONTENTS

15

THE ABELLÓ COLLECTION

CATALOGUE

19 GOTHIC AND RENAISSANCE PAINTING

45 EARLY NATURALISM AND BAROQUE PAINTING

61 THE AGE OF ENLIGHTENMENT

97 ROMANTICISM AND REALISM

113 MODERN AND CONTEMPORARY ART:
 FROM DARÍO DE REGOYOS TO FRANCIS BACON

199

BIBLIOGRAPHY

210

EXHIBITIONS

218

INDEX

Francesco Guardi,
The Grand Canal of Venice
(detail) *ca.* 1780

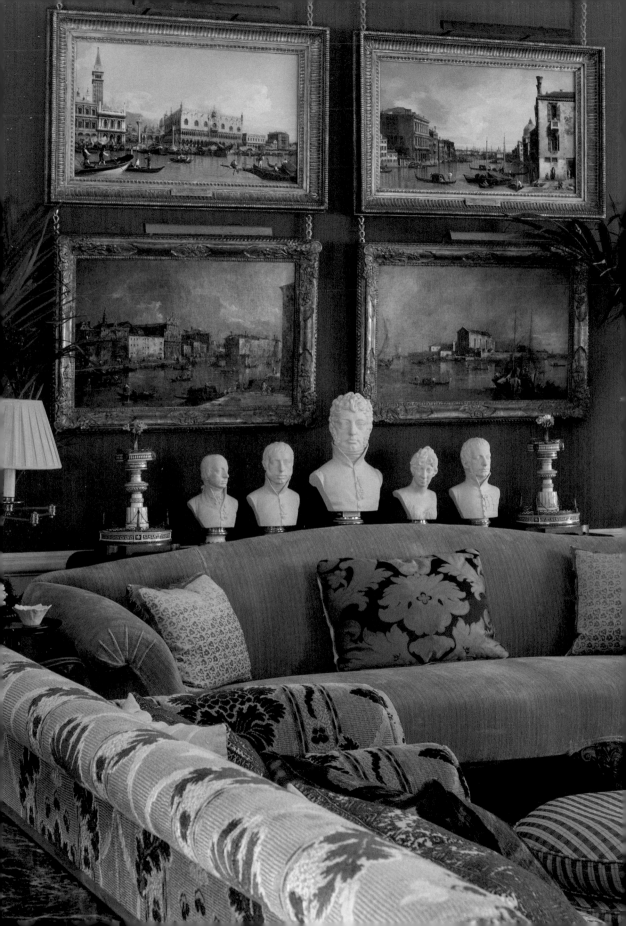

The Abelló Collection

Since the early 1980s, works of art have played a leading role in the lives of Juan Abelló and his wife, Anna Gamazo—specifically, those that make up their own art holdings, one of the most highly regarded private collections in the world. The major monographic exhibition staged at the Meadows Museum in Dallas presents, for the first time in the United States, a careful selection of over one hundred works.

Every collection is different, insomuch as each reflects the character of its owners. The Abelló Collection is no exception. Over the years, its creators have acquired works according to their personal tastes with no concession to trends, and their preference has always been for pieces of great aesthetic beauty with which they live on a daily basis. Passionate about art and history, they have followed their own criteria, assembling a collection whose marked personality is characterized by the beauty and high quality of the artworks. Some collections grow and are passed down from one generation to the next—almost like members of the family. This is not the case with the Abelló Collection; with the exception of a few heirlooms, the vast majority of the pieces have been freely chosen, just as one picks ones friends over the course of one's life. The time, enthusiasm and energy invested in finding the ideal works has paid off. And while not everyone would have made the same choices, there is unanimous agreement about the collection as a whole: it is a pleasure to contemplate.

The aim of the exhibition *The Abelló Collection: A Modern Taste for European Masters* is to share this collection with the American public in a manner consistent with the particular characteristics that distinguish it from other European collections. This selection includes representative works from all of the great artistic periods, spanning five hundred years from the *Baptism of Christ* (*ca.* 1496–99), which Queen Isabella the Catholic commissioned from Juan de Flandes (*ca.* 1465–1519) for the Charterhouse of Miraflores (Burgos, Spain), to the great *Triptych* by Francis Bacon (1909–1992), which dates from 1983.

The presence of that English artist—who is well represented in the collection—brings to light another of its features. The Abellós were pioneers in their acquisition of works by painters who had little presence in Spain's public and private collections, and Francis Bacon was just such an artist. His work could not be found in any Spanish institution and the Abellós set out to make it known through two significant triptychs, a portrait from 1978 and an interesting drawing from his youth (1933) that clearly shows the influence of Picasso's surrealist works.

That latter work, *Composition*, also brings into the open another of the collection's defining characteristics: its predilection for works on paper. The Abelló Collection encompasses a considerable body of drawings that spans from the sixteenth to the twentieth centuries. These traveled outside Spain for the first time in 2008,

The Abelló Collection, photo by Ricardo Labougle

when the Meadows Museum displayed to the American public its modern and contemporary drawings in the unprecedented exhibition *From Manet to Miró: Modern Drawings from the Abelló Collection*.

Until very recently, drawings were considered lesser works in Spain and were treated as mere working documents kept by artists in their studios. From the start, the Abellós understood the concentrated immediacy and virtuosity of these "jottings" (*rasguños*)—works all too often discarded over the centuries—where artists captured their initial ideas on the ephemeral medium of paper. A fine example is the intimate portrait that Francisco de Goya (1746–1828) made of his wife, Josefa Bayeu, in 1805. Standing before his spouse, who poses unadorned and uncoiffed in the private setting of the family home, the Aragonese painter captures her likeness and her facial expression with sincerity and freshness in simple pencil strokes on just a few centimeters of paper.

Drawings are also a significant means to understand the artist's creative process, and the collection has some interesting examples among which there is a group of particularly relevant works. Over the course of nearly three decades, the Abelló Collection has managed to reunite the painting *Le Violoncelliste* (*The Cellist*, ca. 1909), by Amedeo Modigliani (1884–1920), with its preparatory studies. This canvas is painted on both sides, bearing on the reverse a portrait of Modigliani's friend, the great Romanian sculptor Constantin Brancusi (1876–1957). Today, the collection has preparatory drawings for both the composition of the cellist and the portrait of Brancusi, who initiated Modigliani in the art of sculpture. The Italian artist worked in that discipline for several years but only twenty-seven of his sculptures have survived. One of them is in the Abelló Collection and completes the group of works that pay homage to two great twentieth-century artists in this exhibition.

The charcoal drawing that Edgar Degas (1834–1917) made for his pastel, *La Sortie du bain* (*After the Bath*, ca. 1895), is another fine example of an artist's preparatory work. The pastel and sketch were acquired seven years apart, and have been brought together under the same roof for the first time since they were made.

The presentation of the Abelló Collection's drawings is rounded off by a wide selection of works on paper by Pablo Picasso (1881–1973) that range from his earliest work and his blue period to cubism, surrealism and beyond. They share a room presided over by a large canvas titled *Nu assis* (*Seated Nude*, 1922–23), which also resembles a large-scale drawing. At a time when color held sway, abstraction was triumphing and tradition was being negated, a young and daring Picasso painted a monochrome work of white on white with just a trace of charcoal, a depiction of Venus before the looking glass that recovers an academic theme dating back to Classical Antiquity. The artist's boldness imbues this painting with a special and timeless attraction.

While the collection's presentation here follows a chronological model based on traditional museum practice, these paintings and sculptures are combined in other ways in the collectors' home. Goya shares one wall with Gris and Guardi while Bacon is in dialog with Murillo and El Greco on the other. This domestic setting has been reproduced in the show, at the same human-scale and with the same wall colors, in order to present the works in a manner suggestive of their original arrangement as part of a private collection.

Several iconographic groups from the collection stand out in the exhibition's chronological organization. A leading role is played, for example, by some fifty Spanish still lifes, represented here by painters such as Juan van der Hamen y León (1596–1631), Antonio Ponce (1608–1677) and Juan de Arellano (1614–1676), among others, as well as Venetian *vedute* by Giovanni Antonio Canal, "Canaletto" (1697–1768) and Francesco Guardi (1712–1793), or Spanish ones by Antonio Joli (*ca.* 1700–1777).

In the early 1980s, when the Abellós began their collection with Darío de Regoyos's (1857–1913) *Crags of Urquiola* (1907), they were probably unaware that, somehow, they were already charting their future course. Regoyos is considered not only the artist who marks the transition to modern painting in Spain, but also one of the most cosmopolitan of his time, totally conversant with international artistic trends. Thus, as we mentioned above, from the outset, the collection was built to span ancient and modern, Spanish and international alike.

Since then, the collection has made notable strides in recovering part of the Spanish heritage with important paintings such as the transgressive allegory *The Sense of Smell* (*ca.* 1615) by Jusepe de Ribera, "Lo Spagnoletto" (1591–1652), or *The Young Cock Fighter* (*ca.* 1660) by Bartolomé Esteban Murillo (1617–1682). Curiously, both paintings were originally commissioned by private collectors, and today they continue to hang in private houses.

Before any work enters the Abelló Collection it becomes the object of careful study, including an investigation of its provenance and state of conservation. And once it becomes a part of the Abellós' art holdings, all aspects, from the support and medium to the framing, are systematically monitored to keep it in the finest possible condition. As a result, the Abelló Collection can be proud of the fine condition of its artworks.

Today, the Collection policy of new acquisitions continues and the present exhibition includes three eighteenth-century works that have recently entered the collection: a *Self-portrait* by Luis Paret (1746–1799) and a pair of portraits by Miguel Jacinto Meléndez (1679–1734) of King Philip V and his wife, María Luisa Gabriela of Savoy (1709), similar to those recently acquired by the Meadows Museum.

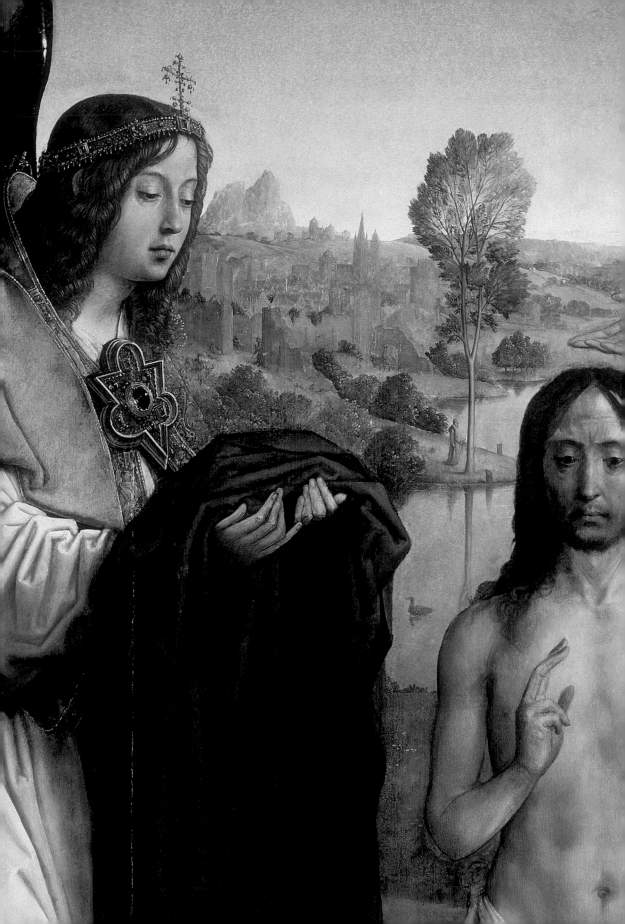

Gothic and Renaissance Painting

JAUME BAÇO, "JACOMART" (*ca.* 1411–1461)

The Virgin and Child Enthroned among Musician Angels, 1450
Tempera and oil on panel with original frame and crestwork,
85 ½ x 48 ¼ in. (217 x 123 cm)
P155

PROVENANCE
Museros (Valencia, Spain), church of the Assumption, probably the central panel of the altarpiece
of the Joys of the Virgin, 1450; Madrid, private collection, 1940; Madrid, Galería Caylus

BIBLIOGRAPHY
Angulo 1940–41, pp. 85–86, pl. 1; Post 1947, vol. IX, part II, pp. 827–29; Saralegui 1954, p. 108; Saralegui
1960, p. 18; Company 1986, vol. I, p. 267, vol. III, p. 159, fig. 182; Company and Garín 1988, p. 243; Ximo
Company in *Reyes y mecenas* 1992, pp. 279–81; José Gómez Frechina in Benito Doménech and Gómez
Frechina 2001, pp. 186–91, fig. 22.5; Amadeo Serra in *Renacimiento mediterráneo* 2001, pp. 450–53;
Fernando Benito Doménech in *Bartolomé Bermejo* 2003, p. 33 (ill.); José Gómez Frechina in *Bartolomé
Bermejo* 2003, pp. 206–7 (ill., detail); Joseph A. Ferre Puerto in Benito Doménech et al. 2009, p. 162;
Ros de Barbero 2014, pp. 36 (ill.) and 169–70

EXHIBITIONS
Toledo-Innsbruck 1992, no. 5, pp. 279–81; Santander 1993, no. 2; Madrid-Valencia 2001, no. 73;
Madrid 2014–15, no. 18

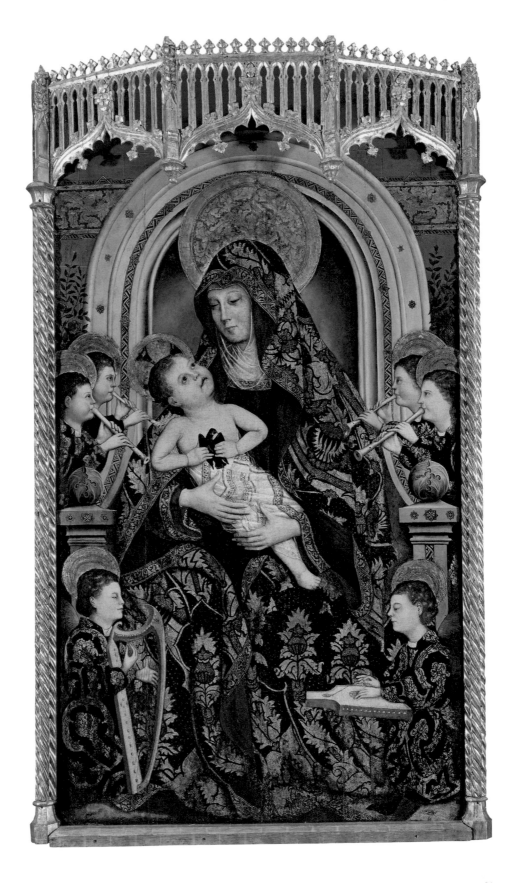

This central panel from a mid fifteenth-century altarpiece presents the Virgin enthroned with the Christ Child and surrounded by musician angels. The monumental figure of Mary with her spectacular mantle is flanked by six angels who are also elegantly dressed in velvet and brocade. The painter's capacity to render the details and varied textures of their clothing is outstanding, and he is equally adept at depicting the grand inlaid marble Renaissance throne. The child's posture is rather forced as he gazes at his mother while holding a black bird—possibly a raven—in his hands. This may be an allusion to the human soul before Redemption.

The work combines Flemish influences with a new Italianate style. The former is visible in the composition, which is mainly occupied by the monumental figure of the Virgin, and in the decorative character of the throne, the background and the clothing. The latter, more "modern" influence is clear in the shape of the faces, which are closer to Italian painting, as well as the architectural aspects of the throne, with its round arch, and the roses in the background, which evoke a garden. The Italianate influence is clearly the stronger of the two here, and permeates the whole painting.

This panel was first published in 1940–41, when Diego Angulo attributed it to the artist whom Chandler Rathfon Post had recently referred to as the Master of Alacuás[1] on the basis of an *Annunciation* in the Marquis of Mascarell's collection that was thought to be from that town. In 1942, Leandro de Saralegui[2] associated the Master of Alacuás

1 Post 1938, vol. VII, part II, pp. 879–83; Post 1941, vol. VIII, part II, pp. 715–17.

with the Master of Bonastre, who had painted a *Transfiguration* in 1448 for the chapel of Canon Joan de Bonastre at Valencia Cathedral. José Gómez Frechina[3] recently suggested that the Master of Bonastre may actually have been the painter Jaume Baço, known as Jacomart, whose personality has grown increasingly clear since he was originally studied by Elías Tormo,[4] although much remains to be learned. He probably apprenticed to Luis Dalmau (active 1428–1460), from whom he would have received the Flemish influence of the Eyckian models visible in his work.

The latest research suggests that this painting was probably the central panel from a 1450 altarpiece dedicated to the Joys of the Virgin, which Jacomart made in Museros (Valencia) at the behest of the Town Councilors as part of the church of the Assumption's main altarpiece. A painting described in their contracts as "la Verge Maria ab lo Jesús al braç ab sos àngels entorn e ab sa cadira" coincides with this image.[5] A *Coronation of the Virgin* at the Museum of Fine Arts in Boston (MFA 10.36) and an *Adoration of the Kings* in the former Álvarez Collection of Villafranca del Penedés may also be from that altar.

Since Jacomart traveled to Naples after being appointed chamber painter to Alfonso the Magnanimous in 1442, the new proposed attribution would explain the Italianate characteristics of this work made two years after his definitive return to Valencia in 1448. It would also make this painting the missing link between the Master of Bonastre and Jaume Baço.

2 Saralegui 1942, pp. 111–12.
3 José Gómez Frechina in Benito Doménech and Gómez Frechina 2001, pp. 186–91.
4 Tormo 1913.
5 Fernando Benito Doménech in *Bartolomé Bermejo* 2003, p. 33.

PEDRO BERRUGUETE (*ca.* 1450–1504)

The Virgin Nursing the Child, ca. 1485–90
Oil on panel, 25 ½ x 20 ¼ in. (65 x 51.5 cm)
Inscription: "miserere mey mater dey domina mea" (on the parapet)
P29

PROVENANCE
Viscount of Roda Collection; Madrid, Sotheby's

BIBLIOGRAPHY
Angulo 1943, pp. 111–15; Angulo 1945, p. 230; Post 1947, vol. IX, part I, pp. 122–24; Angulo 1954, pp. 111–15,
fig. 95; Consuelo Sanz Pastor in *Alonso Berruguete* 1961, no. 119; Camón Aznar 1970a, pp. 183–84, fig. 177;
Enrique Valdivieso in *Tesoros* 1987, p. 20; Joan Sureda in *Arte y cultura* 1992, p. 257; Alfonso E. Pérez
Sánchez in *Obras maestras* 1993, no. 5; Isabel Mateo in *Tres siglos de pintura* 1995, p. 50, fig. 1; Silva
Maroto 1998, p. 251, pl. 95; Ros de Barbero 2014, pp. 37 (ill.) and 170

EXHIBITIONS
Madrid 1954–55, no. 1; Madrid 1961–62, no. 119; Madrid 1987, no. 1; Seville 1992, no. 176, p. 257;
Santander 1993, no. 5; Paredes de Nava 2003, no. 40; Madrid 2014–15, no. 19

This panel probably made for private worship is a very fine and rare work by Pedro
Berruguete, a painter from Palencia who made very few paintings with these characteristics
and format for use other than as altarpieces. In fact, when Diego Angulo first mentioned this
work in 1943, he suggested, with some hesitation, that as a half-length figure on a parapet it
might come from an altarpiece predella.[1] But according to Pilar Silva Maroto,[2] its small size
and subject matter make that unlikely, which reinforces Diego Angulo's apprehension.

The Virgin nurses the Christ Child, who gazes at the angels bearing the *Arma Christi*
that symbolize the Lord's Passion: a spear, a crown of thorns and a cross with nails from
which whips dangle. The bond between mother and child is made visible in the detail
of the Virgin's little finger, which the Christ Child grasps in his small hand. This image of
Christ's infancy also foreshadows his own Passion, of which he was aware from his earliest
childhood. Contemplating the *Arma Christi*, he reflects upon his future death to redeem all
of humanity. The red mantle that partially covers the Virgin's luxurious green gown also
alludes to the future Passion.

The subject of the Virgin of the Milk (*Maria Lactans*) nursing Jesus was common among
Spanish artists as far back as the thirteenth century. According to Manuel Trens,[3] the earliest
such image appears in a miniature on the founding charter of the Brotherhood of the Virgin
Mary and Saint Dominic at the Church in Tárrega (Lerida), which dates from 1269. Here,
the iconography serves to present Mary as the Savior's Mother. Curiously, in other works on
the same subject, her bare breast has been related to the spear wound in Christ's side.[4]

The Virgin wears a crown, along with a red mantle that partially covers her sumptuous
green gown, and sits on a throne before a parapet that bears the following inscription:
"miserere mey mater dey domina mea" (Have mercy on us, Our Lady, Mother of God).
The cherries in the foreground allude to Christ's future Passion, as does the coral rosary
hanging on the wall, although the fruit may also symbolize Paradise.

This Flemish-influenced work is of great quality and virtuosity. Berruguete displays his
mastery as a painter and draftsman in the marked realism of this technically detailed and
meticulous panel. Not only does he render the details and varying textures of the clothing,

1 Angulo 1943, pp. 111–15.
2 Silva Maroto 1998, p. 251,
 pl. 95.
3 Trens 1947, p. 461.
4 Enrique Olivares Torres
 in Benito Doménech et
 al. 2009, p. 178.

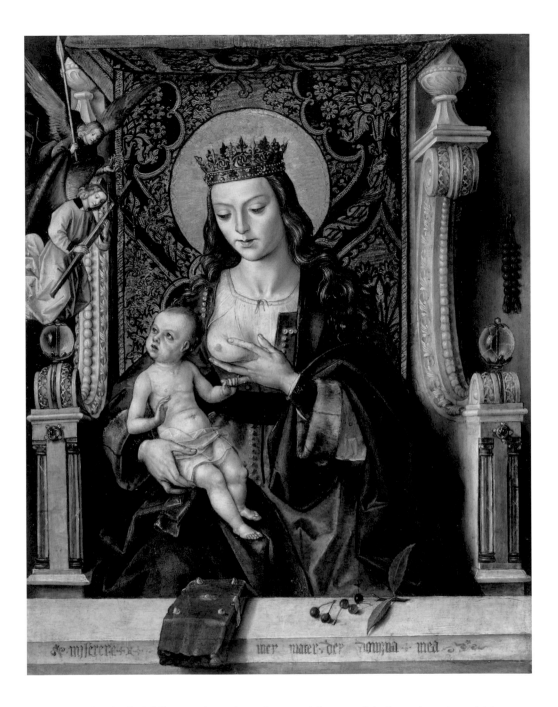

he also faithfully reproduces the architectural throne and the brocade against which the Virgin's bust stands out. The luxurious marble throne with columns and volutes is the composition's most Italianate element.

It is very difficult to date a work of these characteristics when it is not associated with any decorative group. Angulo believed it was not from Berruguete's earliest period, but that it nonetheless predated the *Virgin and Child* at Palencia Cathedral. On the basis of the Virgin's garb, Silva Maroto recently considered it to be an even earlier work, possibly from between 1485 and 1490. At any rate, this panel's combination of Flemish and Renaissance influences indicates that it was painted after the artist's stay in the court of Urbino (*ca.* 1477–82).

JUAN DE FLANDES (*ca.* 1465–1519)

The Baptism of Christ, ca. 1496–99
Oil on Baltic oak, 73 ⅜ x 43 ½ in. (186.3 x 110.5 cm)
P48

PROVENANCE
Burgos, Charterhouse of Miraflores, altarpiece of Saint John the Baptist; Bordeaux, General
d'Armagnac Collection, 1810; Madrid, Viscount of Roda Collection; Madrid, private collection

BIBLIOGRAPHY
Ponz 1778, vol. XIV, letter III, p. 56; Ceán Bermúdez 1800, vol. II, pp. 118–19; Arias de Miranda 1843,
letter 3, 9, p. 1045; Tarín 1925, p. 180, note 1; Sánchez Cantón 1931, p. 151; Post 1933, vol. IV, pp. 37–54;
Post 1934, vol. V, p. 324; Post 1958, vol. XII, pp. 615–25; Bermejo 1962, p. 30; Tzeutschler 1976, p. 125
(ill.); Coo and Reynaud 1979, pp. 125–44; Bermejo and Portús 1988, no. 52; Antigüedad del Castillo-
Olivares 1989, p. 336; Silva Maroto 1990, vol. I, pp. 111–16, vol. III, p. 996; José Rogelio Buendía in *Arte
y cultura* 1992, pp. 264–65; Silva Maroto 1994, p. 573; Garrido 1995, p. 25; Urbach 2001, pp. 189–207;
Mund et al. 2003, pp. 16, 33 and 36–37, figs. 2 and 21; Joaquín Yarza Luaces in *Bartolomé Bermejo* 2003,
p. 111 (ill., detail); Ishikawa 2004, p. 48; Silva Maroto 2006, pp. 134–47, 155–58, 427–31 (ill.), pp. 145,
157 and 428; Syfer-d'Olne et al. 2006, pp. 275 and 278, note 32; "Exposiciones", *Crónica 08* (March,
2009), n.p. (a Museo de Bellas Artes de Bilbao publication); Hans Nieuwdorp in *Juan de Flandes* 2010,
p. 11 (ill.); Matthias Weniger in *Juan de Flandes* 2010, pp. 42 and 50–51; Kasl 2014; Ros de Barbero 2014,
pp. 38 (ill.) and 171–72

EXHIBITIONS
Bruges-Louvaine La Neuve 1985, no. 2; Madrid 1986, no. 11; Seville 1992, no. 183; Santander 1993,
no. 6; Bruges 2002, no. 116; Bilbao 2008–9; Madrid 2014–15, no. 20

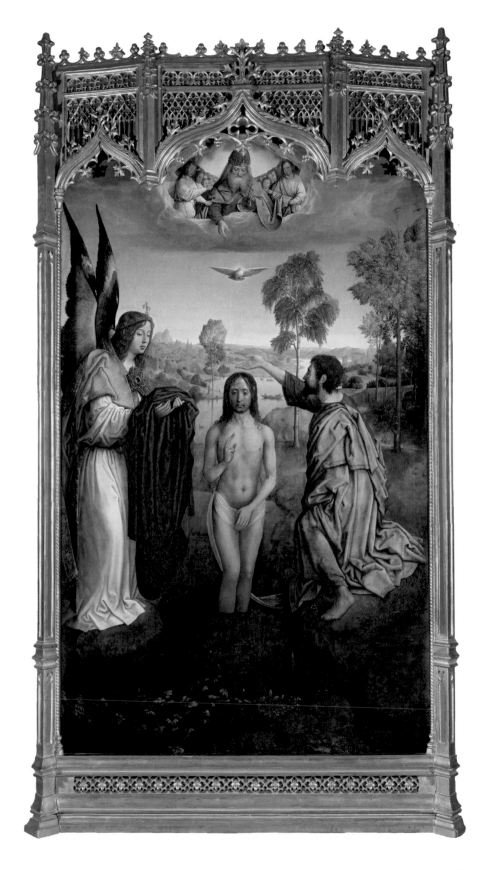

MASTER OF ARTÉS (Pere Cabanes?, active 1472–1538)

The Adoration of the Shepherds, ca. 1500
Oil on panel, 24 ½ x 16 ¾ in. (62.5 x 42.5 cm)
Inscription on the phylactery: "Gloria tibi domine
qui natus est de virgine cun patre et fili spiritu"
P71

PROVENANCE
New York, Koetser Gallery, 1957; Barcelona, Xavier Vila

BIBLIOGRAPHY
Post 1953, vol. XI, pp. 428–30, fig. 184; José Gómez Frechina in Benito Doménech et al. 2009, p. 196;
Ros de Barbero 2014, pp. 39 (ill.) and 172

EXHIBITIONS
Santander 1993, no. 3; Valencia 2009a, no. 52; Madrid 2014–15, no. 21

In this work, the Master of Artés simultaneously depicts various episodes from the New
Testament and the Apocrypha to create a work of great iconographic interest. Specifically,
the panel represents the angel appearing to the shepherds, the adoration of the shepherds
and the "Gloria in excelsis Deo" sounding from heaven beneath the image of God the Father.

The annunciation to the shepherds is painted at a smaller scale to the left of the main
scene, which shows the Virgin and Joseph worshiping and meditating alongside the nude
infant Jesus. The lamb next to the Christ Child in the foreground is an offering from the
shepherds that clearly evokes the Lamb of God and Christ's Redemption. All eyes are
turned to the infant except for those of one of the shepherds kneeling on the right, who
looks directly at the viewer. The latter's clothing and posture suggest he may have been
the work's patron.

When this panel first appeared in print in 1957 Chandler Rathfon Post attributed it to
the Master of Játiva (active 1490–1515), a painter from the circle of the Master of Perea
(active 1490–1510), although he, too, said it recalled the style of the Master of Artés.[1]
Recently, after studying the works of both masters, José Gómez Frechina has concluded
they are one and the same. He maintains the attribution of this work and proposes painter
Pere Cabanes as the possible artist behind the two anonymous masters.[2] The Master
of Artés takes his name from an *Altarpiece of the Last Judgment* (Museo de Bellas Artes,
Valencia, 129.96) originally at the Artés family chapel in the charterhouse at Portaceli.

This work dates from the first Valencian Renaissance, when the presence of late
fifteenth-century Italian artists such as Paolo da San Leocadio (1447–1519) influenced the
soft idealization of the figures, the tranquil naturalism of the landscape and the overall
composition. The Master of Perea's influence is also visible. These novelties coexist with
other elements of Flemish origin, such as the angular folds of the Virgin's robes.

Documents show that painter Pere Cabanes had a large studio in Valencia, where
he was active between 1472 and 1538, so the present work could date from the late
fifteenth or early sixteenth century.

1 Post 1953, vol. XI, p. 428.
2 Gómez Frechina in
 Benito Doménech et al.
 2009, p. 196.

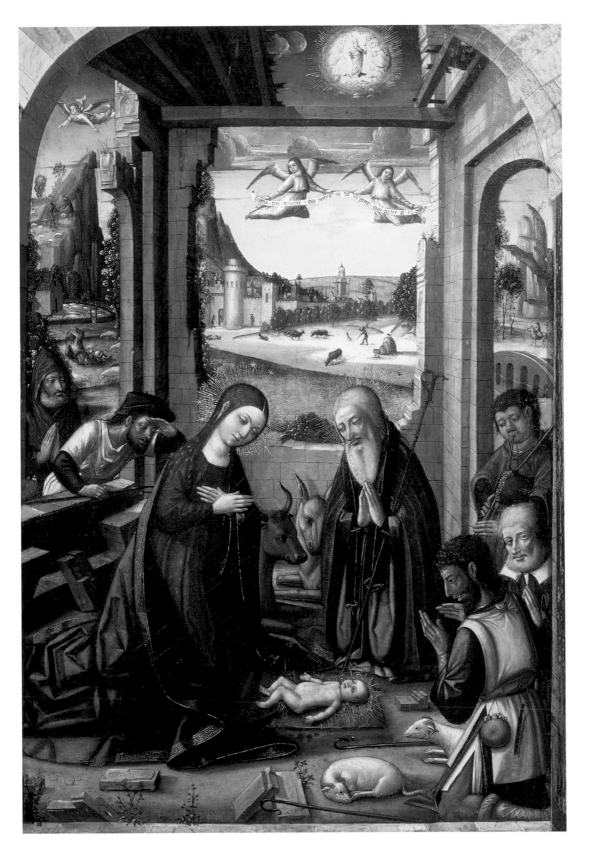

FERNANDO YÁÑEZ DE LA ALMEDINA (ca. 1475–1540)

The Salvator Mundi between Saints Peter and John, ca. 1506–7
Oil on panel, 29 ½ x 24 ⅜ in. (75 x 62 cm)
P86

PROVENANCE
Paris, King Louis-Philippe d'Orléans Collection; Paris, Spanish Gallery at the Louvre, 1838–48; London, Christie's, auction of the King Louis-Philippe d'Orleans Collection, May 6–7, 1853, lot no. 101, acquired by Pearce; Robert Napier sale, Christie's, April 13, 1877, lot no. 364, acquired by Sir J. C. Robinson; Berlin, Sir J. C. Robinson sale, March 31, 1914; Dortmund, Joseph Cremer Collection, *ca.* 1929; Berlin, Wortheim, Joseph Cremer sale, May 29, 1919, lot no. 176; London, Sotheby's

BIBLIOGRAPHY
Notice des tableaux 1838, no. 418; Mayer 1922, pp. 121–22; Tormo 1924, p. 38; Tormo 1949, p. 33; Garín 1953, p. 137 (ill.); Post 1953, vol. XI, pp. 227–28, fig. 82; Angulo 1954, p. 48; Garín 1978, pp. 148–49, fig. 56; Garín 1979, pp. 87–90; Baticle and Marinas 1981, p. 279, no. 429; Fernando Checa in *Reyes y mecenas* 1992, pp. 295–96, no. 23; Ximo Company in *Edad Media* 1993, p. 52 (ill.); Ibáñez Martínez 1993, vol. I, p. 96, fig. 44; Miguel Ángel Catalá in *Osona* 1994, pp. 196–97; Pérez Sánchez 1996, pp. 66–67; Pérez Sánchez 1997, pp. 46–47; Benito Doménech 1998, pp. 162–63; Ibáñez Martínez 1999, pp. 318–20, fig. 135; María Cruz de Carlos in Marías and Pereda 2000, pp. 504–5; Ibáñez Martínez 2011, pp. 194–201, no. 10 (ill.); Ros de Barbero 2014, pp. 40 (ill.) and 173

EXHIBITIONS
Toledo-Innsbruck 1992, no. 23; Santander 1993, no. 4; Valencia 1994–95, no. 26; Seville-Madrid 1996–97, no. 17; Oviedo 1997, no. 9; Valencia-Florence 1998, no. 25; Granada 2000, no. 163; Madrid 2011–12, no. 10; Madrid 2014–15, no. 22

This extraordinarily beautiful panel by Fernando Yáñez de la Almedina—almost certainly for private worship—was considered the artist's masterpiece by Chandler Rathfon Post. It reveals Yáñez's direct knowledge of Italian painting as a result of the artist's trip to Florence, where he very likely worked in Leonardo da Vinci's (1452–1519) studio. By 1506, Yáñez was already back in Spain, where he was one of the first artists to bring in elements of the Italian Renaissance. In works like this, Leonardo's influence is patent.

This panel, which was part of King Louis-Philippe d'Orléans's Spanish Gallery at the Louvre, depicts Christ as the *Salvator Mundi*. His cross-shaped halo and the golden letters on the edge of his tunic reinforce that iconography, as "IHS" stands for "Iesus Hominum Salvator," that is, "Jesus, Savior of men." The other monogram, "XPS" is known as the "Chrismon" and contains the capital Greek letters corresponding to *Christos*.

Saint Peter and Saint John appear alongside Jesus with their names inscribed above their heads. The two extended fingers of the right hand with which Jesus offers his blessing symbolize his dual nature as man and God, while the remaining three fingers represent the Holy Trinity. The composition with three half-length figures serves to contrast the beauty and perfection of Christ's face with the less-idealized and more human physiognomy of the apostles. Fernando Checa interpreted this composition as a presentation of active and contemplative lives. Miguel Ángel Catalá later went so far as to consider it a representation of the three ages of man.

The three heads are exceptionally alive and each shows the influence of Leonardo, including the somewhat aged Peter and, especially, the young John. Christ's thin lips

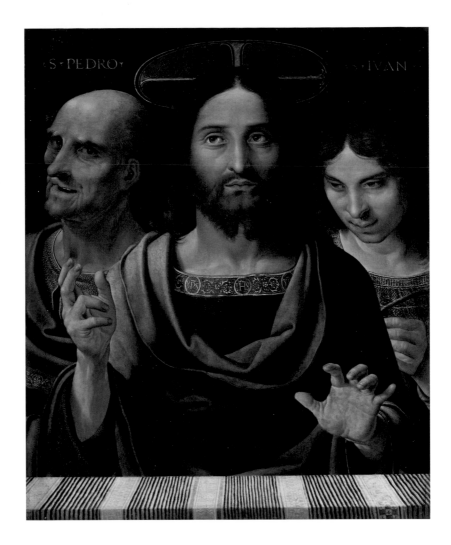

and the marked corners of his mouth also recall Leonardo's models. Still, the meticulous finish reflects Yáñez de la Almedina's personal style, lacking Leonardo's characteristic *sfumato*. His attentive rendering of the anatomy through careful drawing and his virtuoso foreshortening of Christ's hand also stem from his Italian training and they appear in other works as well, including his *Saint Cosme* at Valencia Cathedral.

The painter manages to create a sense of depth and perspective by placing the figures on different planes, leaving space between them, separating the images. Christ's hand extended towards the viewer and the parapet in the foreground also contribute to that effect. The light entering the composition from the left brings out the colors creating a chiaroscuro on the three figures' faces, which stand out against the darker background. The entire work transmits strength and serenity at the same time.

Fernando Checa linked the figure of Christ to that in a work which, formerly in a private English collection, has been recently purchased by the Metropolitan Museum of Art, New York (2014.149).[1] That painting shows only Christ's bust, but the similarities in the clothing and halo, as well as in the figure's frontal presentation, are very clear.

While working on this piece, Zahira Véliz commented on "the artist's diligence" in handling its painterly aspects. She was especially struck by the high quality of the chosen materials and by the manner in which they were employed.[2]

1 Fernando Checa in *Reyes y mecenas* 1992, p. 296. The work had been thought to be by Jacopo de Barbari (ca. 1465 -1515/16). After its incorporation into the holdings of The Metropolitan Museum of Art it has been correctly attributed to Yáñez de la Almedina.

2 Restoration report, Abelló Collection Archives.

LUCAS CRANACH THE ELDER (1472–1553)

The Virgin Lactans, ca. 1540
Oil on panel, 22 ¼ x 13 ¾ in. (56.5 x 35 cm)
Signed on the right, at the height of the Virgin's neck, with the dragon monogram
P85

PROVENANCE
Vienna, Ullrich Collection, *ca.* 1950; London, Harari & Johns Ltd.

BIBLIOGRAPHY
Ros de Barbero 2014, pp. 41 (ill.) and 174

EXHIBITIONS
Santander 1993, no. 1; Madrid 2007–8b; Madrid 2014–15, no. 23

In 1987 Dieter Koepplin called this panel signed with the dragon monogram "one of the most impressive Madonnas" by Lucas Cranach the Elder,[1] and he related the Virgin's face to similar ones appearing in works by Lucas Cranach the Younger (1515–1586).

Considered to be a work from the artist's mature period, it is impressive in its virtuosically detailed drawing, as can be seen in the hair, the transparent veil and the folds of the Virgin's chemise.

The iconography of the *Galaktotrophousa (Maria Lactans)* or Virgin of the Milk is quite ancient, dating back to the first Christians. Here, the Virgin is shown nursing her son, whom she very naturally cradles in her right arm. The Christ Child appears comfortable and rests his tiny hand on his mother's bosom. The two figures are set against a dark, neutral background that contrasts with the foreground light that illuminates the figures and brings out the colors. The painter's characteristic rendering of the fabrics is outstanding in its colors and its particular folds, especially in the sleeves of the Virgin's chemise.

1 Written communiqué, August 21, 1987; Abelló Collection Archives.

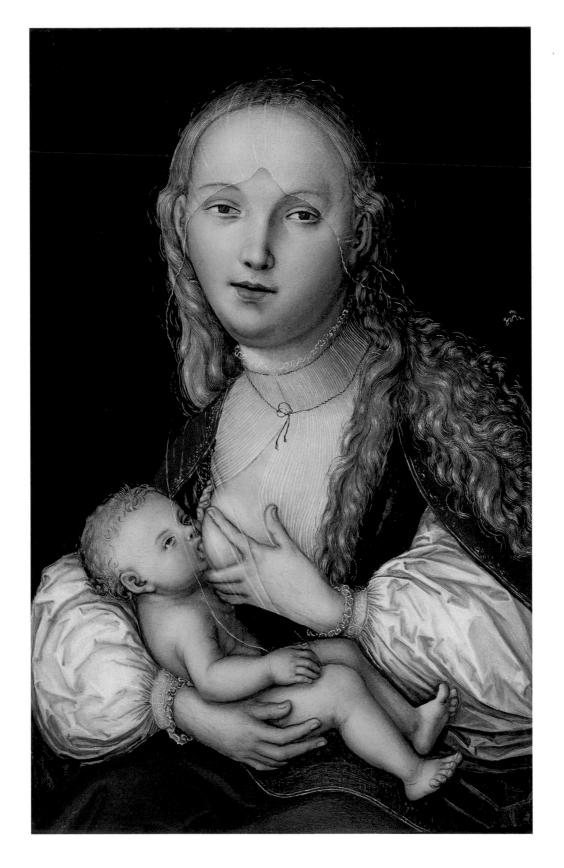

LUIS DE MORALES, "EL DIVINO" (*ca.* 1510–1586)

The Virgin of Silence, ca. 1550
Oil on panel, 22 ½ x 16 ½ in. (57 x 42 cm)
P99

PROVENANCE
Madrid, private collection

BIBLIOGRAPHY
Berjano Escobar 1917, p. 120; Mayer 1947, p. 233; Angulo 1954, p. 240; Backsbacka 1962, no. 38, pl. 168; Enrique Valdivieso in *Tesoros* 1987, pp. 30–31; Ros de Barbero 2014, pp. 42 (ill.) and 174

EXHIBITIONS
Madrid 1917, no. 29; Madrid 1987, no. 6; Santander 1993, no. 7; Madrid 2014–15, no. 24

This exquisite image conceived for private worship presents the iconography of the Virgin of Silence, with the infant Jesus placidly sleeping under his mother's eye as she covers him with a veil and a young John the Baptist brings a finger to his lips in a request for silence.

This is a characteristic work by Luis de Morales, an artist often referred to as "The Divine" owing to the piety and devotion he was able to transmit in his works. It invites the viewer to look inwards while contemplating the Son of God, presented by the Virgin, his mother, who treasured all things and "pondered them in her heart" (Luke II:19, 51). As usual, despite being an image of Christ's infancy, the basket of red cherries in the foreground alludes to the blood that will be spilled by him in the Passion and Redemption.

Stylistically, Morales merges the Flemish tradition's meticulous draftsmanship and attention to detail with a *sfumato* finish that echoes Leonardo da Vinci's (1452–1519) approach. The latter technique greatly softens the composition, in which the three figures seem to be related with a contained expressiveness. The palette, the proportions of the Christ Child's body and the Virgin's original clothing also link this work to Italian mannerism.

A very similar composition by Morales at the Museo Nacional del Prado in Madrid (P03147) shares the present painting's iconography, but its model of the Virgin more closely resembles that of a Virgin dressed as a gypsy with the Christ Child at the Ashmolean Museum of Art and Archaeology in Oxford (WA 1954.52).

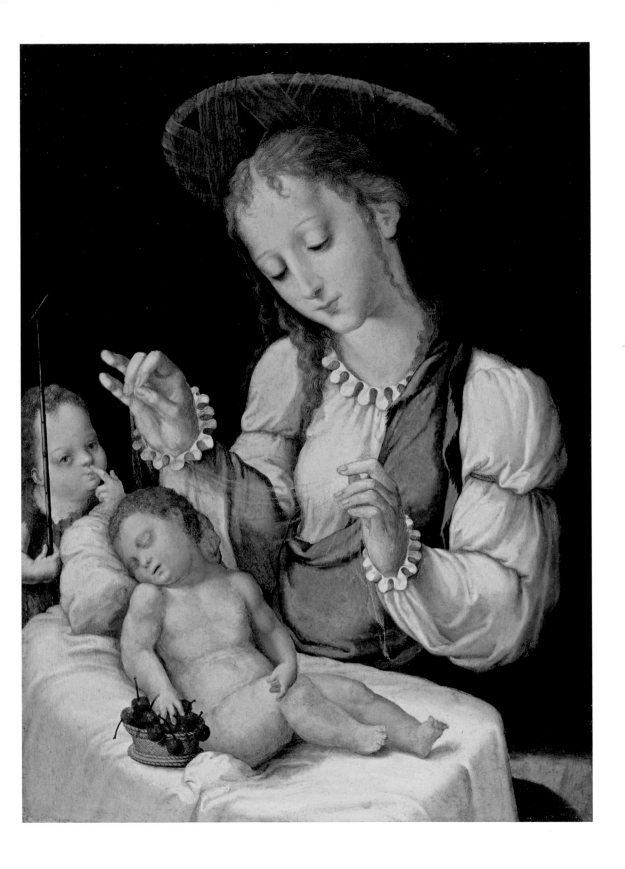

DOMENIKOS THEOTOKOPOULOS, "EL GRECO" (1541–1614)

The Stigmatization of Saint Francis, ca. 1580
Oil on canvas, 42 ½ x 33 in. (108 x 83 cm)
Signed with cursive Greek letters: "doménikos thotokópolis e' poíei" (lower right)
P26

BIBLIOGRAPHY
Cossío 1908, pp. 376 and 572, no. 121; Mayer 1926, no. 234; Legendre and Hartmann 1937, p. 421; Camón Aznar 1950, no. 548, pls. 224 and 227; Soehner 1957, pp. 125, 128, 132 and 138; Soehner 1959, p. 180, no. 20; Wethey 1962, no. 210; Wethey 1967, pl. 233; Manzini and Frati 1969, p. 125, no. 59a; Camón Aznar 1970b, p. 370, no. 550; Cossío 1981, no. 210; Gudiol 1982, pp. 108–9, no. 67, fig. 94; Enrique Valdivieso in *Tesoros* 1987, pp. 34–35; Álvarez Lopera 1993, no. 65; "El Greco llega en su itinerario a Atenas," *El Punto de las Artes* (October 22–28, 1999), ill.; Ros de Barbero 2014, pp. 43 (ill.) and 175

This work from approximately 1580 was painted by Domenikos Theotokopoulos, "El Greco," in Toledo, where he settled around 1577. During that period, he also painted *The Disrobing of Christ* and the canvases for the altarpiece at the Cistercian convent of Santo Domingo el Antiguo. Unable to obtain patronage in Rome, the painter traveled to Spain in hopes of working with other artists on the decoration of El Escorial, which was being built at the behest of King Philip II (1527–1598). In Toledo, El Greco also worked for other clients, many of them private, for whom he painted medium-format devotional works like this *Saint Francis.*

The stigmatization of Saint Francis depicted here coincided with the Feast of the Exaltation of the Cross on September 14, 1224, two years before the saint's death, as Tomasso da Celano recounts in his *Vita Beati Francisci* (part II, chap. 3). The vision of Christ as a crucified seraph came to the saint as he was praying at the hermitage on Mount Alvernia. Moments later, "his hands and feet began to show nail marks like those he had just seen on the crucified man that had hovered above him." This work is "the first version of this subject executed in Spain, a splendid creation of undisputable authorship that stands among the most beautiful ever painted by El Greco."[1]

The miracle is represented here by rays of light that shine down from the crucified seraph to the stigmata. In Tomasso da Celano's narrative, Saint Francis hid this mystery all his life, sharing it with very few despite the fact that they were truly bleeding wounds.

El Greco places the saint at the center of the composition, depicting him slightly more than half length and gazing fixedly at the apparition. The skull below his right arm signifies his meditation on death. The figure of Saint Francis of Assisi appears lit up against a dark, cloudy sky that is a feature of El Greco's work. The young saint's facial expression reflects mystic devotion and longing, although his face is haggared by fasting and penitence. While El Greco made various canvases on this subject, the present work is among the most convincing in terms of composition and pictorial quality.

1 Margarita Cuyás in Milicua 1996, p. 136.

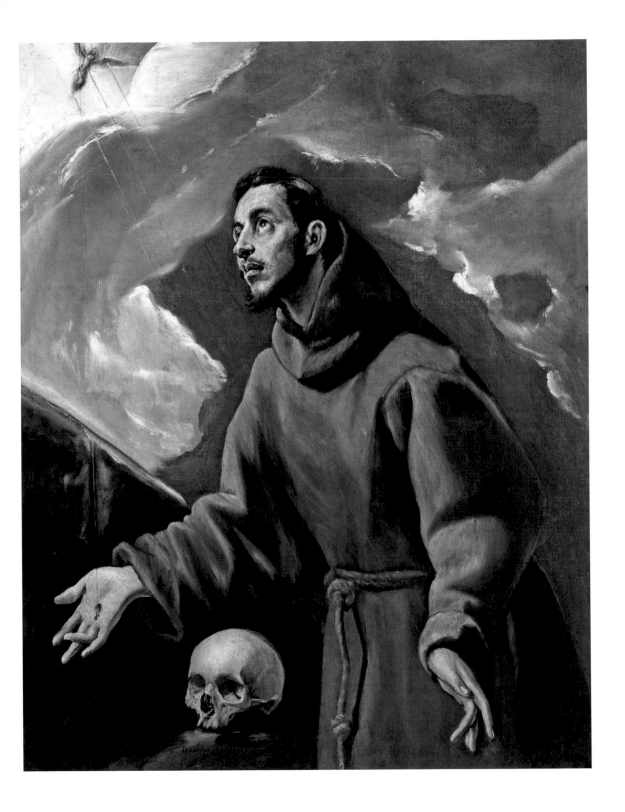

JOORIS VAN DER STRAATEN, "JORGE DE LA RÚA" (active 1556–1578)

Portrait of Philip II with the Order of the Garter, ca. 1554
Oil on canvas, 48 x 35 in. (121.9 x 88.9 cm)
Inscription: "Philip 2nd of Spain" (lower right corner)
P810

PROVENANCE
Probably painted in spring 1554 for Queen Mary Tudor of England on the occasion of her marriage to
Philip II; Ditchley Park, Oxfordshire, Collection of Sir Henry Lee (1533–1611), knight to Queen Elizabeth
I; Great Britain, Collection of Sir Edward Lee, Earl of Lichfield; Great Britain, Collection of Lady
Charlotte Lee, who married Henry Dillon, 11th Viscount Dillon (1705–1787); Great Britain, Collection
of Harold Dillon, 17th Viscount Dillon, 1930; London, Sotheby's; England, private collection; Madrid,
Galería Caylus

BIBLIOGRAPHY
Waagen 1854, vol. III, p. 134; Kusche 2003, pp. 144–46, fig. 16; Ros de Barbero 2014, pp. 44 (ill.) and 175–76

EXHIBITIONS
Manchester 1897; Madrid 2014–15, no. 26

On July 25, 1554, Philip II (1527–1598), then king of Naples, remarried, taking Queen
Mary I of England (1516–1558) as his second wife. Eleven years earlier, on November 15,
1543, he had married María Manuela of Portugal (1527–1545), with whom he fathered
Charles of Austria (1545–1568). His marriage to Mary Tudor, the daughter of Henry VIII
and Catherine of Aragon, lasted until the queen died four years later and it insured the
future Philip II's claim to the English throne.

Here, he is depicted as that country's monarch in a three-quarters view, turned to the left
but looking directly at the viewer. He is elegantly dressed in black velvet with a frock coat,
yellow breeches and a black cap with trimmings, but the most interesting element of his
apparel is a medallion of the Order of the Garter hanging from a chain on his chest, which
he received from the Earl of Arundel upon his arrival in England on July 20, 1554. The
fact that this is the only official decoration to appear in this portrait of Philip II suggests it
was intended for use by the English crown. The later inscription in the lower right corner,
"Philip 2nd of Spain" is written in English, which supports that provenance.

The author of this work, Jooris van der Straaten, was better known in Spain as Jorge de
la Rúa. Originally from Ghent, he painted portraits of royalty and other members of the
European courts in Portugal, England, Spain and France. He very likely accompanied Philip
to England and documentation between 1560 and 1568 lists delivery of numerous paintings
he made at the behest of the king's third wife, Queen Elizabeth of Valois (1546–1568).
After her death, Van der Straaten moved to France, where he worked for Charles IX's wife,
Elizabeth of Austria (1554–1592).[1]

Here, the artist displays his precise, meticulous style, paying particular attention to
the sumptuous clothing. He also focuses on details such as the curtain's highlights, the
trimming and the sword's pommel, where his impeccable technique betrays his Flemish
origins. The strong, contrasting colors contribute to this work's aesthetic quality.

The Museo Nacional del Prado in Madrid has a small work with a bust of the king that
matches the present portrait. While it is attributed to Anthonis Mor (1516/21–1576/77),
Maria Kusche considers it "undoubtedly a copy of the de Rúa"[2] in the collection.

1 Kusche 2003, pp. 139–62.
2 Ibid., p. 156, fig. 117.

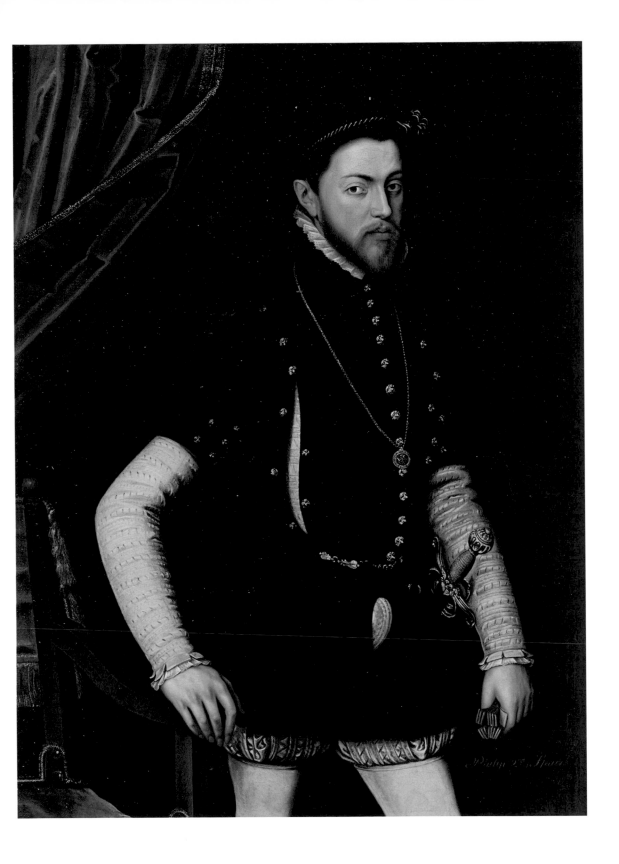

JUAN PANTOJA DE LA CRUZ (*ca.* 1553–1608)

Portrait of the Infanta Doña Ana of Austria as a Girl, 1607
Oil on canvas, 47 ¾ x 40 in. (121.2 x 101.6 cm)
Signed: "Joannes Pantoja dela + / Façiebat 1607" (lower left corner)
P1381

PROVENANCE
Commissioned from the artist by Queen Margaret of Austria in 1607; given by Queen Margaret of Austria to the Countess of Barajas with other portraits of infantes; Madrid, private collection, 1900; Madrid, Galería Caylus

BIBLIOGRAPHY
Sánchez Cantón and Allende Salazar 1919, p. 167; Sánchez Cantón and Moreno Villa 1937, p. 131; Kusche 1964, no. 33; Camón Aznar 1970a, p. 508, fig. 433 (as Isabel Clara Eugenia and in Las Descalzas); Kusche 2007, pp. 54 (ill.) and 148–49 (ill.); Ros de Barbero 2014, pp. 45 (ill.) and 176

EXHIBITIONS
Madrid 1918; Madrid 1925, no. 22 (as Isabel Clara Eugenia); Madrid 2014–15, no. 27

On September 22, 1601, Philip III's (1578–1621) wife, Margaret of Austria (1584–1611), gave birth to their first child, the Infanta Ana Mauricia (1601–1643), who was baptized on October 7 at the church of San Pablo in Valladolid.

This Spanish infanta, future wife of Louis XIII of France, appears here at the age of six, wearing the same dress she wore to her sister Maria's baptism, the documents of which indicate she acted as godmother: "The same day, April 7, 1607, another full-length portrait on canvas, one-and-a-half rods high, of the Most Serene Infanta Doña Ana, dressed in white with a shawl, who was godmother in San Lorenzo, with jewels, curtain and one hand resting on a crimson buffet with the other holding a canvas; delivered to Our Lady the Queen in Madrid, who graciously gave it to the Countess of Barajas. Valued at 660 reales."[1]

Queen Margaret of Austria thus commissioned Juan Pantoja de la Cruz to paint this portrait as a gift to her favorite lady, the Countess of Barajas. It depicts Doña Ana as the godmother of her sister Maria (1606–1646), who later married Emperor Ferdinand III of Germany (1608–1657). Doña Maria was born on August 18, 1606 and baptized at El Escorial on September 8. She received the same name as the monarchs' second daughter, who had died two months after birth in 1603.[2]

Doña Ana became the mother of Louis XIV (1638–1715) and Philippe d'Orléans (1640–1701), and after Louis XIII's death in 1643 she acted as Regent of France with Cardinal Mazarin as Prime Minister until her son came of age. She died in Paris on January 20, 1666.

A disciple of Alonso Sánchez Coello (1531/32–1588), Pantoja de la Cruz also studied in France, where he followed Jooris van der Straaten (active 1556–1578), and Vienna, where he worked for Elizabeth of Austria. The present portrait, which he painted a year before his death, shows his teacher's influence. The figure stands out against the background and, though still a child, her image follows the model used for adult portraits. Even the furnishings—the buffet and window— have been adapted to match the stature of Doña Ana, who is depicted as a miniature adult.

Among the works related to the present portrait, mention should be made of one (Ambras Castle, Innsbruck) from the same year (1607) with a very similar depiction of the infanta, although there she is holding hands with her brother, Philip IV.[3] Pantoja also painted an earlier portrait (Ambras Castle, Innsbruck), in 1604, that shows the infanta with a similar pose and clothing, but with a Walloon collar rather than a ruff.[4]

1 *Cuenta de J. Pantoja de la Cruz a la Reina Margarita por trabajos de los años 1600–1607,* published in Kusche 2007, p. 148.
2 González-Doria 1986, p. 179.
3 Kusche 2007, p. 145, fig. 98.
4 Ibid., fig. 96.

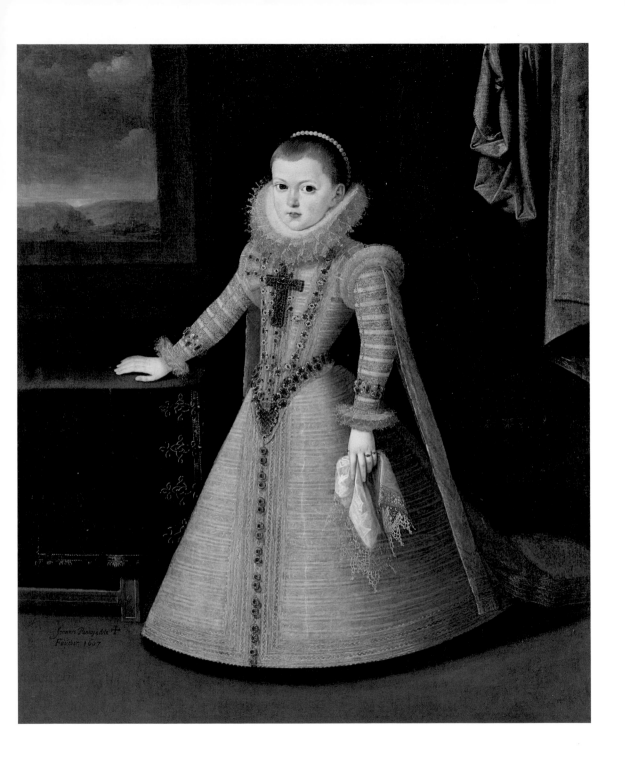

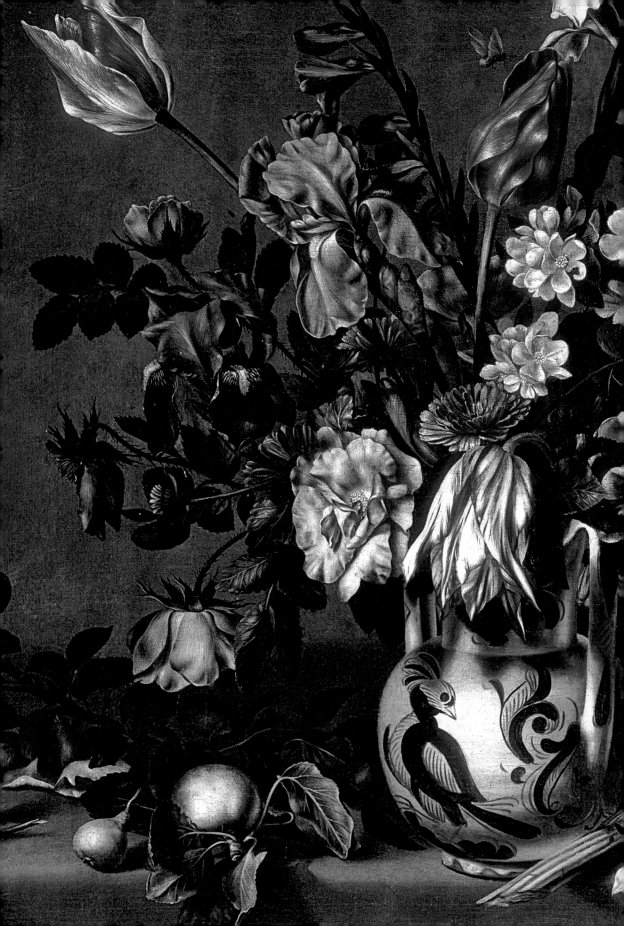

Early Naturalism
and Baroque Painting

JUSEPE DE RIBERA, "LO SPAGNOLETTO" (1591–1652)

The Sense of Smell, ca. 1615
Oil on canvas, 45 ¼ x 34 ¾ in. (114.8 x 88.3 cm)
P73

PROVENANCE

Rome, Pedro Cosida Collection, *ca.* 1615; Rome, by descent to his son, Juan Francisco Cosida, 1622;
Moscow and Saint Petersburg, Youssoupov Collection, 1917; New York (?), collection of the art dealer,
Duveen; New York, George Farkas; Riverdale (New York), Mrs. Alfred Pordy Collection; Cranbury
(New Jersey), Alfred Pordy Collection; New York, Christie's, Richard L. Feigen Collection; New York,
Piero Corsini

BIBLIOGRAPHY

Milicua 1952, pp. 309–22; Mancini 1956–57, vol. I, pp. 149–50; Longhi 1966, pp. 74–78; Felton 1969,
pp. 2–11; Spinosa 1978, no. 5a; Christiansen 1987, p. 212, fig. 83; Piero Corsini in *Ribera inedito* 1989,
pp. 6–7; Benito Doménech 1991, pp. 26 and 28; Felton 1991a, pp. 125–26, XII (ill.); Felton 1991b, pp. 74
and 78–80 (ill.); Cherry 1999, p. 112 (ill.); Scholz-Hänsel 2000, p. 26, fig. 21; Papi 2002, pp. 21–43, no. 44;
Lange 2003, no. A15; Mena 2003, p. 284, fig. 132; Spike 2003, p. 32; Spinosa 2003, p. 259 (ill.), no. A33;
Spinosa 2005, p. 21, fig. 3; Spinosa 2006, p. 273, no. A44; Papi 2007, p. 163, figs. LX–LXI; Spinosa 2008,
no. A64; José Milicua in Milicua and Portús 2011, p. 152; Ros de Barbero 2014, pp. 52–53 (ill.) and 178–79

EXHIBITIONS

New York 1986, no. 19; Madrid 1992, no. 2; Naples 1992, no. 1.4; New York 1992, no. 3; Santander 1993,
no. 9; Edinburgh 1996, no. 11; Seville-Madrid 1996–97, no. 23; Oviedo 1997, no. 14; Bilbao 1999–2000,
pp. 92–93; Seville-Bilbao 2005–6, no. 43; Naples 2009–10, no. 1.20; Madrid 2011, no. 21; Madrid 2014–15,
no. 33

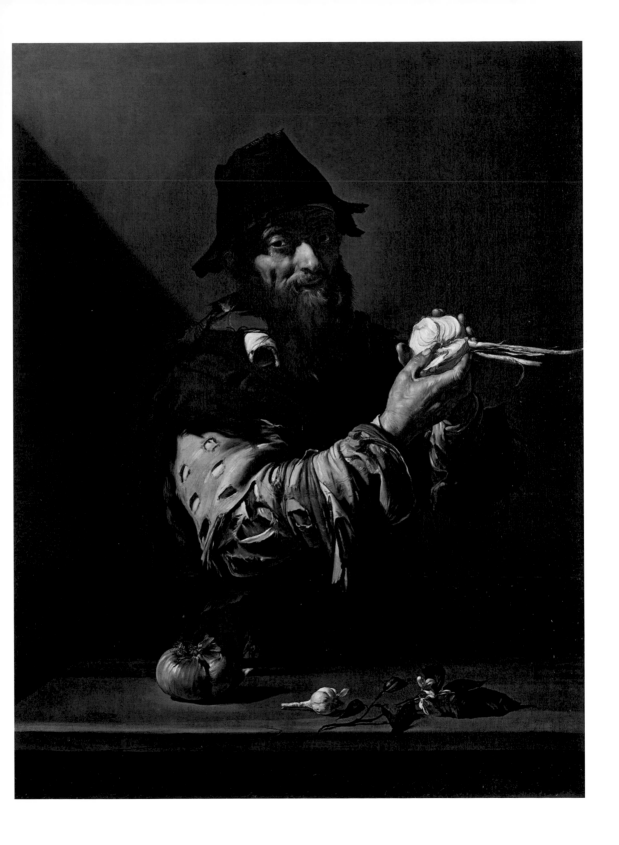

This important early work by Jusepe de Ribera was painted around 1615 during his stay in Rome. It is one of five depictions of the senses and was mentioned early on by Giulio Mancini (1558–1630), who was physician to Pope Urban VIII (Maffeo Barberini, 1631–1685) as well as a critic of that period's art trends and styles. In his *Considerazioni sulla pittura*, Giulio Mancini mentions "cinque mezze figure per i cinque sensi, molto belli" ("five half figures for the five senses, very beautiful")[1] painted in Rome for an unnamed Spanish client.

Gianni Papi[2] has recently identified that client as Pedro Cosida, a native of Zaragoza who represented the Spanish monarchy at the Vatican and collected paintings of the Caravaggio school in Rome. The inventory of the possessions of Cosida's son, Juan Francisco, lists five paintings of the five senses, which he must have inherited when his father died in 1622. Cosida also owned other works by Ribera, including an *Apostolate*. Before this documentation was published, the provenance of this series on the five senses had been linked to five paintings with the same subject matter mentioned in a manuscript that placed them in Cardinal Ottoboni's palace in Rome around 1650. There, they were attributed to Diego Velázquez (1599–1660) as "Don Diego Velasco."[3]

While the iconography of the senses comes from Dutch mannerist painting, the present singular series is related to Roman art circles and to the naturalism of the Caravaggio school. The complete series includes *The Sense of Sight* at the Franz Mayer Museum in Mexico City, *The Sense of Taste* at the Wadsworth Atheneum in Hartford (1963.194), *The Sense of Touch* at the Norton Simon Foundation in Pasadena (F.1965.1.052.P) and *The Sense of Hearing*, of which only copies are known, as the original has yet to be discovered. The present depiction of *The Sense of Smell* appeared on the American art market in 1985. Until then, its composition was known only through various copies, one of which is also in the Abelló Collection (P657).

The sense of smell is represented by a beggar dressed in rags who holds two halves of a cut onion. Another half-peeled onion rests on the table in front of him, together with a

1 Mancini 1956–57, vol. I, pp. 149–50, and Milicua 1952, pp. 309–22.
2 Papi 2002, pp. 21–43.
3 Spinosa 2008, p. 338.

head of garlic and a spray of orange blossoms. The naturalist current from the Catholic Counter-Reformation that flooded religious painting with images of the saints as flesh-and-blood humans is also visible in the present canvas, which lacks the allegorical character of earlier works on the same subject. The image of the beggar appears to be taken from life and the entire work is imbued with naturalism—a very appropriate style for representing the senses.

The sense of smell is typified by two disagreeable odors, onion and garlic, and the fragrance of orange blossoms. The chiaroscuro illumination bathes those elements in light, along with the figure's nose, leaving the rest of his face in shadows. The violent ray of light striking his nose also highlights his right eye, from which a tear emerges in response to the onion's fumes.

This painting is a sensory experience unto itself, lacking only its own smell. The textures of its different elements are outstanding, especially the onion and garlic, as well as the beggar's grimy hands and, most of all, his pearl-gray sleeve, practically in rags, with fraying rips and tears. In the background, the intense light forms a very marked diagonal that is also visible in *The Sense of Taste, The Sense of Sight* and *The Sense of Touch*.

The paint itself is thick and rich in oil, although the finish appears smooth. Professor Alfonso E. Pérez Sánchez drew a relation between the variety of human types appearing in these works and the greater or lesser dignity of the sense represented in each.[4] The beggar shown here is probably the most humble of all, which would coincide with the lowest of the senses: the one that links man to the animal kingdom. Hence, its relative lack of prestige with regard to the others.

Among the copies of this series,[5] mention can be made of one in Murcia (D'Estoup Collection),[6] another in Vienna (Europahaus)[7] and others in Zamora (Provincial Government) and in a private collection (New York), as well as the one in the Abelló Collection, mentioned above (P657).

4 Alfonso E. Pérez Sánchez in Pérez Sánchez and Spinosa 1992a, no. 1.4; in Pérez Sánchez and Spinosa 1992b, no. 2; and in Pérez Sánchez and Spinosa 1992c, no. 3.
5 Spinosa 2008, p. 338.
6 Martínez Ripoll 1981, p. 109, no. 94 (the same collection also has a "rather mediocre copy," p. 110, no. 97).
7 Auctioned at the Dorotheum (Vienna) in January 1966 and published in Longhi 1966.

JUAN VAN DER HAMEN Y LEÓN (1596–1631)

Pears and Grapes in a Fruit Bowl, 1622
Oil on canvas, 23 ¼ x 36 ¾ in. (59 x 93.3 cm)
Signed: "JuᵃVander Hamen / de Leon a.1622." (lower left corner)
P107

PROVENANCE
New York, Christie's

BIBLIOGRAPHY
Jordan 1985, p. 110, fig. IV.9; Pérez Sánchez 1987, p. 45, pl. 29; Cherry 1999, p. 156, pl. XXXV; Felix
Scheffler in *Esplendores de Espanha* 2000, p. 221; Aterido 2002, pp. 37–39 (ill.); Jordan 2005, pp. 92–93,
fig. 6.15; Oppermann 2007, p. 23, note 29; Romero Asenjo 2009, p. 79, figs. 1 and 2, p. 90, fig. 10; Peter
Cherry in Cherry, Loughman and Stevenson 2010, p. 152; Ros de Barbero 2014, pp. 56 (ill.) and 180–81

EXHIBITIONS
Santander 1993, no. 12; London 1995, no. 11, p. 50; Seville-Madrid 1996–97, no. 28; Oviedo 1997, no. 17;
Rio de Janeiro 2000, p. 221; Madrid 2014–15, no. 36

Born to an aristocratic family with an important military tradition, Juan van der Hamen y
León was one of the most important and influential still-life painters in seventeenth-century
Spain, though he also made religious paintings and portraits. As far back as his paternal
grandfather, the male members of his family had belonged to Spain's Royal Guard of Archers,
an elite corps entrusted with the monarch's protection, no doubt due to the noble Dutch
lineage of his father's family.

His still lifes were highly coveted in the city and court of Madrid, where they adorned
the houses of that period's courtiers and aristocrats. Van der Hamen was able to meet the
growing demand for his works with the help of his studio assistants.

Signed and dated in 1622, the present canvas depicts a sumptuous fruit bowl with
pears and grapes resting on a windowsill. The green glass and gilded bronze fruit bowl
framed here by two suspended bunches of grapes, some pomegranates and a few flowers
frequently appears in his work, although no such object is listed in the inventory of his
possessions drawn up after his untimely death in 1631. It has therefore been suggested that
he may have drawn on engravings as a reference for it.[1] On the other hand, the similar size
and shape of all the fruit bowls of this type in his still lifes suggest that he may have used a
pattern or stencil to transfer the image onto the canvas.[2]

Pomegranates also appear in other compositions by Van der Hamen, including one at the
Royal Seat of San Lorenzo de El Escorial, which belongs to Patrimonio Nacional (10014637).
Despite this repetition of elements in various still lifes, the artist brilliantly endowed each
with its own identity, so that they can be related to each other without being mere replicas.

The composition is highly symmetrical, with an equilibrium that derives from the
positioning of its different elements. The fruit is shaped with a powerful chiaroscuro
underscored by the dark background. Van der Hamen casts the light wherever he wants
to emphasize something, including the *trompe l'oeil* of the split pomegranate on the
left, which is projected toward the viewer. While this still life is very representative of
the artist's personal style, the hanging grapes and the window opening also reflect the
influence of Juan Sánchez Cotán (1560–1627).

1 Cherry 1999, p. 156
 and note 57.
2 Romero Asenjo 2009,
 p. 90, fig. 10.

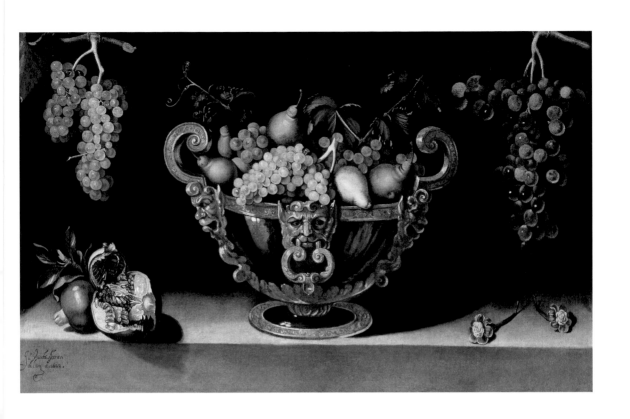

ANTONIO PONCE (1608–1677)

Still Life with Artichokes and Talavera Urn with Flowers, ca. 1650–60
Oil on canvas, 28 ¼ x 37 in. (72 x 94 cm)
Signed: "A. Ponze fecit" (lower left corner)
P70

PROVENANCE
Private collection; Monaco, Sotheby's; London, Matthiesen Fine Art Ltd.

BIBLIOGRAPHY
Jordan 1997, no. 8; Cherry 1999, pp. 289–90, pl. XLIX; Aterido 2002, pp. 98–99; Oppermann 2007,
pl. 9; Romero Asenjo 2009, pp. 110–14, fig. 23; Peter Cherry in Cherry, Loughman and Stevenson 2010,
pp. 214–15; Ros de Barbero 2014, pp. 60 (ill.) and 184

EXHIBITIONS
London 1986, no. 20; Santander 1993, no. 13; London 1995, no. 19, p. 66; Seville-Madrid 1996–97, no. 38;
Oviedo 1997, no. 26; Bilbao 1999–2000, no. 20; Haarlem-Madrid 2002–3, no. 21; Lisbon 2010, no. 46;
Madrid 2014–15, no. 42

As Professor Peter Cherry points out, this still life from the 1650s is "Ponce's masterpiece."[1]
Here, the student very nearly surpasses his teacher, Juan van der Hamen y León
(1596–1631), abandoning highly ordered and structured layouts in favor of a lush floral
composition far more baroque in character.

Two butterflies hover over flowers in a ceramic vase from Talavera de la Reina in an
image that also includes pears and apples on the branch alongside artichokes. Thus, in a
single still life, Antonio Ponce brings together flowers, fruit, insects and vegetables. The
flowers include tulips, irises, gladioli, roses and yellow daisies.

All of these elements are rendered in great detail, and the artist displays great virtuosity
in his ability to capture even the tiniest details of their different textures, including a chip
on the base of the vase and the jagged end of a stem at the lower right of the composition,
which appears to have been pulled off. Those two elements, along with some leaves, are
projected into the air to create a *trompe l'oeil* effect.

In order to add further depth to the composition, Ponce places the objects at different
distances between the viewer and the background, playing with the light to create volume.
This three-dimensional effect is reinforced by the somewhat turned position of the vase,
and the view, in perspective, of a yellow daisy through its handle.

The cadence of colors is very successful throughout the painting and combines perfectly
with the background and the green of the leaves and artichokes. The flowers are depicted
in various states of maturity, from a closed bud to a withering rose that is losing its petals.
According to Cherry, the velvety texture of the petals, which recalls the work of Juan
Fernández, "El Labrador" (active 1629–1657), may be due to the use of artificial silk flowers,
which still-life painters employed as models during the winter months.[2]

1 Cherry 1999, p. 289.
2 Peter Cherry in
 Cherry, Loughman and
 Stevenson 2010, p. 214.

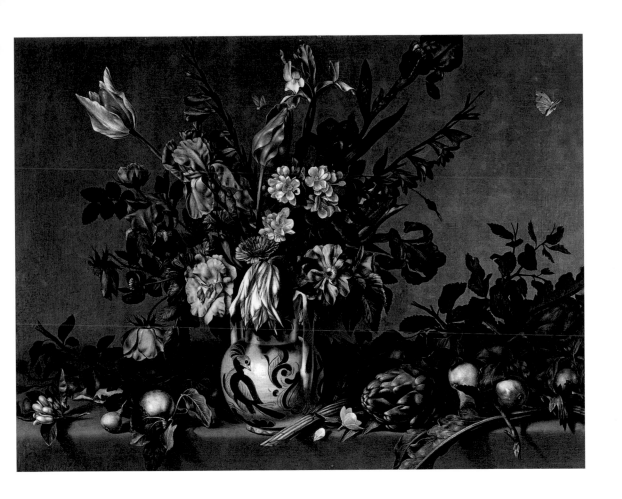

JUAN DE ARELLANO (1614–1676)

Basket of Flowers on a Stone Cornice, 1664
Oil on canvas, 37 ½ x 24 ¾ in. (95 x 63 cm)
Signed and dated: "Joannes de Arellano / faciebat anno / 1664." (lower left)
P499

Basket of Flowers on a Stone Cornice, 1664
Oil on canvas, 37 ½ x 24 ¾ in. (95 x 63 cm)
Signed and dated: "Juan deare llano / 1664." (lower right)
P500

PROVENANCE
Count of Gamazo Collection

BIBLIOGRAPHY
Cherry 1999, p. 295, pl. CXXII; Aterido 2002, p. 95 (ill.) [only the first painting]; Romero Asenjo 2009, p. 309, fig. 6 [only the first painting]; Ros de Barbero 2014, pp. 62–63 (ill.) and 185

EXHIBITIONS
Haarlem-Madrid 2002–3, nos. 28 and 29; Madrid 2014–15, nos. 44 and 45

This pair of flower paintings signed and dated in 1664, at the height of Juan de Arellano's career, reveal his skill and mastery in this genre. Moreover, the signatures are very visible, probably so they would be legible when the floral still lifes were hung, as this type of work was usually placed at some height, above doors or windows. That would also explain why the viewpoint is so low. The artist displays his pride in these works by signing them, thus distinguishing himself from numerous imitators who sought to benefit from his popularity.

Arellano was much in demand among collectors owing to his capacity to combine the dynamism of Italian flower painters such as Mario Nuzzi (1603–1673) with the attention to detail of Flemish works.[1] According to Antonio Palomino, Arellano learned his craft by copying paintings by Nuzzi, who was also known as Mario dei Fiori (Mario of the Flowers).[2] The results are much more baroque and exuberant than works by Juan van der Hamen (1596–1631) or Antonio Ponce (1608–1677).

In the present two works the flowers appear to have been recently cut and are clearly very fresh. They have been carefully laid in a basket that extends beyond a molding in ruins taken from an engraving of classic orders by Marcantonio Raimondi (*ca.* 1480–*ca.* 1534).[3] The composition is dynamic and the results are highly decorative, especially when both works are seen together. The vertical format and low viewpoint draws attention to the moldings that bear the baskets, bringing great originality to this pair of flower paintings. The intense yet delicate colors reveal the artist's preference for primary tones such as blue, red and yellow, along with white, and are one of his trademarks. In these works from his mature period, the brushstrokes are very fluid, standing out alongside the fine quality of his drawing.

1 Cherry 1999, pp. 294–95.
2 Palomino 1986, p. 326.
3 Peter Cherry in *Flores españolas* 2002, p. 135.

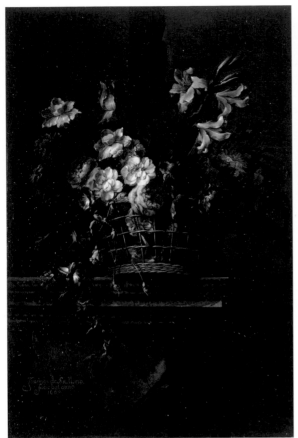
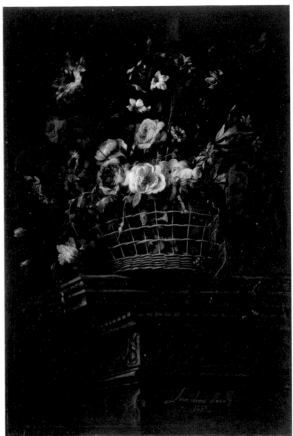

JAN VAN KESSEL THE YOUNGER (1654–1708)

Portrait of Charles II, ca. 1690
Oil on canvas, 11 ⅝ in. (29.5 cm) in diameter
P286

Portrait of Mariana of Neuburg, ca. 1690
Oil on canvas, 11 ⅝ in. (29.5 cm) in diameter
P287

PROVENANCE
Madrid, Galería Caylus

BIBLIOGRAPHY
Sánchez del Peral 2001, pp. 67–68 (ill.); López Sánchez 2007, p. 21 (ill.); Martínez Leiva 2013, p. 247, fig. 4 [only *Portrait of Mariana of Neuburg*]; Descalzo 2014, p. 27 (ill.); Ros de Barbero 2014, pp. 66–67 (ill.) and 186

EXHIBITIONS
Madrid 2014–15, nos. 48 and 49

Son of Jan van Kessel I (1626–1679), this painter of Flemish origin settled in Madrid around 1680 at the behest of a Flemish nobleman. Around the same time, he began working for King Charles II (1661–1700), who was then married to Queen Marie Louise d'Orléans (1662–1689). In 1690, barely a year after the latter's death, he married Princess Mariana of Neuburg (1667–1740).

Van Kessel probably painted this pair of delicate portraits of the new royal couple around that time. Despite their small, round format of a mere 11 ⅝ inches (29.5 cm) in diameter, they are very detailed and realistic: both are true likenesses, depicting the monarchs without excessive idealization.

Charles II appears with his long blond tresses, his ivory skin and accentuated Habsburg chin. Following the protocol of that family's court, the king wears a sober and elegant black suit with a ruff collar. The only royal emblem that appears in this portrait is the necklace of the Order of the Golden Fleece. The conventional background of red curtains is completed by a luminous blue-and-green landscape.

Mariana of Neuburg is depicted with an ornamented brocade-and-lace dress adorned with a large gold-and-diamond brooch, in keeping with that period's fashion. Her skin is very light and velvety and her loose hair is spotted with jewels. Her contemporaries described her as having reddish hair, somewhat bulging eyes and a long nose, just as she appears in this likeness.[1] As in the king's portrait, there is a red curtain in the background, but here it is on the right, with the landscape on the left, so that the composition is balanced when the two paintings are hung together.

1 González-Doria 1986, p. 243.

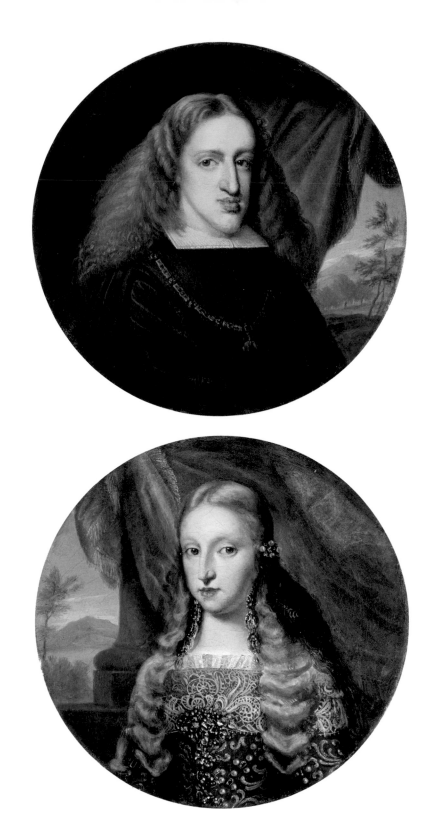

The Age of
Enlightenment

MIGUEL JACINTO MELÉNDEZ (1679–1734)

Portrait of Philip V, 1709
Oil on copper, 10 ½ x 7 ⅞ in. (26.7 x 20 cm)
Signed with a monogram and dated: "DMGELZ F. 1709" (verso)
P2402 (1)

Portrait of María Luisa Gabriela of Savoy, 1709
Oil on copper, 10 ½ x 7 ⅞ in. (26.7 x 20 cm)
Signed with monogram and dated: "DMGELZ / f. 1709" (verso)
P2402 (2)

PROVENANCE
Sale following the death of M. Cottreau, Paris, Hôtel Drouot (Maître Bonnefons de Lavialle), December 15–16, 1851, lot nos. 85–86; sale following the death of Mme. Nelson-Cottreau, Paris, Hôtel Drouot (Maître Charles Pillet), January 17, 1881, lot nos. 5–6; sale of the collection of *Monsieur le Comte de X....* [Count of la Haye-Montbault], Paris, Hôtel Drouot (Maître Gustave Larbepenet), June 10, 1913, lot nos. 15–16

BIBLIOGRAPHY
Ros de Barbero 2014, pp. 78–79 (ill.) and 189–90

EXHIBITIONS
Madrid 2014–15, nos. 63 and 64

These portraits of King Philip V (1683–1746) and Queen María Luisa Gabriela of Savoy (1688–1714) form part of the small number of signed and dated works by Miguel Jacinto Meléndez. They were made in 1709, an important year in the reign of Spain's first Bourbon sovereign. That April, his son Louis was sworn-in as Prince of Asturias at the church of San Jerónimo el Real,[1] and on that same date, Louis XIV of France decided to cease all direct interference in the rule of the Spanish monarchy.[2]

It is precisely Prince Louis (1707–1724), the future King Louis I, who appears alongside his mother in this unusual royal image that predates *Elisabeth Farnese with her Eldest Son Infante Carlos (Future Charles III of Spain)* (Palacio de Viana, Cordoba, *ca.* 1716), another work by the same artist that was previously considered the first royal representation in the bourgeois style.[3]

Meléndez was a leading portrait painter for the new monarchs, who sought to consolidate their newly acquired powers by spreading official images of themselves as the sovereigns, despite their involvement in the War of Succession at that time.

Originally from Asturias, Meléndez traveled to Madrid, where he studied with painter José García Hidalgo (1646–1719), a disciple of Juan Carreño de Miranda (1614–1685) and author of treatises including *Principios para estudiar el nobilísimo y real arte de la pintura* (Principles for Studying the Most Noble and Royal Art of Painting) and *Geometría práctica* (Practical Geometry). On June 12, 1712, Meléndez was appointed the king's painter,[4] beginning an artistic tradition that would be completed by the artist's older brother, Francisco Antonio, a specialist in miniatures, and his nephew, Luis, who was considered one of the eighteenth-century's finest still-life painters.

Shaped by Madrid's baroque style of the last quarter of the seventeenth century, Meléndez's work combines deeply Spanish tradition with new French and English trends in portraiture that he learned from engravings. In fact, the inventory of his possessions drawn up after the death of his first wife in 1716 lists one thousand two hundred and fifty-three prints.[5] His renewal of portraiture as a genre antedates the founding of the Royal Academy of San Fernando, where those new artistic ideas were consolidated.

Here, we see the painter's characteristic style, a mixture of elegance and grace that idealizes the monarchs' appearance with a fragility that approaches the rococo. The short brushstrokes, cool colors and rococo feeling recall the work of Luis Paret (1746–1799), another very talented eighteenth-century Spanish painter.

Both paintings have highly original compositions, far from the sobriety of traditional Spanish portraiture. Adorned with the Golden Fleece and the Order of the Holy Ghost on his chest, the king turns to look at the viewer, while the queen presents her son, the heir to the throne. The unusual presence of the Prince of Asturias alongside the monarchs reflects the important role these images played in consolidating the new dynasty's power and stability through future generations. The lady in the background of the queen's portrait may be her chief lady in waiting, Marie-Anne de la Trémouille de Noirmoutier, Princess of the Ursins (1642–1722), who played an important role in court during the reign of Philip V as the young monarchs' confidante.

1 González-Doria 1986, p. 280.
2 Bottineau 1993, p. 78.
3 Santiago Páez 1990, p. 22.
4 Ceán Bermúdez 1998, vol. III, p. 118.
5 Santiago Páez 1995, p. 183.

Portrait of Philip V, 1709

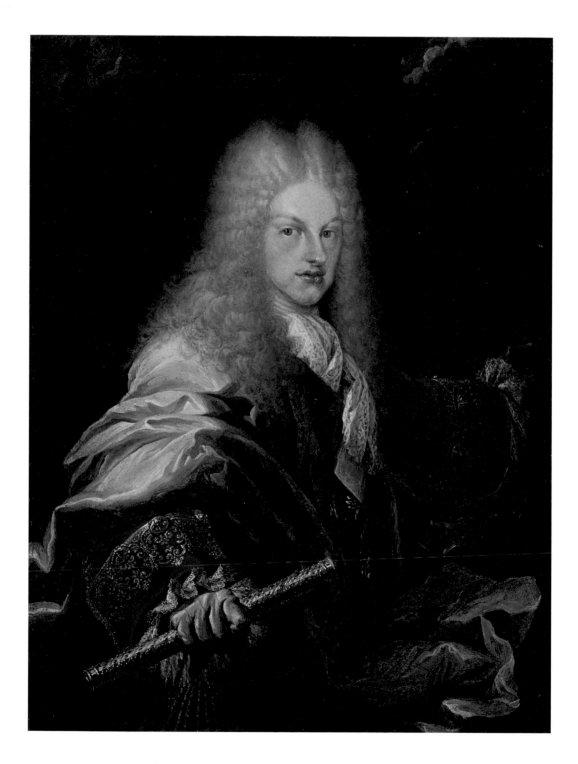

Portrait of María Luisa Gabriela of Savoy, 1709

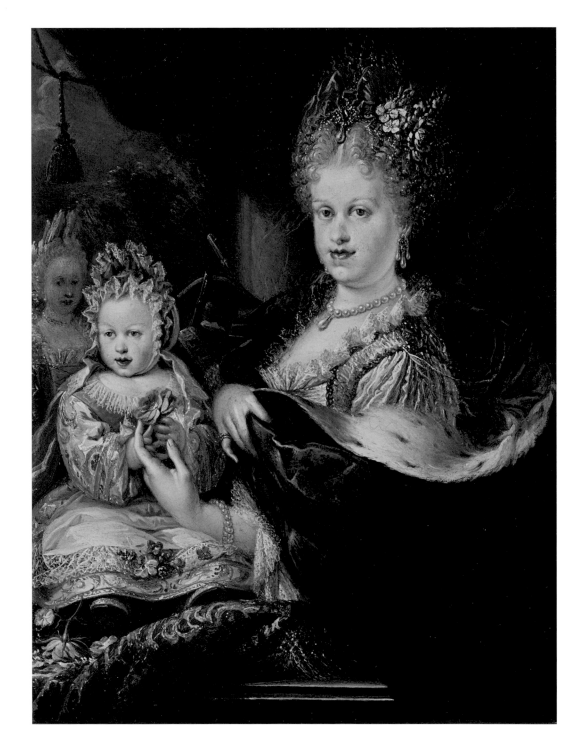

GIOVANNI ANTONIO CANAL, "CANALETTO" (1697–1768)

Venice Docks near the Piazza di San Marco, ca. 1729
Oil on canvas, 19 ⅛ x 31 ⅝ in. (48.5 x 80.5 cm)
P678

The Grand Canal of Venice from the Campo di San Vio, ca. 1729
Oil on canvas, 19 ⅛ x 31 ⅝ in. (48.5 x 80.5 cm)
P679

PROVENANCE
England, private collection; London, P. & D. Colnaghi, 1948; London, Agnew & Sons Ltd.; Sao Paulo, Matarazzo Collection; New York, Sotheby's; New York, Chaus Collection; London, Sotheby's; Great Britain, private collection; London, Sotheby's

BIBLIOGRAPHY
Constable 1962, vol. I, pl. 28, 41, vol. II, pp. 227 and 263, nos. 105 and 189; Puppi and Berto 1968, nos. 132A and 112B; Corboz 1985, vol. II, pp. 632–33, nos. P228 and P229, p. 632 (ill.); Ros de Barbero 2014, pp. 80–81 (ill.) and 190–91

EXHIBITIONS
Bilbao 2004; Rome 2005; Basel 2008–9, pp. 42–43; Madrid 2010a, no. 65 [only *Venice Docks near the Piazza di San Marco*]; Madrid 2014–15, nos. 65 and 66

Giovanni Antonio Canal, "Canaletto," was the most famous of Venice's *vedute* painters. He learned the art of perspective from his father, painter Bernardo Canal (1674–1744), who specialized in theater sets. In 1719, he traveled to Rome to continue his artistic training but settled in Venice the following year, joining the *fraglia*, a guild of artists specialized in vistas and cityscapes.

Venice was one of the obligatory destinations on the Grand Tour that was especially popular with young Englishmen from the most powerful and influential families. Views of the city like the present one served as *souvenirs de voyage*, and many of Canaletto's clients were English. Under his attentive gaze, the already decadent Venice of the eighteenth century emerges as an immobile, stagnant city.

The quality of this pair of canvases suggests they date from the late 1720s or early 1730s and thus belong to the artist's finest period. In the first, Canaletto offers a foreground view of the Grand Canal with various vessels seen from the isle of la Giudecca. Some of the city's most beautiful buildings appear on the horizon, including, from left to right, the Biblioteca Marciana built by Jacopo Sansovino (1486–1570); the Piazza di San Marco with the façade of the Clock Tower in the background—the tower lacks the third floor, which was not built until around 1755—and the Basilica of San Marco; and finally, the Palazzo Ducale with the prison building alongside. The dock in front of the Piazza has the two famous columns bearing statues of the city's patrons: Saint Theodore on the right, and the lion of San Marco on the left. In the eighteenth century, this was the space used for public executions.

The Grand Canal of Venice from the Campo di San Vio depicts, on the left, the imposing façade of the Palazzo Corner della Ca'Grande, designed by Sansovino in 1545 for Giacomo Corner and his family. On the right, the lateral façade of the Palazzo Barbarigo occupies the foreground while various figures on boats bring a picturesque touch that reveals the painter's interest in reflecting the city's everyday life.

There are some twelve known versions of the first of these two *vedute* by Canaletto and around ten known versions of the second scattered among different collections, including the Royal Collection of Windsor Castle (RCIN 400518). The urban landscapes of both are flooded with a sweet, soft light that envelops these works in a silvery atmosphere despite the rigor and exactitude of their perspectives. The harmony of the grayish blue sea and sky, the earth tones of the buildings and the black of the gondolas is broken by light touches of more intense color visible on the boats and especially on the figures.

Canaletto made sketches from life for his paintings, which he then composed in his studio. He also employed optical devices such as the *camera obscura*, which allowed him to reproduce the details of Venice's urban landscapes with the careful and meticulous technique visible in these virtuoso works.

Venice Docks near the Piazza di San Marco, ca. 1729

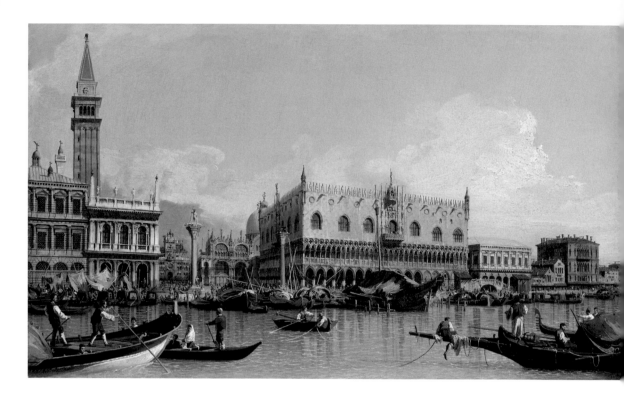

The Grand Canal of Venice from the Campo di San Vio, ca. 1729

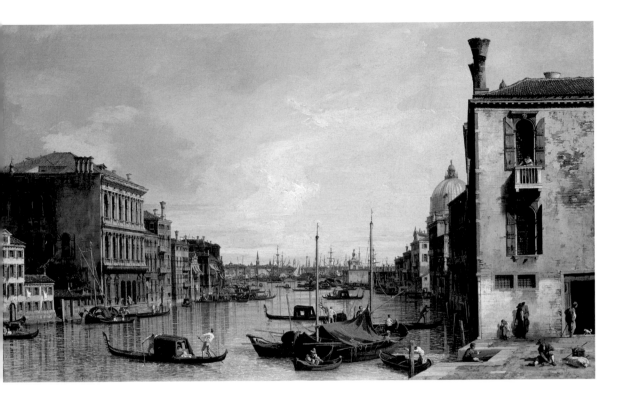

FRANCESCO GUARDI (1712–1793)

The Isle of San Cristoforo, near Murano, Venice, ca. 1780
Oil on canvas, 19 ½ x 30 ½ in. (49.5 x 77.5 cm)
P1309

The Grand Canal of Venice, ca. 1780
Oil on canvas, 20 x 30 ⅝ in. (50.8 x 77.7 cm)
P1310

PROVENANCE

Bath, Evill, April 22, 1802, lot nos. 53 and 54; London, Christie's; London, Thomas Agnew and Sons, Ltd.; Champalimaud Collection; London, Christie's

BIBLIOGRAPHY

Morassi 1969, p. 30, fig. 9 [only *The Isle of San Cristoforo, near Murano, Venice*]; Rossi Bortolatto 1974, p. 130, nos. 678 and 679, p. 128 (ill.); Morassi 1975, p. 147, no. 387, and p. 151, no. 409; Morassi 1984, vol. I, pp. 225, 250, 420 and 431, nos. 647 and 586, pl. LIV (detail), vol. II, fig. 609, pl. XLIX (detail), fig. 563; Ros de Barbero 2014, pp. 82–83 (ill.) and 191

EXHIBITIONS

London 1971, nos. 27 and 26; Madrid 2014–15, nos. 67 and 68

This pair of canvases reveals the considerable artistic personality of Francesco Guardi, a painter with his own particular and original style, who was to some degree Canaletto's (1697–1768) successor.

The first is a view from Fondamenta San Simeone of the church on the small island of San Cristoforo, near Murano, with Venice's northern coast on the horizon at the right of the composition.

The second, which Antonio Morassi considered a masterpiece, offers a vibrant and colorful view of Venice's Grand Canal, with the church of Santa Maria di Nazareth, also known as *degli Scalzi* (the barefoot ones) in the center of the composition. Visible to its left are the Palazzo Barzisa and the Palazzo Bragadin, which were destroyed when the station was built. The Rio di Spagna, now the Lista di Spagna, is visible on the other side of the church. The banks of the Grand Canal mark diagonal perspective lines that add depth to this composition painted from the entrance of the church of San Simeone Piccolo, on the other bank of the canal.

These two works, with their nervous, loose and free brushstrokes, reveal the personal and mature style of Guardi's final period, when he was less indebted to Canaletto. While both painters focused on the city's canals, their work was quite different. Guardi renders the urban landscape with vigorous lines, where Canaletto is much less linear. And while the latter scrupulously depicts the buildings with great solidity, Guardi merely suggests them, like ethereal visions built of light and color.

The Akademie der Bildenden Künste in Vienna (GG-604) and the Museo Thyssen-Bornemisza in Madrid (174 [1934.6]) have works similar to the view of the Grand Canal, although with a more westerly orientation that includes the church of Santa Lucia. A third version is in an English collection and there is a preparatory drawing for this work at the Académie des Beaux-Arts in Paris. There are also two compositions similar to the present depiction of the Isle of San Cristoforo in collections in Milan and New York, respectively, as well as a preparatory drawing at the Musée des Beaux-Arts in Dijon.[1]

1 Morassi 1975, no. 409, fig. 413.

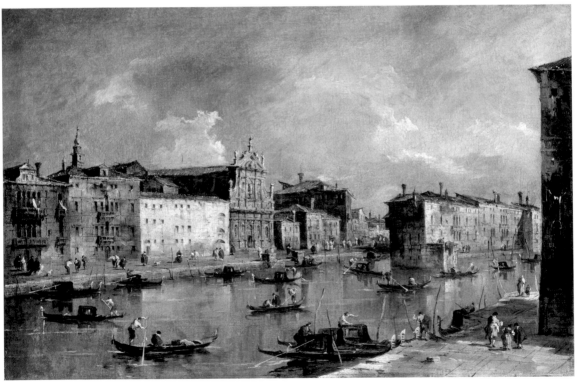

71

ANTONIO JOLI DE DIPI (*ca.* 1700–1777)

View of the Royal Palace of Aranjuez from the Northeast,
with King Ferdinand VI of Spain and Queen Maria Barbara of Bragança, ca. 1753–55
Oil on canvas, 29 ½ x 49 ½ in. (75 x 125.5 cm)
P1223

View of the Plaza of the Church of San Antonio of Aranjuez from the North, ca. 1753–55
Oil on canvas, 30 ¼ x 49 ½ in. (77 x 125.5 cm)
P1224

PROVENANCE

London, 20 Stanhope Gardens, Mrs. Shelley; London, Christie's, July 28, 1927, lot no. 163; F. Sabin
Collection; London, Christie's, W. M. Sabin and Sons, July 24, 1936, lot no. 62; F. Partridge Collection;
London, Christie's; Montecarlo, private collection; Paris, Gismondi Galleries

BIBLIOGRAPHY

Middione 1995, p. 80, nos. 8 and 9 (ill.); Manzelli 2000, pp. 114–15, nos. S15 and S17 (ill.); Toledano 2006,
nos. S.VIII.2 and S.IX.1; Urrea 2012, pp. 127–37 (ill.); Ros de Barbero 2014, pp. 84 (ill.) and 192

EXHIBITIONS

Madrid 2014–15, nos. 69 and 70

A specialist in *vedute* paintings, Antonio Joli de Dipi began studies in his native Modena with the landscape painter Raffaello Rinaldi, "Il Menia" (1648–1722). In 1720, he traveled to Rome, where he discovered archeological views through the work of Giovanni Paolo Panini (1691–1765). However, the painters that most influenced him were Bernardo Bellotto (1721–1780) and Canaletto (1697–1768), whose work he encountered during his stay in Venice in 1740. After visiting Germany and London in 1744, Joli arrived in Spain around 1749, where he remained until he moved to Venice in 1755. There, he helped found the Accademia di Belle Arti.

Joli painted these views of Aranjuez during his stay in Spain. Both depict the ruling monarch, Ferdinand VI (1713–1759) and Maria Barbara of Bragança (1711–1758). Normally, the court sojourned at that Royal Seat between Easter and the Feast of Saint John, which has led Middione to consider the possibility that these works depict the festivities of May 30, the king's saint's day and celebration of Saint Ferdinand.

In the first canvas, Joli depicts felucca rides on Aranjuez's Tagus River, which the royal couple greatly enjoyed. Specially designed for this royal pastime, those vessels sailed from the shipyards to the Royal Palace. There were five in all, along with sixteen smaller boats, and they were collectively known as "La Escuadra del Tajo" (The Tagus Squadron). Along with the monarchs, they carried the royal retinue and even the king's musicians. Both Ferdinand VI and Maria Barbara of Bragança were music lovers and during their reign, the famous *castrato*, Farinelli, was appointed director of royal entertainments, charged with organizing and participating in this type of events.

Farinelli's appointment as director of Aranjuez's Royal Theater coincided with Joli's arrival in Spain to paint the sets and backdrops for works presented there and also at the Buen Retiro palace's Coliseum. During that same period, the great Neapolitan composer Domenico Scarlatti, also worked in the Spanish court at the behest of the monarchs.

On the second canvas, Joli depicts the Plaza de San Antonio, an enormous esplanade that is one of the city's nerve centers. The Royal Chapel of San Antonio appears in the background. Designed by architect Giacomo Bonavia (1700–1760), it was completed in 1753. A fountain topped by a statue of King Ferdinand VI appears at the center of the plaza, where a sculpture of Venus known as the *Mariblanca* now stands. The royal couple is shown arriving at the palace in a carriage drawn by six horses and escorted by soldiers of the Royal Guard. Various figures and other carriages have stopped to admire the cortege.

View of the Royal Palace of Aranjuez from the Northeast, with King Ferdinand VI of Spain and Queen Maria Barbara of Bragança, ca. 1753–55

View of the Plaza of the Church of San Antonio of Aranjuez from the North, ca. 1753–55

LUIS EGIDIO MELÉNDEZ (1715–1780)

Still Life with Partridges, Cloves of Garlic, Mug and Kitchen Utensils, 1772
Oil on canvas, 16 ³⁄₈ x 24 ³⁄₈ in. (41.5 x 62 cm)
Signed and dated: "Ls. Eº. Mz. D Rª. Dº I Sto. P. Fat. ADONOREN Dº / ANO 1772"
(on the edge of the table to the right)
P74

PROVENANCE
Madrid, Manuel Godoy Collection; collection of the Infante Don Sebastián Gabriel de Borbón, 1835; collection of the former's eldest son, Francisco de Borbón, Duke of Marchena; London, Christie's, July 17, 1925, lot no. 154; London, Christie's, July 31, 1925, no. 195; Brussels, Fievez Gallery, 1926; J. B. Weber Collection; Vienna, Sanct Lucas Gallery, 1931; Amsterdam, J. Goudstikker Gallery, 1933, lot no. 1844; Rotterdam, Baron Sweerts de Landas Wyborgh Collection, 1933–40; Holland, private collection; London, Rafael Valls Ltd.

BIBLIOGRAPHY
Águeda 1982, no. 72; Tufts 1982, p. 163, no. 80; Rose Wagner 1983, vol. II, p. 266, no. 353; Tufts 1985, no. 79, p. 184 (ill.); Luna 1989, p. 375; Luna 1995a, pp. 154–55, no. 49; Claudie Ressort and Almudena Ros de Barbero in Gerard and Ressort 2002, pp. 324–25, note 6; Vischer 2005, fig. 101; Cherry 2006, no. 79; Sánchez López 2008, pp. 198–200; Ros de Barbero 2014, pp. 90 (ill.) and 197

EXHIBITIONS
Pau 1876, no. 701 or 704; Rotterdam 1928–29; Amsterdam 1933, no. 220; Rotterdam 1933, no. 65; Santander 1993, no. 23; Indianapolis-New York 1996–97, no. 57; Oviedo 1997, no. 40; Madrid 2004, no. 34; Madrid 2014–15, no. 78

This still life by Luis Egidio Meléndez was in Manuel Godoy's (1767–1851) collection, and later belonged to the Infante Sebastián Gabriel de Borbón (1811–1875), who was the grandson of Charles IV's brother, the Infante Gabriel. Meléndez made a series of still lifes for that monarch when he was still Prince of Asturias, and Godoy emulated the king's taste in art by including this work in his collection.

A kitchen scene, it shows partridges surrounded by cooking utensils (a frying pan, mug and mortar) as well as various condiments, including garlic cloves in the foreground and packages of spices. Together, these elements constitute the ingredients of a particular recipe, and it has been suggested that they represent the first step in preparing pickled partridge.[1]

The composition groups the ingredients in the center, where they occupy different planes in order to create a sense of depth. Their layout is characterized by diagonals that are repeated in a balanced way across the entire canvas. Both objects and food are painted with a meticulous and detailed technique that reveals the artist's pleasure at reproducing their varied textures in an unabashed imitation of nature. The volumes are defined by light in a composition filled with darker tones but enlivened by a few touches of color on the partridges. The entire composition has a certain sobriety and a monumentality strengthened by the low viewpoint.

Meléndez painted his still lifes in pairs with contrasting gastronomic subjects.[2] Thus, the pendant to this work is a *Still Life with Salmon, Oysters, Plates of Eggs, Garlic and Containers* (private collection) that represents food from Lent (Lenten fish and eggs) as opposed to a meaty repast of partridges (the hunt). The two works were still together in the Infante

1 Sarah Schroth in Kasl and Stratton 1997, pp. 266–67, no. 57.
2 Cherry 2006, p. 183.

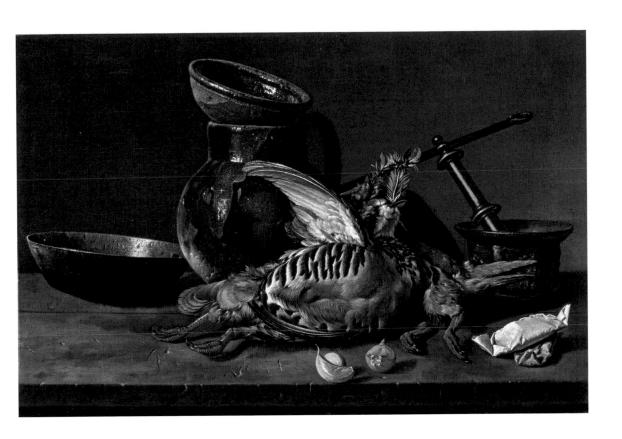

Sebastián Gabriel de Borbón Collection, along with another pair of still lifes and a beautiful self-portrait signed by Meléndez in 1746, which is now at the Musée du Louvre (RF 2537) in Paris.[3]

Among the works related to the present still life, mention should be made of one that the artist painted for the Prince of Asturias[4] and another in the Masaveu Collection,[5] both of which contain several of the same elements depicted here, including the partridges, the mortar and the frying pan.

The inscription that accompanies the artist's signature on this painting is significant. Meléndez dedicates the work to God as if it were an ex-voto: "ADONOREN Dº."[6] That religious touch may be explained by a written text in which Meléndez gives thanks to God for allowing him to imitate his works, transforming fiction into reality. And here he does exactly that in one of the finest eighteenth-century still lifes by this artist.

3 Almudena Ros de Barbero in Gerard and Ressort 2002, pp. 320–23.
4 Madrid, Museo Nacional del Prado (P00908); Cherry 2006, no. 43.
5 Ibid., no. 115.
6 Ibid., pp. 152, 156 and 237.

JOSÉ DEL CASTILLO (1737–1793)

Still Life with Mallards, Wood Pigeons and Shotgun, 1773
Oil on canvas, 61 x 44 ⅞ in. (155 x 114 cm)
Inscription: "Poniente sobrep.ta An 4-4 At 5-1, Jph Castillo ft. 1773" (verso)
P1305

PROVENANCE
Madrid, Royal Tapestry Factory of Santa Bárbara; Madrid, Sala Retiro

BIBLIOGRAPHY
Held 1971, pp. 133–34, no. 217, pl. 224; Sánchez López 2008, pp. 248–50 (ill.)

This cartoon was made for a series of tapestries designed to decorate the Prince of
Asturias's chamber-room at El Escorial. José del Castillo, a disciple of Corrado Giaquinto
(1703–1766), must have painted it at the behest of Francesco Sabatini (1722–1797), under
the tutelage of Mariano Salvador Maella (1739–1819).

This canvas was paired with another hunting still life that depicts a rabbit, a partridge,
an oriole and a shotgun. Currently on loan to the Spanish embassy in Stockholm, that work
belongs to the Museo Nacional del Prado (P02847).[1] Together, they constitute some of the
earliest examples of palace over-door decoration with still lifes.

Delivered on August 10, 1773, the present cartoon reveals the qualities of this
eighteenth-century Spanish artist whose highly realistic depictions of dead animals
are rendered with loose brushstrokes.

1 Sánchez López 2008,
p. 250, note 82.

BENITO ESPINÓS (1748–1818)

Still Life with Flowers on a Cornice, ca. 1780
Oil on canvas, 26 ¾ x 35 ½ in. (68 x 90 cm)
Signed: "Benito Espinos ft" (on the edge of the stone cornice)
P858

Still Life with Flowers and a Glass Vase on a Cornice, ca. 1780
Oil on canvas, 26 ¾ x 35 ½ in. (68 x 90 cm)
Signed: "Benito Espinos ft" (on the stone cornice)
P859

PROVENANCE
Mexico, private collection

BIBLIOGRAPHY
Ros de Barbero 2014, pp. 91 (ill.) and 198

EXHIBITIONS
Valencia 2007, no. 179; Madrid 2014–15, nos. 79 and 80

The author of these two still lifes, Benito Espinós, was the finest representative of Valencian flower painting and the first director of the School of Flowers and Ornamentation (1784–1814) at the Royal Academy of San Carlos in Valencia. Both works are of the highest quality and beauty, with the flowers transcribed from a life study showing great technical virtuosity in the rendering of each petal.

The two compositions include architectural elements in the background. The first has a vase on a terrace, which enabled Espinós to paint part of a balustrade and a second stone vase in the background. The flowers are arranged to form a pyramid and are so exuberant that they almost entirely hide the vessel that holds them.

In the second work, a glass vase allowed the painter to play with transparencies. It, too, appears on a terrace which also holds various objects inspired by Antiquity, including the wall with classical sculptures in the background to the right and the Greco-Roman influenced urn to the left. Espinós includes anecdotal elements alongside the urn: some painting tools and a paper that appears to be an engraving of the setting depicted in the painting.

Espinós's art was also known outside Valencia. We know that King Charles IV (1748–1819) enjoyed the work of this Valencian painter, who took some of his still lifes to the Palace as gifts when he visited the Court in 1788 and 1802.[1] Moreover, several of his works were in private collections in Madrid.

His influence lasted throughout the nineteenth century in the work of his students and that of numerous followers inspired by his compositions. His success and the attractiveness of his canvases are partially due to his capacity to combine aspects of French, Italian and Flemish flower painting with seventeenth-century Spanish models.

1 Cherry 2006, p. 286.

LUIS PARET Y ALCÁZAR (1746–1799)

Self-portrait, ca. 1780
Oil on paper mounted on canvas, 20 ½ x 15 ⅜ in. (52 x 39 cm)
Signed: "L. Paret" (lower left corner on the edge of a drawing extending from the portfolio)
P2430

PROVENANCE
Paris, sale of March 31, 1900; Madrid, Félix Boix Collection; Madrid, Antiquarian Apolinar Sánchez;
Bilbao, Julio de Arteche Collection; Madrid, Enrique Gutiérrez de Calderón Collection

BIBLIOGRAPHY
Delgado 1957, p. 252, no. 59 and pp. 176–77; Gaya Nuño 1958, p. 208; Sánchez Cantón 1965, p. 238;
Morales y Marín 1984, p. 175; Javier González de Durana in Otxagabia and González de Durana 1990,
pp. 263–65, no. 25; Calvo Serraller 1996, p. 30; Morales y Marín 1997, p. 147, no. 70; Romero Asenjo and
Illán Gutiérrez 2008, pp. 47–67; Romero Asenjo and Illán Gutiérrez 2014, p. 108; Blanco Mozo and
Martínez (forthcoming)

EXHIBITIONS
Bilbao 1991–92, no. 25; Rio de Janeiro 2002, p. 320; Madrid 2012–13, no. 40

In the first biography of this painter, Juan Agustín Ceán Bermúdez indicates that he was
a student at the Royal Academy of San Fernando, where he took lessons from Antonio
González Velázquez (1723–1794). Later, when Charles François de la Traverse (1726–1787)
visited Spain in company of the French ambassador, the Marquis of Ossun, Luis Paret
y Alcázar continued his artistic training with this painter who, as Ceán put it, "noticed
that he was inclined to paint small and medium-sized figures and let him follow his path,
offering him very opportune rules for this genre. These produced such good results that
his works were soon celebrated at court and, though he was still quite young, he received
numerous commissions from Charles III and his august sons."[1]

Paret's personal style reflects his meticulous training as an intellectual painter who
traveled around Italy, carried out Latin studies and learned Oriental languages. He would
have been even more successful at court had he not been banished to Puerto Rico for
almost three years. As a protégé of the Infante Luis de Borbón, he was accused of collusion
in the latter's libertine affairs. Tired of his brother's amorous dalliances, the king made an
example of his collaborators, including Paret, by banishing them for concealment.

This painting is outstanding for both its careful drawing and its brilliant colors.
Traverse, who had studied with François Boucher (1703–1770), exposed Paret to French
rococo painting, an influence that is clear here. The brilliant, creamy brushstrokes and
rich colors are combined with an attentive rendering of the details, while the highly
original composition foreshadows the melancholy associated with romanticism.

Until very recently, this was considered to be a portrait of a Navy officer, but a
comparison with the likeness in Paret's *Self-portrait* at the Museo del Prado (P07701) is
sufficient to recognize that both pictures are of the same person. Two other self-portraits
by this artist are known: his *Self-portrait as a Jivaro* (Puerto Rico, Museo de Arte de Ponce)
and a miniature on ivory, which was his first, painted around 1775.[2] The identification of
the sitter with a sailor stems from the ship in the background, to which the figure points.
It is not yet clear what relation that vessel had with the painter. Alejandro Martínez[3] has
suggested that it might be an allusion to his return to Spain, possibly in the form of

1 Ceán Bermúdez 1998,
vol. IV, p. 54.
2 Martínez 2014, pp. 94–107.
3 In a written
communication dated
February 7, 2015.

an emblem, the *Spes proxima* ("Hope at hand"), after his banishment was lifted. Moreover, his walking stick and luxurious garb—a blue velvet frock coat, silk stockings and elegant buckled shoes—did not help to identify him as a painter. Only the portfolio resting by his side, with some red-chalk drawings protruding from it, suggests he was an artist.

The format, composition and presentation of the figure all indicate this was a pendant to the portrait of his wife, Micaela Fourdinier (former Julio Muñoz Ramonet Collection), also erroneously titled *Lady in a Garden* until Xavier de Salas proposed the correct identification.[4] Inasmuch as the latter portrait was signed and dated in 1780, the present work should be considered from the same year, rather than dating from around 1785–87, as has been suggested in earlier bibliography. This date would coincide with Paret's return from exile and his hope and desire to receive the king's pardon.

4 Salas 1977, pp. 255–56.

LUIS PARET Y ALCÁZAR (1746–1799)

Virgin and Child, ca. 1780
Oil on copper, 6 ⅛ x 4 ⅝ in. (15.6 x 12.2 cm)
Signed: "L. Paret P." (lower left corner, on the edge)
P1974

PROVENANCE
London, Jean-Luc Baroni

BIBLIOGRAPHY
Romero Asenjo and Illán Gutiérrez 2008, pp. 47–67 (ill.); Ros de Barbero 2014, pp. 85 (ill.) and 193

EXHIBITIONS
Madrid 2014–15, no. 71

Luis Paret y Alcázar studied at the Royal Academy of Fine Arts of San Fernando.
A scholarship from King Charles III's (1716–1766) brother, the Infante Luis de Borbón
(1727–1785), allowed him to spend the period between 1763 and 1766 in Rome. After
returning to Spain, he worked for Don Luis until he fell out of favor and was exiled to
Puerto Rico. After his pardon, he was allowed to return to Spain under the condition that
he live at least forty leagues from the Court. As a result, he settled in Bilbao, not returning
to Madrid until 1792, when he was appointed secretary of the architecture committee at
the Royal Academy of Fine Arts of San Fernando.

There are few works by this eighteenth-century painter born to a French father and a
Spanish mother. The scarcity of his works, and the quality of this oil on copper make it an
interesting example of this artist's original production. Paret was the finest representative
of the Rococo in Spain, with a very personal, creative and inventive style. The presence of
a very precise underlying preliminary drawing, detected through infrared reflectography,
links this work to the self-portrait in a private collection in Madrid, which he painted
around 1786.

This delicate religious image, of small dimensions but considerable quality, depicts a
Virgin and Child surrounded by flowers and cherubs. The chromatic harmony of pink and
blue in the clothing stands out against a rather dark background, with the flesh tones of the
Virgin's face and the Christ Child's body directly lit and accentuated by the metal support.
The work is imbued with a welcoming and agreeable intimacy perfectly suited to its private
devotional character.

The analysis of this work with non-destructive techniques carried out by Rafael Romero
Asenjo and Adelina Illán Gutiérrez has revealed some pentimenti, such as a string or band
that diagonally crosses the Christ Child's torso in the underdrawing but does not appear in
the finished painting.

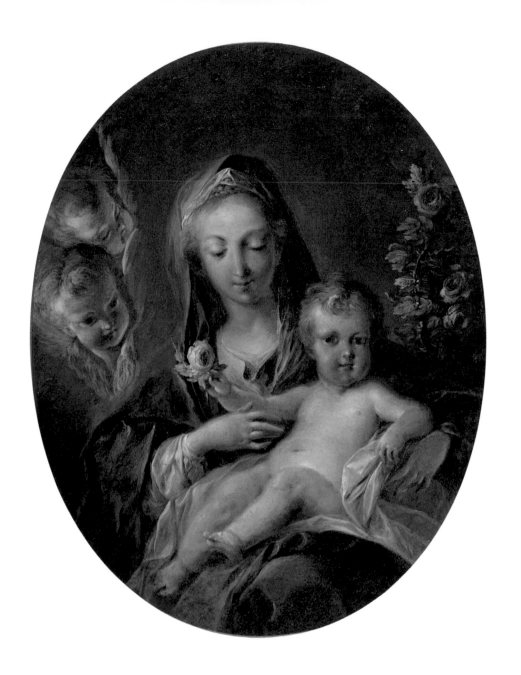

FRANCISCO BAYEU Y SUBÍAS (1734–1795)

Allegory of the Common Good, ca. 1786
Oil on canvas, 22 ⅞ x 11 ⅞ in. (58 x 30 cm)
P641

Allegory of Virtue and Honor, ca. 1786
Oil on canvas, 22 ⅝ x 11 ⅞ in. (57.5 x 30 cm)
P642

PROVENANCE
Madrid, Count of Barbate Collection, *ca.* 1930; Madrid, private collection; Madrid, Alcalá Subastas; Madrid, Galería Caylus

BIBLIOGRAPHY
Álvarez Cervela 1968, p. 155, nos. 8 and 9; Bartolomé 1996, p. 36, note 33; Arturo Ansón Navarro in Ansón Navarro, Gutiérrez Pastor and Mano 2007, pp. 234–37; Ros de Barbero 2014, pp. 86 (ill.) and 193–94

EXHIBITIONS
Rio de Janeiro 2002, pp. 50–51 (ill.); Zaragoza 2007; Madrid 2014–15, nos. 72 and 73

Over the course of his career as court painter for Charles III (1716–1788) and Charles IV (1748–1819), Francisco Bayeu made various paintings at several Royal Seats, including El Pardo, Aranjuez, La Granja and, of course, the Royal Palace in Madrid, where he painted frescoes in several rooms. The present works are sketches for the ceiling of the quarters of the Infante Don Gabriel and the bedroom of the Infanta Doña Mariana Victoria at the Royal Palace in Madrid.

The first presents The Common Good[1] on a seat of honor in a cloud holding the caduceus—a symbol of unity and agreement—in one hand and the cornucopia of Amalthea in the other. Her foot rests on a pillow that symbolizes the welfare she concedes. Abundance, which is inseparable from The Common Good, is beneath her, to one side, holding a large bundle of wheat ears. Behind them, another young woman holding an olive branch represents Peace.

The composition is crowned by a winged figure similar to that depicted by Bayeu some years before for a sketch of *The Surrender of Granada* (1763), which is now at the Musée du Louvre in Paris (RF 2000-2). Here, the figure carries a torch that symbolizes light and clarity, while the glow coming from the heavens implies that true wellbeing can only come from there.

The sketch for Infanta Doña Mariana Victoria's room presents Virtue[2] as a beautiful winged woman sitting on a throne over the clouds. In one hand she holds a spear that symbolizes strength and the ability to overcome vice, and in the other, the laurel crown borne by the victorious. The sun shines on her bosom and she is surrounded by various cherubs bearing a palm, floral and laurel wreaths and a ribbon with the words "MEDIO. TUTISSIMA" ("Virtue lies in the middle ground"). The scepter and lion skin on the right signify her strength and power, while the young man at her feet, with his own laurel crown, spear and cornucopia of fruit, represents Honor. Finally, Glory is shown with a bugle in her hand and a crown on her head.

1 Fabre 1828, pp. 292–98.
2 Ibid.

These subjects were part of the Royal Palace's iconography and were intended to praise and represent the glories of the Spanish Monarchy, rich in Virtues and Victories. Most of the allegorical figures are based on models from Cesare Ripa's classic *Iconologia* (Rome, 1606).

The elegant foreshortened compositions are enriched by a vivid yet delicate color scheme of pastels that was characteristic of eighteenth-century painting. The figures' dynamic postures and movement add to the attraction of these sketches. The quality of the brushstrokes is manifest in the highlights of the robes, the glowing sky and the dense clouds where the allegories are seated.

The Museo de Zaragoza has a set of paintings (11 ⅞ x 6 ¾ in. [30 x 17 cm]) on loan from the Museo Nacional del Prado, Madrid, that constitute the first sketches or ideas for these compositions.[3] At the Prado there is also a preparatory drawing for the figure bearing the torch in the *Allegory of The Common Good*.[4]

3 Ismael Gutiérrez Pastor in *Francisco Bayeu* 1996, nos. 54 and 55.
4 Arnáez 1975, p. 121, pl. LIX.

ZACARÍAS GONZÁLEZ VELÁZQUEZ (1763–1834)

The Eternal Father with Angels of the Passion, ca. 1818–19
Oil on canvas, 8 ⅞ x 20 ⅞ in. (22.5 x 53 cm)
P720

Angels Bearing the Attributes of the Passion, ca. 1818–19
Oil on canvas, 8 ⅞ x 20 ⅞ in. (22.5 x 53 cm)
P719

PROVENANCE
General inventory of July 14, 1834 of the painter's property following his death, no. 35; assigned
to his daughter, Mariana; Madrid, Alcalá Subastas

BIBLIOGRAPHY
Núñez 2000, pp. 38, 167, 182–83 and 308 (ill.), nos. P-59 and P-60; Ros de Barbero 2014, pp. 87 (ill.)
and 194–95

EXHIBITIONS
Madrid 2014–15, nos. 74 and 75

These two works are preparatory sketches for the fresco decorations of the semicircular
dome at the chapel in the Queen's Casino. In 1817, the City Government of Madrid gave
King Ferdinand VII's (1784–1833) second wife, Maria Isabel of Bragança (1797–1818), a
small leisure house at what is now that city's Plaza de Embajadores. Known as the Queen's
Casino, this building is now occupied by classrooms and a library.

The frescoes on the dome were taken down and transferred to canvas in 1967, forming
twenty-three fragments now stored at the Instituto del Patrimonio Histórico Español
(Institute of Spain's Historical Heritage).[1] The subject chosen for these works is God the
Father on High, accompanied by boy angels bearing the *Arma Christi* or attributes of
Christ's Passion.

The canvas depicting God the Father also shows the cross and the whipping column,
while the other image includes angels with whips, the ladder, the sponge with vinegar
that Christ rejected on the cross, and the spear with which he was stabbed in the side. The
dome's spandrels show mourning child angels of the kind that also accompany the boy
angels on the dome.

González Velázquez had already used this subject, which has clear links to the Eucharist,
in 1803 to decorate the small prayer chapel adjacent to King Charles IV's office at the Royal
Palace in Aranjuez. A sketch for that earlier work is now in a private collection.[2]

Payments for the paintings at the Queen's Casino appear in two documents. The first,
from 1818, details payment of 1000 reales to the artist's son, Vicente. The second, which
is dated January 13, 1819, lists the cost of materials, the wages of the pigment grinder, and
extraordinary expenses for a total of 2505 (*billon*) reales. We can therefore date these works
from around that time.[3]

The painter used these sketches not only as preparatory models in planning the
composition, but also as graphic documents which he presented to the king or other
contractors for their approval. Despite their sketchy character, such works were much
appreciated by collectors of that period and some even entered royal collections.[4]

1 Núñez 2000, p. 167.
2 Ibid., p. 182, P-58.
3 Ibid., p. 167, P-14.
4 Mano 2002, p. 53.

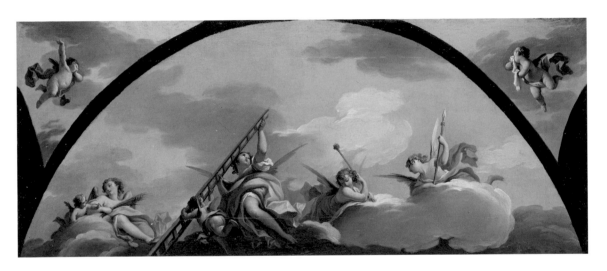

5 Núñez 2000, p. 182, P-59
and P-60.

In the present works, the motives for such interest are clear: vivid colors, an elegant composition and masterfully foreshortened figures. Both works appear in the general inventory of July 14, 1834 that lists the painter's possessions following his death: "35 Two sketches of the semicircular dome at the Chapel of the Queen's Casino, one foot and ten inches long by nine inches high [8 ¼ x 20 ⅛ in. (20.8 x 51 cm approx.)], with frames of the same [rods], at one hundred and fifty reales."[5] They were subsequently assigned to his daughter, Mariana.

Portrait of Juana Galarza de Goicoechea, 1810

Portrait of Martín Miguel de Goicoechea, 1810

Despite her wealth, Doña Juana wears a straightforward bourgeois dress adorned only with a lace collar that may be a "reference to the family business of fine fabrics."[6] Both husband and wife were originally from Navarre and following their daughter, Gumersinda's wedding, they became the in-laws of the famous painter from Aragon. For that very reason, we must associate the straightforward nature of these compositions with the intimate character of portraits, as they were members of Goya's family by marriage. As we mentioned above, Goya had already depicted Doña Juana in a miniature, and she also appears in profile in a drawing he made for his son's wedding.[7]

This work shows Goya's technical mastery at combining a very free approach and loose brushstrokes with the care and attention to details visible, for example, in Doña Juana's lace collar. The tonalities are almost perfectly harmonious and the color of her dress is achieved with two hues that create a shimmering combination of gray and green. During this period, variations of black and white, including every shade of gray, were more important than colors for Goya, and they filled his palette.

Goya assigns greater priority to the overall appearance than to specific details, so some of the latter are occasionally neglected, including the hand holding the fan or the sleeve of that same arm. Doña Juana's large black eyes look directly at the viewer, establishing a direct connection with her gaze. In his psychological analysis, Goya presents her as a strong, practical and direct woman occupied with her house and family. The importance of her role is brought out by Goya's decision to place her to the right of her husband in this pair of portraits. Curiously, only one of the sitters' hands is visible in each picture, despite the fact that, along with the face, hands are the most important elements of a portrait. The background is neutral, like the one in her husband's portrait, but somewhat darker.

These works belonged to Mariano Goya (1806–1874), grandson of the artist and of Martín Miguel de Goicoechea. Future research into Mariano's will, which was drawn up before notary José Miguel Rubías on June 11, 1868, may provide new information about what happened to these works after the death of Goya's grandson.

6 Anna Reuter in Calvo Serraller 2001, p. 204.
7 Gassier and Wilson 1970, nos. 849 and 841, respectively.

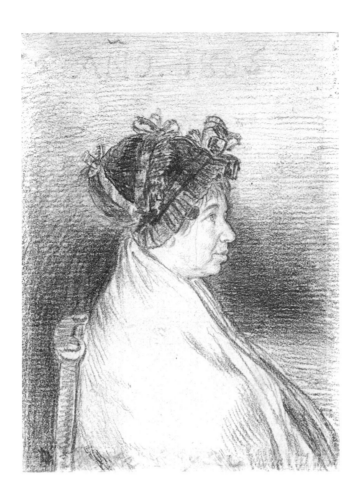

39

FRANCISCO DE GOYA (1746–1828)

Doña Josefa Bayeu, 1805
Pencil on paper, 4 ⅜ x 3 ⅛ in. (111 x 81 mm)
INSCRIPTIONS: "AÑO 1805" (above); "Doña Josefa Bayeu, por Goya, en el año 1805"
(verso, in period handwriting)
D1523

PROVENANCE
Marquis of Casa Torres Collection; private collection

BIBLIOGRAPHY
Boix 1922, no. 186 D; Mayer 1924, no. 688; Gassier and Wilson 1994, no. 840; López Ortega 2008,
pp. 62–68 (ill.); Manuela Mena in Mena 2008, p. 215; Ros de Barbero 2014, pp. 93 (ill.) and 199

EXHIBITIONS
Madrid 1922, no. 186 D; Madrid 2007–8a, p. 4; Dallas 2008, pp. 31–32; Madrid 2008a, no. 45; Valencia
2009b, pp. 48–49; Madrid 2014–15, no. 82

Romanticism and Realism

40

LEONARDO ALENZA Y NIETO (1807–1845)

Genre Scene, ca. 1840
Oil on canvas, 13 x 10 ⅜ in. (33 x 26.5 cm)
Signed: "L. Alenza." (lower left corner)
P818

PROVENANCE Madrid, Galería José de la Mano

A native of Madrid, Leonardo Alenza y Nieto is one of the finest exemplars of Spanish romanticism, both in his work and in his ill-fated life. Sickly and melancholy, he died before his time after studying drawing with Juan Antonio Ribera (1779–1860) and painting at the Royal Academy of Fine Arts of San Fernando, where he attended José de Madrazo's (1781–1859) course on color and composition. His work reflects the influence of Francisco de Goya (1746–1828), which predominates throughout his oeuvre. His loose, sketchy technique also resembles that of the Aragonese painter, and he even made a series of *Caprichos* (Caprices) after the latter's manner.

The present work depicts homeless youths who have found shelter in a rural building. The composition's focus and the seated figure recall the setting of Bartolomé Esteban Murillo's (1617–1682) *Young Beggar* (often called *The Lice-Ridden Boy, ca.* 1645–50), now at the Musée du Louvre in Paris (inv. 933). But this painting also recalls certain works by Goya, including the indoor scenes from a series of paintings of the Marquis of La Romana. Like Goya, Alenza was interested in people of the lowest social class, and this backlit scene, with light penetrating from outside the canvas, resembles some of his prison compositions.

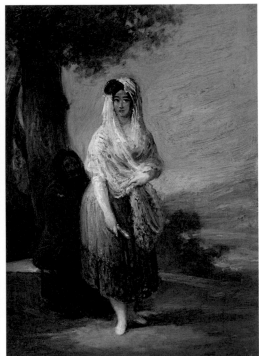

41 – 42

LEONARDO ALENZA Y NIETO (1807–1845)

Lady on the Balcony, ca. 1840
Oil on canvas, 15 x 10 ⅜ in. (38 x 26.5 cm)
P1271

Lady in a Landscape, ca. 1840
Oil on canvas, 15 x 10 ⅜ in. (38 x 26.5 cm)
P1272

PROVENANCE Madrid, private collection

Once again, the shadow of Francisco de Goya (1746–1828) is clearly present in this pair of paintings by Leonardo Alenza y Nieto. The first recalls the Aragonese painter's *Majas on a Balcony* (New York, The Metropolitan Museum of Art, 29.100.10) and a composition with that subject by Alenza is, in fact, mentioned in his biography by Manuel Ossorio y Bernard.[1] The second canvas depicts a maja in a scene that recalls plates seven ("Even thus he cannot make her out" [Ni así la distingue]) and sixteen ("For heaven's sake: and it was her mother [Dios la perdone: Y era su madre]) of Goya's *Los Caprichos* (The Caprices).

 In both works, Alenza employs his customary loose technique and harmonious palette to shape the figures and their contours directly with his brushstrokes. These *costumbrista* paintings reflect his interest in scenes from popular life and leave no doubts as to his capacity as an observer and witness of everyday events in Madrid during his lifetime.

1 Ossorio 1883–84, p. 20.

ANTONIO BRUGADA (1804–1863)

Bullfight at the Plaza Mayor of Carabanchel Alto (Madrid), ca. 1840
Oil on canvas, 28 ⅞ x 36 ¼ in. (73.4 x 92 cm)
Signed at lower center: "Bru [damaged area] a"
P2428

PROVENANCE
Madrid, Galería Caylus

A conversation with Spanish scholar José Luis Sancho has revealed the exact spot where this bullfighting scene is set. It is the Plaza Mayor of Carabanchel Alto, a resting place and summer resort for Madrid's nineteenth-century aristocrats and bourgeoisie. The time they spent there, enjoying a climate comparatively cooler than Madrid's, led to a proliferation of estates and leisure villas in both Carabanchel Alto and Carabanchel Bajo. Of the buildings appearing in this painting, only the late eighteenth-century bell tower of the now lost church of San Pedro Apóstol y Mártir remains today.

One of the leading landscape painters from the first half of the nineteenth century, Antonio de Brugada was highly esteemed in his time, especially for his seascapes. Those are the works mentioned by Manuel Ossorio y Bernard in his *Galería biográfica de artistas españoles del siglo XIX* in 1868,[1] just five years after Brugada's death. A student at the Royal Academy of San Fernando, Brugada became an exile in France, where he met Francisco de Goya (1746–1828) while passing through Bordeaux. He renewed his art studies in Paris with Théodore Gudin (1802–1880), a painter specialized in maritime scenes.

In this typically Spanish romantic painting, Brugada blends the landscape genre with that of *costumbrismo*,[2] taking obvious pleasure in the festive character of the bullfight. He also takes advantage of its picturesque depiction of everyday life to portray various popular types and Spanish customs, such as the water seller in the foreground, the *majos* drinking from a bota bag wineskin, the *majas* with their fans, an argument in the ring and the matador's assistants challenging the bull. The bleachers set up for the occasion to seat the most distinguished spectators are painted in detail, with an outstanding depiction of the tapestries that decorate the one on the right. In a written communication art historian Enrique Arias has suggested that the Spanish royal family, dressed informally, presides over the bullfight from the central box.

Drawing on his experience as a landscape painter, Brugada paints the scene with a low horizon, dedicating more than half of the upper part of the composition to a sky that alternates clear areas with low storm clouds. The multiple coats of paint that constitute light impastos all over the canvas bear a variety of vivid colors in the figures and textiles that contrast with the ochers and dark browns of the bullring and buildings. The small, nervous brushstrokes that define the spectators on the bleachers become more precise and detailed in the foreground.

1 Ossorio 1868, p. 106.
2 Sometimes called costumbrism, this nineteenth-century genre portrayed local customs and regional traditions as well as scenes of everyday life.

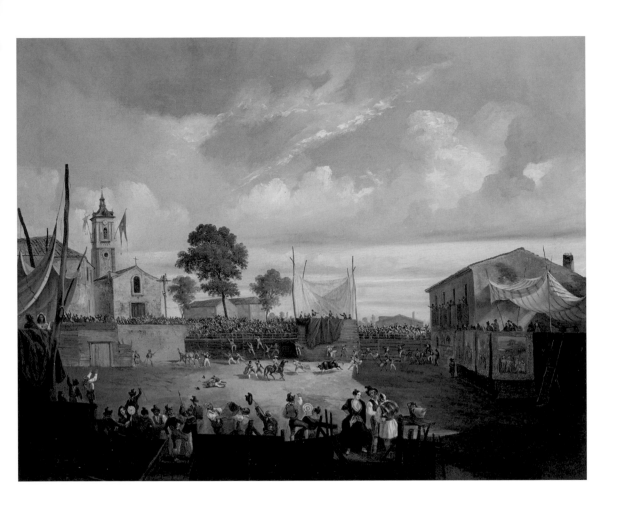

EUGENIO LUCAS VELÁZQUEZ (1817–1870)

The Goring, ca. 1850
Oil on canvas, 22 x 31 ⅛ in. (56 x 79 cm)
Inscription: "Excma. Sra. Duquesa de Parcent" (verso)
P32

PROVENANCE
El Quexigal (Cebreros, Avila), Duchess of Parcent Collection; El Quexigal, Princes of Hohenlohe
Collection; El Quexigal, Sotheby's; Madrid, Sotheby's

BIBLIOGRAPHY
Arnáiz 1981, pp. 326–27, no. 72; Ros de Barbero 2014, pp. 92 (ill.) and 198

EXHIBITIONS
Madrid 1991, no. 12, p. 88; Santander 1993, no. 26; Madrid 2014–15, no. 81

Romantic painter Eugenio Lucas Velázquez made most of his art under the influence of
Francisco de Goya (1746–1828), whose work he knew first hand. He was even involved in
the appraisal of the *Black Paintings*. In fact, he was influenced by both Goya's oils and his
engravings.

Here, Lucas drew his inspiration not only from Goya's oil paintings of bullfights, but also,
very clearly, from his etchings on the same subject, known collectively as *La Tauromaquia*
(The Tauromachy). Like that famous collection, the present work captures a precise
moment of the bullfight, and not one chosen by chance. This is the intense and tragic
instant when the bull gores a matador and holds him in the air while members of his
retinue rush to his aid and the picador's horse flees in panic. Lucas mirrors the moment's
agitation in his sketchy, nervous technique, vigorously rendered in scribbled brushstrokes.

The scene takes place under dark, stormy skies. The spectators huddle together on
the stands, as only a few enjoy the shelter of umbrellas. The light shines directly on the
"silver" bull's white skin, which stands out in a powerful way. The dark background and
ochre shades of the bullring contrast with touches of pure blue, red, green and yellow on
the capes, clothing and umbrellas. Rain also appears in other works by Lucas, including the
Musée du Louvre's *Stagecoach in the Storm* (RF 1954-21), dated 1856 and currently on deposit
at the Musée Goya in Castres.[1]

1 Almudena Ros de
Barbero in Gerard and
Ressort 2002, pp. 374–75.

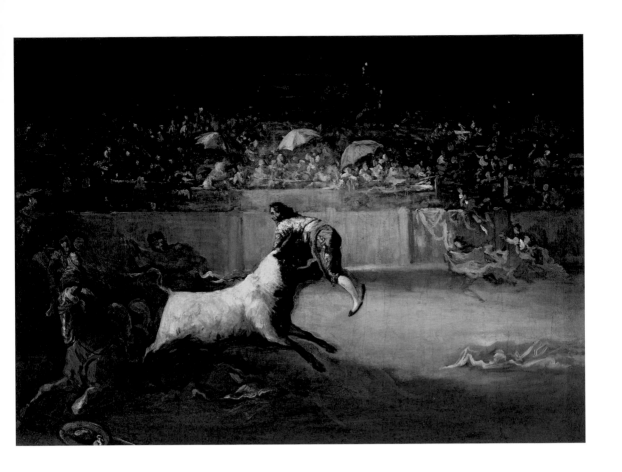

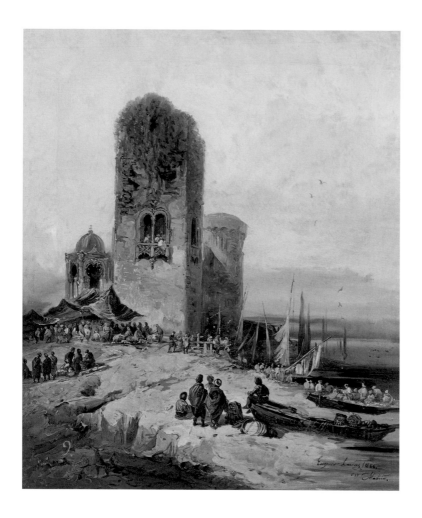

45 – 46

EUGENIO LUCAS VELÁZQUEZ (1817–1870)

Oriental Landscape (I), 1856
Oil on canvas, 20 ⅞ x 17 ⅛ in. (53 x 43.5 cm)
Signed and dated: "Eugenio Lucas 1856 / en Madrid." (lower right corner)
P61

Oriental Landscape (II), 1856
Oil on canvas, 20 ⅞ x 17 ⅛ in. (53 x 43.5 cm)
Signed and dated: "Eugenio Lucas 1856 / en Madrid." (lower right corner)
P62

PROVENANCE
Madrid, Enrique Gutiérrez de Calderón Collection

EXHIBITIONS
Madrid 1991, nos. 13 and 14, pp. 90–91; Santander 1993, nos. 27 and 28

This pair of coastal landscapes with Mudéjar ruins and Arab encampments was painted in Madrid during artist Eugenio Lucas Velázquez's finest period. Signed and dated in 1856, just a year after he participated in the Exposition Universelle in Paris, they are not so much landscapes as Orientalist fantasies or caprices, invented out of the imagination by a painter who did not actually visit Morocco until three years later, in 1859.

The loose technique, with broken brushstrokes and patches of color, marks these as two of the artist's finest depictions, exquisite and very original works in the context of nineteenth-century Spanish painting.

The two scenes complement each other perfectly in their luminosity and in the pastel tones of their crepuscular light—one with a warm palette of pinks and the other with cool blues illuminating the figures and boats.

MARIANO FORTUNY MARSAL (1838–1874)

Arabian Fantasia, 1866
Oil on canvas, 20 x 24 ½ in. (50.8 x 62.2 cm)
Signed and dated: "Fortuny / Roma 1866" (lower right corner)
P2322

PROVENANCE
Rome, Walther Fol Collection, purchased directly from the artist; New York, William H. Vanderbilt Collection (exhibited at the Metropolitan Museum of Art, New York, 1886–1903, loan by W. H. Vanderbilt); New York, William H. Vanderbilt sale, Parke-Bernet Galleries, April 18, 1945, lot no. 43, acquired by Flora Whitney Miller, New York; New York, Sotheby's, Flora Whitney Miller sale, May 21, 1987, lot no. 75; London, Sotheby's, June 22, 2000, lot no. 13; Madrid, private collection; London, Christie's

BIBLIOGRAPHY
Fol 1875, p. 275; Yriarte 1875, p. 366; *Private Collection of W. H. Vanderbilt* 1879, p. 14, no. 34; Shinn 1882, vol. III, pp. 98–99, 102, 108 (ill.); *W. H. Vanderbilt's Collection* 1884, no. 36; Ricardo de Madrazo (1852–1917), *Mis memorias*, Guadalajara, private archive, n.d., n.p.; González López and Martí Ayxelá 1989, vol. I, pp. 234–35, pls. 82–82bis, and vol. II, p. 42, no. OR-0.01.66; Carlos González López in Durán, González López and Martí Ayxelà 1998, p. 32; Mark Roglán in *Prelude to Spanish Modernism* 2005, p. 98; Llodrá 2006, pp. 54–55 (ill.); Ros de Barbero 2014, pp. 99 (ill.) and 199–200

EXHIBITIONS
Barcelona 1989, no. 17; Madrid 1989c, no. 17; Reus 1989, p. 8; Barcelona 2003–4, no. 35; Madrid 2014–15, no. 86

"In the winter of 1866, Fortuny painted an Arabian fantasy in Morocco that I own [...] the group of sheiks is magnificently painted and the harmony of the whites is almost unimaginable."[1] This description from 1875 was written by the painting's first owner, Swiss collector Walther Fol, who was a friend of Fortuny in Rome.

A year later, the work had become so successful that Fortuny made a second version, with some variations, for the French art dealer Adolphe Goupil, who later sold it to American collector William H. Stewart. That second version, painted in 1867, is now at the Walters Art Museum in Baltimore (*Arab Fantasia*, 37.191). The origins of this composition lie in the artist's second visit to Morocco, which took place in 1862. We know that in Tetuan he attended the national festival known as *Lab el baroud* (The Gunpowder Play),[2] in which a group of riders fire their arms while charging in a line, as portrayed in other works. But the event that actually inspired this painting was the dance called *Fantasia*, in which the warriors shoot their rifles at the ground while dancing, as can be seen in an early twentieth-century engraving that depicts this Moroccan custom. On the basis of these scenes, Fortuny made notes and sketches that he later used to paint the present canvas in Rome in 1866.

In a studied composition with figures forming a frieze in the painting's middle ground, Fortuny presents a group of warriors in the foreground that jump and dance as they discharge their rifles towards the ground. The work is filled with contrasts: the stillness of the figures versus the frenetic movements of the warriors, the luminous whites of the sheiks' djellabas versus the colors of the figures in the foreground and lastly, the brightly lit center that alternates with marked shadows.

Light and movement play leading roles here and they are perfectly rendered in an advanced style that Fortuny applied with considerable technique in those years. This work's strength lies in its combination of fine, detailed drawing with patches of color rendered with small brushstrokes that add volume to the figures.

During his short life, Mariano Fortuny enjoyed greater success than any other contemporaneous Spanish painter. A cosmopolitan artist who traveled, he soon became known abroad and from early in his career international collectors paid handsomely for his works. His fame has lasted far beyond his untimely death.

1 Fol 1875, p. 275.
2 González López and Martí Ayxelá 1989, vol. I, p. 42.

AURELIANO DE BERUETE (1845–1912)

View of the Guadarrama Mountain Range, ca. 1908–11
Oil on canvas, 19 ½ x 22 in. (49.5 x 55.8 cm)
Signed "A. de Beruete." (lower right corner)
P1409

PROVENANCE
Private collection, 1960; London, Sotheby's

EXHIBITIONS
Segovia-Soria 2007, p. 164

From the beginning of his career, Beruete was interested in acquiring direct knowledge
of nature through travel and field trips. Curious and always eager to learn, he also took an
interest in geography and geology. In 1886, he signed the bylaws of the "Society for the
Study of the Guadarrama" along with Giner de los Ríos, the founder of the Institución Libre
de Enseñanza (The Free Institution of Learning).[1] That initiative clearly demonstrated his
attachment to the Sierra de Guadarrama and the Sistema Central, two mountain ranges
that those intellectuals considered to be Spain's spinal column. Among other activities, their
Society organized scientific excursions involving direct contact with the landscape, and in
the present work, Beruete captures a view of the mountains as he saw it with his own eyes.

Seen from a summit, the view that unfolds includes the city walls of a village, perhaps
Buitrago de Lozoya, in the foothills of the mountain range that stands out against the sky
in the background. The entire work is imbued with the light and cold, pure air of Madrid's
sierra. The purple and blue shades of the boulders topped with snow are not only the result of
the light, but also of the hydration of iron oxide.

Here, despite a realism and scientific rigor that eschews the artifice of romantic landscape
painting, Beruete remains faithful to the philosophy of the Generation of '98 in his effort to
capture his country's lost national identity: cast as the heart of Spain, Castile is the work's
true protagonist. This painting also continues a Spanish tradition of depicting the landscapes
of the Guadarrama, which both Diego Velázquez (1599–1660) and Francisco de Goya
(1746–1828) used as backgrounds for some of their portraits.

1 See note 1 on p. 108.

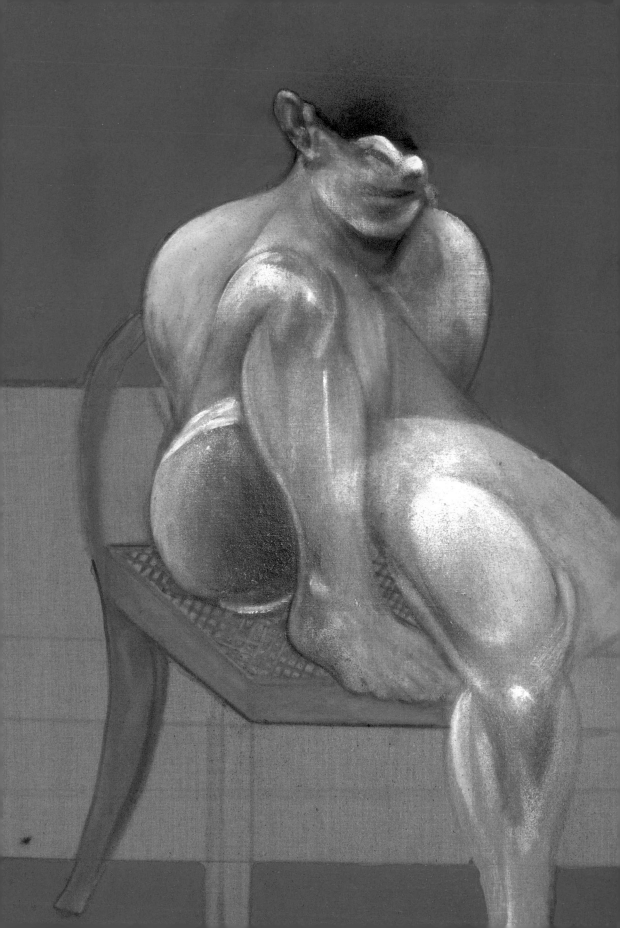

Modern and
Contemporary Art:
from Darío de Regoyos
to Francis Bacon

50

DARÍO DE REGOYOS (1857–1913)

Peñas de Urquiola (*Crags of Urquiola*), 1907
Oil on canvas, 28 ¾ x 39 ⅜ in. (73 x 100 cm)
Signed: "Regoyos" (lower right corner)
P5

PROVENANCE
Bilbao, Museo de Bellas Artes de Bilbao, on deposit to
the Darío de Regoyos Room, 1951–76; Madrid, Galería Biosca

BIBLIOGRAPHY
Ros de Barbero 2014, pp. 105 (ill.) and 201

EXHIBITIONS
Barcelona 1912; Barcelona-Madrid 1986–87, no. 151, p. 222;
Santander 1993, no. 36; Bilbao-Madrid-Málaga 2013–14,
no. 95; Madrid 2014–15, no. 93

51

SANTIAGO RUSIÑOL (1861–1931)

Jardines de Aranjuez (Gardens of Aranjuez), *ca.* 1899
Oil on canvas, 46 x 54 ¾ in. (117 x 139 cm)
Signed: "S. Rusiñol" (lower left corner)
P47

PROVENANCE
Juan Abelló Pascual Collection

BIBLIOGRAPHY
Ros de Barbero 2014, pp. 101 (ill.) and 201

EXHIBITIONS
Santander 1993, no. 33; Madrid 2000a, p. 135; Madrid 2014–15, no. 88

52

JOAQUÍN SOROLLA Y BASTIDA (1863–1923)

Niños en el mar, playa de Valencia (*Boys in the Sea, Valencia Beach*), 1908
Oil on canvas, 31 ⅞ x 41 ¾ in. (81 x 106 cm)
Signed and dated: "J. Sorolla y Bastida / 1908"
(lower left corner)
P1520

PROVENANCE
London, Christie's

BIBLIOGRAPHY
Pantorba 1970, p. 193, no. 1673; Ros de Barbero 2014,
pp. 106 (ill.) and 201

EXHIBITIONS
New York-Buffalo-Boston 1909, no. 297; Segovia-Soria 2007,
p. 181 (ill.); Madrid 2014–15, no. 94

53

JOAQUÍN MIR (1873–1940)

Mercado de pescado en la playa (Fish Market at the Beach), ca. 1922
Oil on canvas, 41 x 47 ¼ in. (104 x 120 cm)
Signed: "J. MIR" (lower right corner)
P18

PROVENANCE
Madrid, private collection

BIBLIOGRAPHY
Miralles 2006, pp. 34 and 136, no. 2 (ill.); Ros de Barbero 2014, pp. 107 (ill.) and 201

EXHIBITIONS
Santander 1993, no. 38; Madrid 2001–2c, p. 244; Barcelona-Bilbao 2009, no. 64,
pp. 128–29 and 170; Madrid 2014–15, no. 95

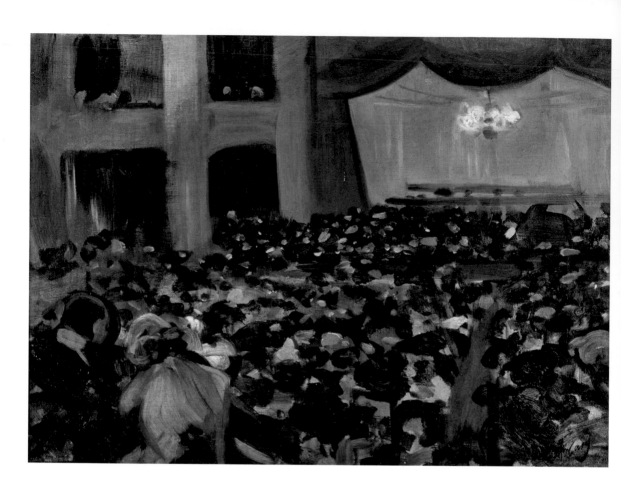

54

RAMÓN CASAS Y CARBÓ (1866–1932)

Teatro Novedades (*The Novedades Theater*), *ca.* 1902
Oil on canvas, 15 ¾ x 21 ¼ in. (40 x 54 cm)
Signed: "R. Casas" (lower right corner)
P43

PROVENANCE
Collection of the painter's heir; Barcelona, Galería Oriol; Barcelona, Galería Barbié;
Private collection; Madrid, Sotheby's

BIBLIOGRAPHY
Ros de Barbero 2014, pp. 92 (ill.) and 201

EXHIBITIONS
Madrid 1991, no. 42; Santander 1993, no. 31; Madrid 2000a, p. 159; Madrid 2005–6a,
pp. 248–49; Valencia 2010, p. 158 (ill.); Madrid 2014–15, no. 91

55

RAMÓN CASAS Y CARBÓ (1866–1932)

Señora en la biblioteca (*Lady in the Library*), 1900
Oil on canvas, 28 ¾ x 21 ⅝ in. (73 x 55 cm)
Signed: "R. Casas" (lower right corner)
Inscription: "42565" (lower right corner)
P168

PROVENANCE
Madrid, Galería del Cisne

BIBLIOGRAPHY
Sala Parés 1978, n.p., fig. 37; Ros de Barbero 2014, pp. 103 (ill.) and 201

EXHIBITIONS
Santander 1993, no. 32; Madrid-Barcelona 1998, no. 337; Madrid 2000a, p. 140;
Madrid 2000b, p. 177; Madrid 2014–15, no. 90

56

HERMENEGILDO ANGLADA CAMARASA (1871–1959)

Mujer en un palco (*Woman in a Theater Box*), ca. 1903–4
Oil on panel, 28 ¾ x 36 ¼ in. (73 x 92 cm)
Signed: "H Anglada Camarasa" (lower right corner)
P22

PROVENANCE
Paris, Joan Busquets Miró Collection; Barcelona, Sala Parés

BIBLIOGRAPHY
Fontbona and Miralles 1981, B-80 (1); Ros de Barbero 2014, pp. 102 (ill.) and 201

EXHIBITIONS
Barcelona 1980–81, no. 10; Madrid 1982a, no. 28, p. 65; Santander 1993, no. 34; Madrid 2000a, p. 172; Madrid 2014–15, no. 89

57

ISIDRO NONELL (1873–1911)

Gitana meditando (*Gypsy Reflecting*), 1906
Oil on canvas, 24 x 19 ⅝ in. (61 x 50 cm)
Signed and dated: "Nonell / 1906" (upper right corner)
P6

PROVENANCE
Dr. Blanco Soler Collection; Madrid, Galería Biosca, 1968; Madrid, private collection, April 1968

BIBLIOGRAPHY
Gonzalo M. Borrás Gualis in *Confines* 2000, p. 71; Ros de Barbero 2014, pp. 104 (ill.) and 201

EXHIBITIONS
Paris 1907, no. 3670; Santander 1993, no. 39; Barcelona-Madrid 2000, no. 54, pp. 166–67;
Valencia 2010, p. 165 (ill.); Madrid 2014–15, no. 92

HENRI DE TOULOUSE-LAUTREC (1864–1901)

Femme au café (Woman in a Café), ca. 1886
Oil on canvas, 24 x 19 ⅝ in. (61 x 50 cm)
P373

PROVENANCE
Heemstede (Holland), Madame C.L.E.H. van der Waals-Königs Collection; Franz Koenigs Collection;
London, Sotheby's

BIBLIOGRAPHY
Dortu 1971, vol. II, p. 119 (ill.), no. P.274; Ros de Barbero 2014, pp. 108 (ill.) and 202

EXHIBITIONS
Amsterdam-Brussels 1947, no. 9; Recklinghausen 1956, no. 217; Barcelona 2004, pp. 142–43;
Madrid 2014–15, no. 96

This early work by Henri de Toulouse-Lautrec was painted by the artist two years after
he settled in the Parisian neighborhood of Montmartre in 1884, the same year he met
Vincent van Gogh (1853–1890). He was twenty-two at the time and had not yet developed
his mature style. The present painting shows the influence of impressionism and
post-impressionism. Its markedly linear brushstrokes, especially in the face, also reveal
Toulouse-Lautrec's contact with Van Gogh's work.

The female figure is lit from behind and emerges like a dark shadow that stands out
against the curtain. Light plays a fundamental role in this composition, illuminating
certain areas, such as the background, tablecloth and reading matter (a newspaper,
book or perhaps the menu) that the woman holds in her hands.

The iconography of this canvas was very modern for its time, not only because it
eschewed traditional painterly subject matter, but also because in 1886 ladies did not visit
public places alone.

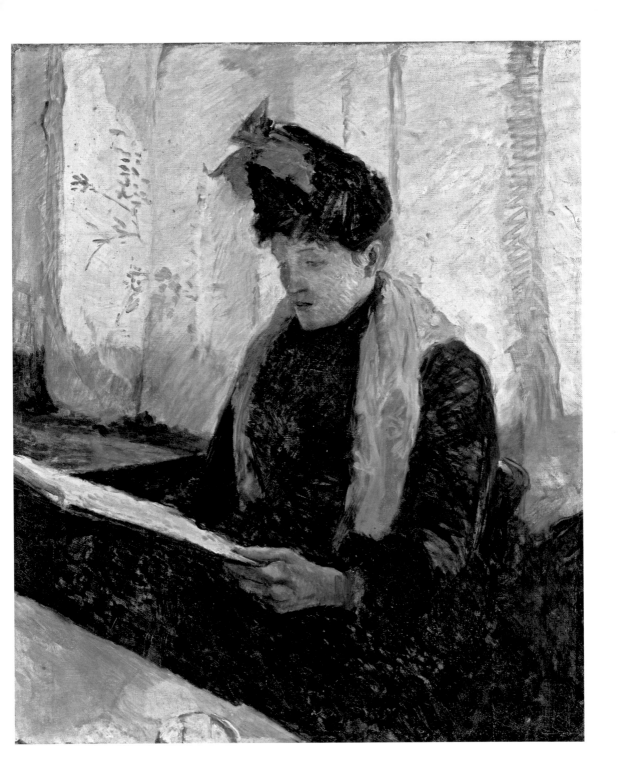

EDGAR DEGAS (1834–1917)

Après le bain, femme nue s'essuyant (*After the Bath, Woman Drying Herself*), ca. 1895
Charcoal on paper, 24 ¾ x 23 ¾ in. (628 x 604 mm)
Stamp of the artist's studio (Lugt 658) (lower left corner)
D2367

PROVENANCE
Artist's studio; third sale of the Edgar Degas Studio, Paris, Galerie Georges Petit, April 7–9, 1919,
lot no. 309, acquired by Alexandre Henriquet, Paris; Paris, by descent to Alec Henriquet; by descent
to a private collection; Paris, Christie's

BIBLIOGRAPHY
Cau 1975, pp. 148–49, no. 73 (ill.); Lemoisne 1984, vol. III, p. 784; Ros de Barbero 2014, pp. 108–9 (ill.)
and 202

EXHIBITIONS
Paris 1975, no. 73; Madrid 2014–15, no. 97

La Sortie du bain (*After the Bath*), ca. 1895
Charcoal and pastel on joined sheets of paper, 20 ⅝ x 20 ¾ in. (52.5 x 52.8 cm)
Signed: "Degas" (lower left corner)
P1521

PROVENANCE
Sold by Degas to Durand-Ruel on January 7, 1902; Paris, Galerie Durand-Ruel; Brookline
(Massachusetts), Peter Fuller Collection, July 8, 1925; Boston, Fuller Collection; New York, Sotheby
Parke Bernet; New York, Robert Guccione and Kathy Keeton Collection; United States, private
collection, 2001; London, Sotheby's

BIBLIOGRAPHY
Moore 1907–8, p. 104 (ill.); Liebermann 1917, p. 24 (ill.); Lemoisne 1946, vol. III, no. 1340, p. 785 (ill.);
Russoli and Minervino 1970, no. 1043, p. 133 (ill.); Gordon and Forge 1988, p. 251 (ill.); *Degas inédit* 1989,
p. 512, no. 11 (ill.); Sutherland and Maheux 1992, p. 137, no. 49 (ill.); Ros de Barbero 2014, pp. 108–9 (ill.)
and 202–3

EXHIBITIONS
London 1905; Boston 1928, no. 5; Boston 1935, no. 21; Boston 1937; Boston 1939, no. 39; Hartford 1946,
no. 19; Paris-Ottawa-New York 1988–89, no. 317; Roslyn Harbor 1993; Roslyn Harbor 1994; Madrid
2007–8a, pp. 46–47 and 132; Basel 2012–13, p. 141 (ill.); Madrid 2014–15, no. 98

Drawing had always played a major role in the work of Edgar Degas, but in 1880 it became even more important as the painter gradually abandoned oils and focused almost entirely on pastels. In the present work, presented alongside a preparatory sketch in charcoal, both made around 1895, Degas fully exploited that technique which allowed him to draw with vibrant, luminous colors.

A nude woman appears in a room, drying herself after bathing. The female figure was a specialty for this painter, who captured it with the greatest objectivity and spontaneity. In this intimate and private scene, the woman is seen from the back and her raised left arm hides her face.

It is almost as though the viewer were a voyeur spying on her through the keyhole, and that is exactly what Degas wanted. He often observed that until then nudes appeared in paintings in postures that presupposed an audience.[1] That is why he chose to depict a straightforward, direct woman, interested only in her own hygiene and fully absorbed in her activity with no awareness that she is being observed.

The chosen viewpoint, behind the woman's back, helps create the reserved atmosphere while photography, which greatly interested Degas, influenced his conception of the framing. Another source of inspiration comes from his own work, as the woman twists her torso much like one of the dancing ballerinas he depicted.

In this vibrantly colored bath scene the large repertoire of strokes—some zigzag, others striped and others calligraphic—gives the composition an almost abstract air that reinforces its vivacity. Intense tones applied in various coats of pastel offset the black lines that define the figure's contours in a practically square work that attains its final format only as the image progresses, as the artist extends the top and bottom with horizontal strips of the same paper.

1 *Benezit Dictionary of Artists* 2006, vol. IV, p. 572.

Après le bain, femme nue s'essuyant (*After the Bath, Woman Drying Herself*), ca. 1895

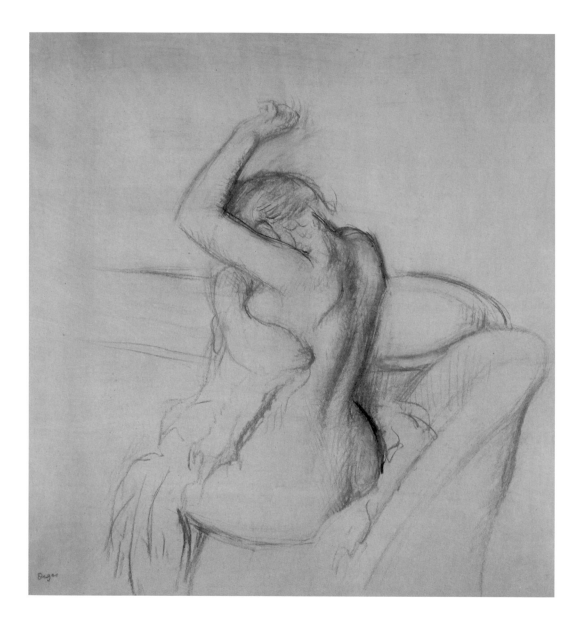

La Sortie du bain (After the Bath), ca. 1895

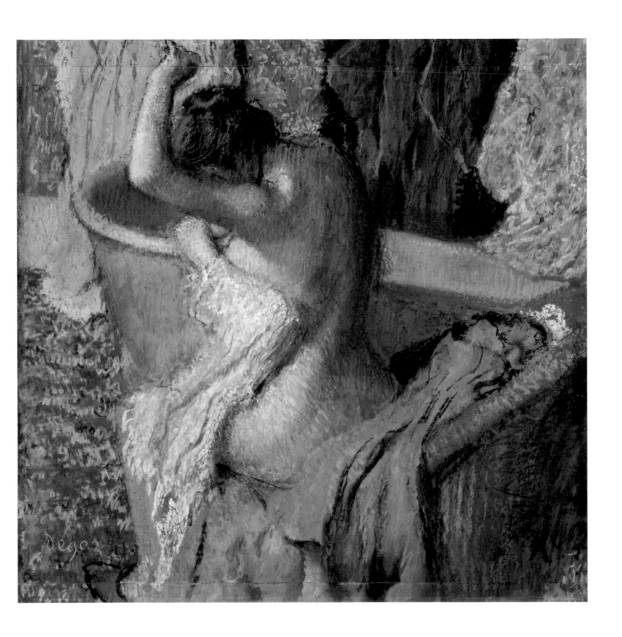

PIERRE BONNARD (1867–1947)

Misia au corsage rose (Misia in a Pink Blouse), ca. 1908
Oil on canvas, 38 x 24 ⅜ in. (96.4 x 61.9 cm)
Signed: "Bonnard" (lower right corner)
P381

PROVENANCE
Artist's estate; private collection, 1974; New York, Sotheby's

BIBLIOGRAPHY
Dauberville and Dauberville 1974, p. 281 (ill.), no. 01941; Ros de Barbero 2014, pp. 111 (ill.) and 203

EXHIBITIONS
Madrid 2014 15, no. 100

The subject of this portrait is the Polish pianist Maria Zofia Olga Zenajda Godebska (1872–1950), known by the Polish diminuitive for Mary: Misia. This fascinating woman shared her life with three influential men from the cultural circles of her time. At the very young age of fifteen she married Thadée Natanson, publisher of the famous magazine, *La Revue Blanche*. In 1905, following his economic ruin, she divorced him and married press magnate Alfred Edwards, whose fortune allowed him to save *La Revue Blanche*. The third man in Misia's life was Spanish artist José María Sert (1874–1945), who became her third husband and by whose name she is now known: Misia Sert.

Comfortable in her period's intellectual circles, Misia hosted a salon at her house, where she welcomed various painters, among them Pierre Bonnard. She also posed for other artists, including Henri de Toulouse-Lautrec (1864–1901), and was an intimate friend of Coco Chanel.

While working on this portrait, Bonnard was also making decorative panels for the dining room at Misia's Quai Voltaire house in Paris. The salon where she poses in the present work, with *boisseries* and striking striped wallpaper in the background, may be from her own apartment. The artist reflects her peculiar beauty with a hieratic appearance that resembles the sculptures from Hellenic Antiquity that he greatly admired. Bonnard pays particular attention to light here, illuminating the pink blouse that lends its name to the painting but leaving her face in the shadows. The rich, impasto brushstrokes in certain parts, such as the flower in her hair, become more liquid and dilute in the lower part of the canvas.

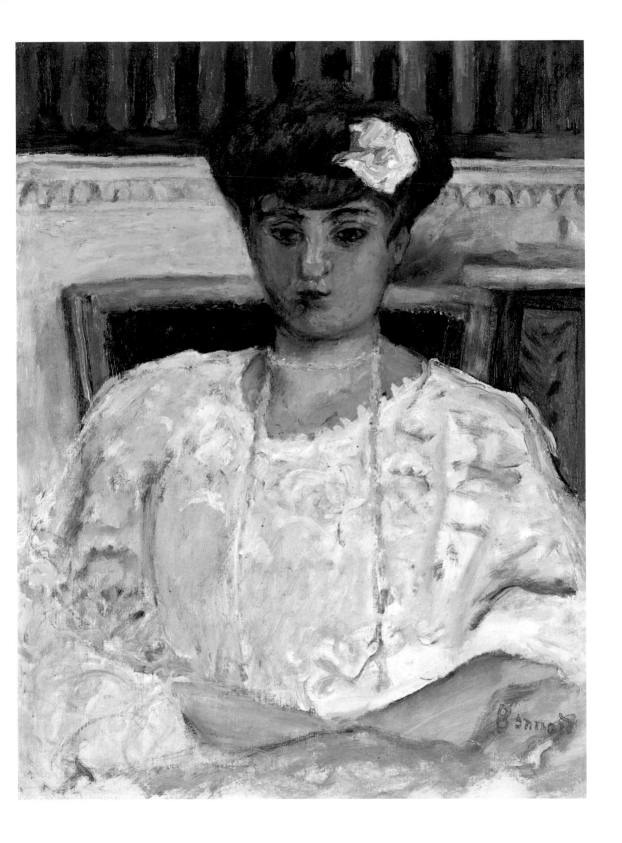

PIERRE BONNARD (1867–1947)

Nu sur fond bleu (Nude on a Blue Background), *ca.* 1914–16
Oil on canvas, 36 ¼ x 18 ¾ in. (92.1 x 47.6 cm)
Signed: "Bonnard" (upper left corner)
P645

PROVENANCE
Paris, Durand-Ruel; Lucerne, Galerie l'Art Moderne (Bernheim-Jeune), *ca.* 1929; Geneva, Galerie
Georges Moos, *ca.* 1947; Soleure (Switzerland), Silvan Kocher, *ca.* 1955; New York, Acquavella Galleries;
Japan, private collection; New York, Sotheby's; private collection; New York, Sotheby's

BIBLIOGRAPHY
Vauxcelles 1935; Dauberville and Dauberville 1968, p. 346, no. 813 (ill.); Ros de Barbero 2014,
pp. 112 (ill.) and 204

EXHIBITIONS
Amsterdam 1947, no. 20; Basel 1955, no. 54; Munich-Paris 1966–67, no. 113 (Munich), no. 80 (Paris);
Madrid 2014–15, no. 101

The female nude was a constant in Pierre Bonnard's work throughout his career. His
particular interest in that subject is beautifully reflected here in a format perfectly adapted
to the composition. High and narrow, it follows the body of the woman standing barefoot.

The painter approaches the female universe of the *toilette* with sensitivity, depicting
a moment of intimacy for this woman who appears to be holding a bottle, possibly of
perfume. The only accessory to her beautiful nudity is her carefully kept hair, adorned
with a blue flower.

The linear nude figure is framed by a table and a bed that enclose a private space of
female intimacy. Bonnard's masterful post-impressionist technique offers the viewer a
woman's luminous body whose nude forms are shaped with marked brushstrokes.

In works such as this, the painter focused on domestic reality without reflecting larger
events occurring at the time he painted this canvas, for example, the First World War.
Bonnard was interested in the comfortable rituals of the new bourgeoisie, almost always
interpreted by women, who were the protagonists of home life.

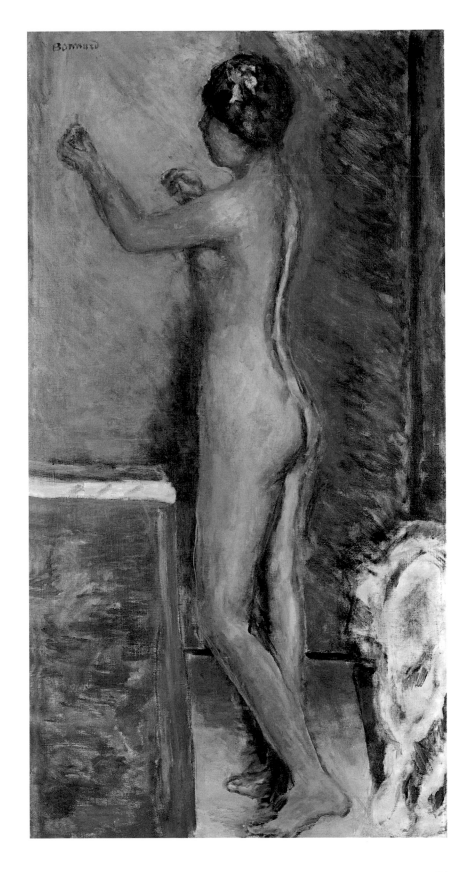

KEES VAN DONGEN (1877–1968)

Jeune fille au robe rouge (Dolly van Dongen) (*Girl in a Red Dress*), ca. 1909
Oil on canvas, 39 ¾ x 31 ¾ in. (99.7 x 80.6 cm)
Signed: "van Dongen" (lower right corner)
P138

PROVENANCE
Budapest, Royal Counsellor Marcel Nemes, 1910; Leipzig, Dr. Alfred Esche Collection, *ca.* 1922;
private collection, *ca.* 1970; London, Christie's

BIBLIOGRAPHY
Gordon 1974, vol. I, p. 170 (ill.), vol. II, p. 393; Ros de Barbero 2014, pp. 113 (ill.) and 204

EXHIBITIONS
Budapest 1910, no. 19; Leipzig 1922, no. 27; Santander 1992, pp. 14–15; Madrid 2014–15, no. 102

Dolly was the painter's daughter by Augusta Preitinger, known as Guus, whom he had
married in Paris in 1901. Gussie, later known as Dolly, was born four years later, when
the family lived at the Bateau Lavoir building on rue Ravignan, as did several other
painters—Picasso (1881–1973) resided there with his lover of that period, Fernande
Olivier. Little Dolly grew up in this atmosphere, surrounded by artists and with Picasso
as a playmate.

This portrait was made around 1909, when Dolly was about three years old. Looking
serious and shy, she grasps a finger and gazes attentively at her father as she poses for him.
Van Dongen floods the image with red, including her dress, the ribbon in her hair and the
background; his choice of this color lends great force to the portrait of such a young child.
Despite her youth, Dolly is depicted like a miniature lady dressed as an adult, seated beside
a bouquet of flowers painted with impastos, and adorned with a necklace.

As in the rest of the painting, color plays a leading role in the girl's face, with impasto
flesh tones and hair. Her face, throat and arms are painted with mixed colors, including
a greenish tint, to create the appearance of skin.

AMEDEO MODIGLIANI (1884–1920)

Le Violoncelliste (The Cellist), 1909
Oil on canvas, 28 ¾ x 23 ⅝ in. (73 x 60 cm)
Signed: "modigliani" (lower right corner)
P67

[VERSO]
Portrait of Constantin Brancusi

PROVENANCE
Paris, Dr. Paul Alexandre Collection, rue du Delta house; Basel, Galerie Beyeler

BIBLIOGRAPHY
Pfannstiel 1929, p. 17 (ill.); Taguchi 1936, n.p. (ill.); Franchi 1946, pl. V; Raynal 1951, pl. 1; Lipchitz 1952, p. 7; Lipchitz 1954, pl. 12; "Omaggio a Amedeo Modigliani" 1954, pl. 5; Soby 1954, p. 14 (ill.); Pfannstiel 1956, p. 61 (ill.), no. 16; Ceroni 1958, no. 18 (ill.); Roy 1958; Werner 1968, pp. 54 and 77 (ill.); Gindertael 1969, pl. II; Ceroni 1970, nos. 22a (front) and 22b (back), p. 84; Lanthemann 1970, no. 35; Garfias 1972, p. 98; Roy 1985, pp. 26 and 30 (ill.); Werner 1985, pp. 54 and 77 (ill.); Arnason 1986, p. 249 (ill.); Millán del Pozo 1989, p. 212 (ill.); Parisot 1991, nos. 8/1909 and 8bis/1909; Alexandre 1993a, pp. 42 and 48; Marie-Christine Decroq in Restellini 2003, p. 110; Lobstein 2003, p. 1227; Ros de Barbero 2014, pp. 115 (ill.) and 205–6

EXHIBITIONS
Paris 1910, no. 36; Brussels 1933, p. 4 (ill.); Cleveland-New York 1951, p. 18; Santander 1992, pp. 12–13; Venice and traveling 1993–96, pp. 48, 60, 96 and 414 (ill.); Rome 2006, no. 5; Madrid 2008b, nos. 3a and 3b, pp. 51–52, and 185; Madrid 2014–15, no. 105

Modigliani had been living in Paris for three years when fame arrived in 1909, the year he traveled to Livorno to spend his summer vacation with his family. His correspondence shows that he returned to France in late September. At that time, he lived in the Cité Falguière, in an apartment that his friend, sculptor Constantin Brancusi (1876–1957), had found for him, quite close to his own residence in Montparnasse.

It was precisely there that he painted the model appearing in this portrait, who some consider to be Brancusi himself. A simple man rather than a well-established artist, he inspired Modigliani to make two works upon his return from Livorno. The second canvas is larger (51 ⅛ x 31 ⅞ in. [130 x 81 cm]) and belongs to a private collection.

The room used as the setting for this picture was so small that there was barely space for the model and his cello, so Modigliani had to stand in the hall as he painted.[1] Part of the tiny room appears in the background of the picture, since Modigliani liked to include details of his sitter's milieu into his work.

Beginning with the model, Modigliani simplifies and distills the form to capture the essence, focusing on the innermost self of the person he is portraying. Each of his portraits, including this one, is the result of a long meditation before the model, a process during which he paid close attention to colors and, especially, shapes. According to his friend Paul Alexandre, who originally owned this work, when a figure interested him, he drew it with fervor. In the case of this cellist, for example, we know of five preparatory drawings, one of which also belongs to the Abelló Collection [*Le Violoncelliste (The Cellist)*, ca. 1909, black crayon on paper, 12 ⅛ x 9 ⅛ in. (309 x 232 mm), see next entry].

1 Alexandre 1993a, p. 414.

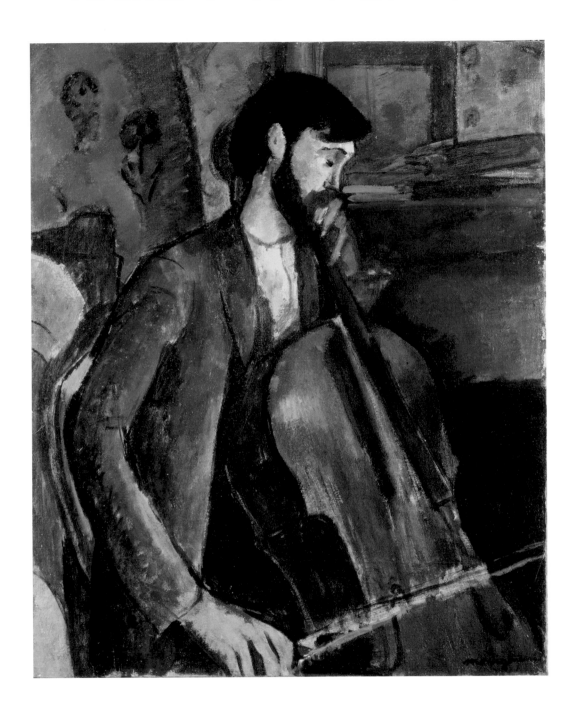

Along with the young model, the instrument plays a major role in the composition. Modigliani marks its contours with blue before extending the highly diluted colors, later varnishing the composition with a coat of thinly spread encaustic. After this varnish dried, he polished it with a piece of flannel or leather.

Some authors see the influence of Paul Cézanne (1839–1906) in this work, although it is already perfectly attuned to Modigliani's style. We do know, however, that in 1908 he made daily visits with Paul Alexandre to the Cézanne exhibition at the Bernheim Gallery and painted a copy of the great French artist's *Boy in a Red Waistcoat* (National Gallery of Art, Washington D. C., 1995.47.5) from memory.[2]

2 Ibid., p. 62.

Alexandre was the first owner of this work. A dermatologist, he was the son of a pharmacist and member of the traditional *haute bourgeoisie*. Educated by the Jesuits in Paris, Alexandre became interested in art at a young age and surrounded himself with artist friends. He eventually rented a house on the rue du Delta to receive various painters and artists of the period. That is where he met Modigliani in 1907, and he remained the latter's closest friend and intimate confidant for the rest of his life.

Thanks to Alexandre's writing and to a photograph, we know that this painting hung in the living room of the house and studio on rue du Delta, as Alexandre and his brother Jean had decided that the walls of the residence should be decorated exclusively with Modigliani's works.[3]

In 1910, this canvas was exhibited in room XVIII of the Salon des Indépendants, close to the works of Kees van Dongen (1877–1968). While it received no negative criticism, it did nothing to increase the artist's sales, either. Modigliani's only client continued to be his friend, Doctor Alexandre. The latter also introduced him to the Romanian sculptor Constantin Brancusi, whose portrait appears on the back of this same work.

3 Ibid., p. 49.

65

AMEDEO MODIGLIANI (1884–1920)

Le Violoncelliste (*The Cellist*), preparatory drawing, *ca.* 1909
Black crayon on paper, 12 ⅛ x 9 ⅛ in. (309 x 232 mm)
Stamp from the Dr. Paul Alexandre Collection: (lower left corner)
Inscription: "3,83" (lower left corner)
Verso, head and bust of a woman
D299

PROVENANCE
Paris, Dr. Paul Alexandre Collection; heirs of Dr. Paul Alexandre; private collection; London, Sotheby's

BIBLIOGRAPHY
Patani 1994, p. 346, no. 762 (ill.); Ros de Barbero 2014, pp. 114 (ill.) and 205

EXHIBITIONS
Venice and traveling 1993–96, pp. 414 and 433, no. 425, cat. 345; Las Palmas-Oviedo 2000, pp. 52–53;
Rome 2006, no. 13; Dallas 2008, p. 67; Madrid 2008b, no. 4; Valencia 2009b, p. 94; Madrid 2014–15, no. 104

66

AMEDEO MODIGLIANI (1884–1920)

Portrait de Brancusi, sculpteur (*Portrait of the Sculptor Brancusi*), ca. 1909
Ink on paper, 14 ⅜ x 10 ⅜ in. (366 x 264 mm)
Stamp from the Dr. Paul Alexandre Collection (lower right corner)
Inscription: "4,14" (lower right corner); and by Paul Alexandre: "Portrait de Brancusi,
sculpteur" (verso)
D2362

PROVENANCE
Paris, Dr. Paul Alexandre Collection (purchased directly from the artist before 1914);
by descent to his heirs; London, Sotheby's

BIBLIOGRAPHY
Alexandre 1993b, pp. 100 and 383, no. 300, fig. 369 (ill.); Patani 1994, p. 343, no. 744 (ill.);
Ros de Barbero 2014, pp. 114 (ill.) and 205

EXHIBITIONS
Venice and traveling 1993–96, no. 161; Madrid 2014–15, no. 103

67

CONSTANTIN BRANCUSI (1876–1957)

Femme nue debout (*Standing Female Nude*), *ca.* 1920–22
Blue crayon on paper, 16 ½ x 10 ⅜ in. (420 x 264 mm)
Signed: "C Brancusi" (lower right corner)
D537

PROVENANCE
New York, Theodore Schempp Collection; New York,
Lee and Isabel Ault Collection; New York, Christie's

EXHIBITIONS
Madrid 2007–8a, pp. 92 and 134; Dallas 2008, p. 60; Valencia 2009b, p. 106

AMEDEO MODIGLIANI (1884–1920)

Tête (Head), ca. 1911–12
Carved stone, 9 ¼ in. (23.5 cm) high (without the base)
E1627

PROVENANCE
Paris, Paul Guillaume Collection; Paris, Corbelline Collection; Paris, A. Kleinmann Collection; Paris, Ernest de Frenne Collection; Paris, Paul Martin Collection, 1941–48; New York, Otto Gerson Gallery, Inc.; New York, Herbert Singer Collection, March 29, 1961; Nell Singer Collection; London, Sotheby's

BIBLIOGRAPHY
Werner 1960–61, p. 73 (ill.); Werner 1962, pls. 34 and 35; Ceroni 1965, no. X, pls. 50 and 51; Ceroni 1970, p. 107 (ill.), no. X; Lanthemann 1970, p. 319 (ill.), no. 641; Ceroni 1972, no. X, p. 107 (ill.); *Modigliani* 1984, no. 7 (ill.); Patani 1992, p. 55, no. 16 (ill.); Ros de Barbero 2014, pp. 116 (ill.) and 206

EXHIBITIONS
Madrid 2008b, no. 29; Madrid 2014–15, no. 106

In 1909, Modigliani met Brancusi through his friend, Doctor Paul Alexandre. Born to a family of humble Romanian peasants, Constantin Brancusi (1876–1957) first developed his passion for sculpture by carving wood as a craftsman. Through considerable effort, he managed to study at the School of Fine Arts in Bucharest before deciding to move to Paris. Having no other means of getting there, he walked.

Once in Paris, he initiated Modigliani in the art of sculpture, as the men were neighbors in Montparnasse. Between 1909 and 1914, the Italian painter worked on his sculptures with technical guidance from Brancusi, who taught him direct carving. During that period, Modigliani defined himself more as a sculptor than as a painter.

The present sculpture was made during that period and it stands out for its monumentality. As with his paintings, the human figure is the principal focus—in this case, a head whose elegant features contrast with the rough treatment of the stone surface. Besides Brancusi's work, Modigliani was inspired by the sculptures of Greece and ancient Egypt.

AMEDEO MODIGLIANI (1884–1920)

Femme nue assise de trois quarts, incline vers l'avant, bras en tournant
la jambe droite relevée (Seated Nude Bending Forward, Arms Hugging Raised Right Leg,
in Three-quarter View), ca. 1907–14
Graphite and crayon on paper, 16 ⅞ x 10 ¼ in. (428 x 261 mm)
Stamp from the Dr. Paul Alexandre Collection (lower right corner)
Inscription: "87" (lower right corner)
D2401

PROVENANCE
Paris, Dr. Paul Alexandre Collection (purchased directly from the artist before 1914);
by descent to his heirs; Paris, Sotheby's

BIBLIOGRAPHY
Alexandre 1993a, no. 289, pl. 366, p. 378 (ill.); Patani 1994, no. 741, p. 342 (ill.)

EXHIBITIONS
Venice and traveling 1993–96, no. 289

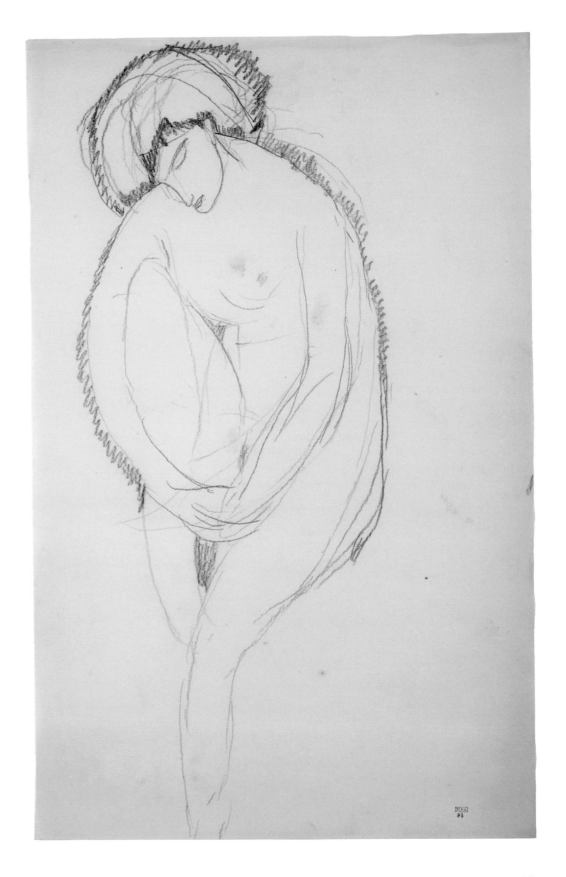

GEORGES BRAQUE (1882–1963)

Rhum et guitare (Rum and Guitar), 1918
Oil on canvas, 23 ⅝ x 28 ¾ in. (60 x 73 cm)
P69

PROVENANCE
Washington D. C., private collection; London, Waddington Galleries Ltd.

BIBLIOGRAPHY
Einstein 1926, p. 395 (ill.); *Bulletin de l'Effort Moderne*, 33 (March, 1927), ill.; Isarlov 1932, no. 226; *Cahiers d'Art*, 1–2 (1933), p. 36 (ill.); Einstein 1934, pl. XL; Mangin 1973, no. 28 (ill.); Ros de Barbero 2014, pp. 117 (ill.) and 207

EXHIBITIONS
Basel 1933, no. 18; Santander 1992, pp. 18–19; Madrid 2002b, no. 20; Paris-Houston 2013–14, no. 102 (ill.); Madrid 2014–15, no. 107

Following his early Fauvist period, when his drawing dissolved into patches of color, Georges Braque began painting his first cubist works in 1907. Breaking objects down into various planes, he advanced along the road to abstraction alongside Pablo Picasso (1881–1973).

This still life dates from 1918, towards the end of the First World War, in which Braque had fought and been gravely wounded in 1915. Following a period of convalescence, he renewed his artistic activity in 1917.

The guitar and bottle of rum from which this painting takes its name are broken into geometric forms. Braque paints them as if he were moving around them, presenting them as various juxtaposed planes at the same time. Some of their facets are decorated with dots or small brushstrokes that recall the wallpaper he would later use in his period of synthetic cubism.

The result is an interesting canvas from Braque's cubist period with an especially striking balance of curved and straight lines, lights and shadows and light and dark colors.

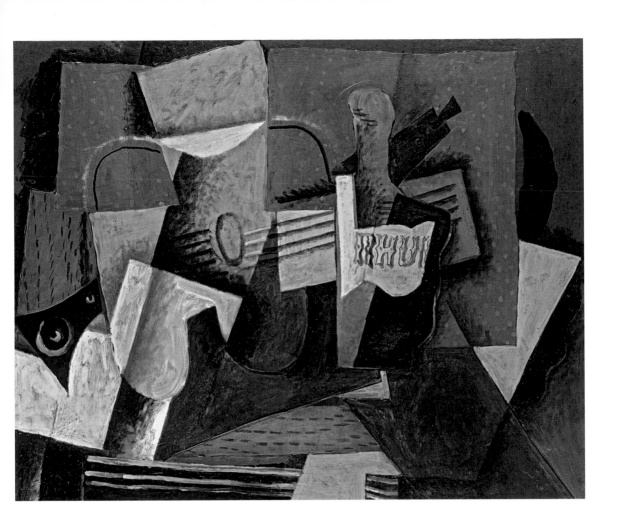

JUAN GRIS (1887–1927)

Femme assise o *L'Écossaise* (*Seated Woman* or *The Scotswoman*), July 1918
Oil on canvas, 36 ¼ x 25 ⅝ in. (92 x 65 cm)
Signed and dated: "Juan Gris / 7–18" (lower right corner)
P3

PROVENANCE
The artist's studio; Paris, Galerie de l'Effort Moderne (stock no. L.R.6057); Saint-Germain-en-Laye, Alphonse Kann; Paris, André Lefèvre; Paris, private collection; Paris, Galerie Jeanne Castel; Barcelona, Galería Trece

BIBLIOGRAPHY
Jardot and Martin 1948, pl. 15; Cooper 1977, p. 43, no. 271 (ill.); Ros de Barbero 2014, pp. 118 (ill.) and 207

EXHIBITIONS
Freiburg 1947, no. 15; Paris-London 1952, no. 38 (Paris), no. 33 (London); Bern 1955–56, no. 60; Paris 1964, no. 98; Dortmund-Cologne 1965–66, no. 50; Madrid 1977; Madrid 1989b, no. 26, p. 112; Santander 1992, pp. 20–21; London-Stuttgart-Otterlo 1992–93, no. 82; Madrid 1993b, pp. 118–19 (ill.); Madrid 2014–15, no. 108

In 1910, following his early work as an illustrator, Juan Gris began experimenting with the cubism of Pablo Picasso (1881–1973) and Georges Braque (1882–1963) in his painting. This work from July 1918 reveals his mature cubism, with a high degree of abstraction and an enormous interest in defining motifs with geometric shapes.

Gris considered painting to be the result of an activity more intellectual than visual, more a matter of evocation than transcription. Hence, he depicted this seated woman with planes of dark brown, gray, white and black, which occupy the surface of the canvas and configure the portrait.

A characteristic of these years was his inclusion of a certain degree of ornamentation in his compositions to draw the viewer's gaze. This is materialized here in the diagonal lines over the figure.

This canvas from the artist's studio belonged to the Galerie de l'Effort Moderne. At the time, Gris had a sales contract with that gallery run by Léonce Rosenberg, a leading dealer of cubist painting.

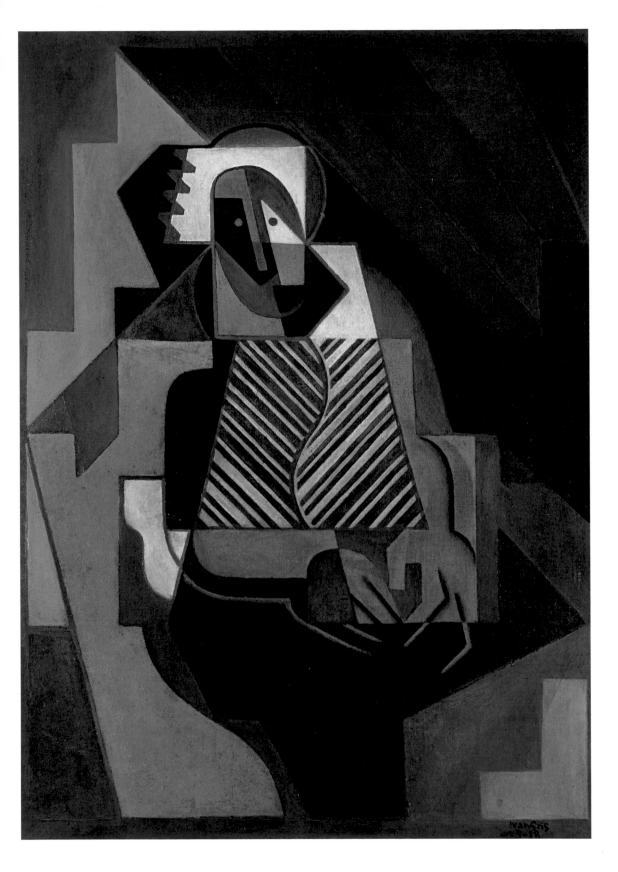

147

JUAN GRIS (1887–1927)

La Casserole (*The Pot*), October, 1919
Oil on canvas, 25 ⅝ x 31 ⅞ in. (65 x 81 cm)
Signed and dated: "Juan Gris / 10–19" (lower right corner)
P302

PROVENANCE
Paris, Galerie de l'Effort Moderne; Lausanne, Dr. Gottlieb F. Reber Collection; Barmen (Wuppertal), Ruhmeshalle, extended loan, *ca.* 1928–30; Germany, private collection, 1930; New York, Christie's

BIBLIOGRAPHY
Raynal 1920, fig. 14; Gleizes 1926 (ill.); Raynal 1933, p. 200 (ill.); *L'Amour de l'Art*, 14 (November, 1933), p. 233, fig. 295; Huyghe 1935, p. 233, fig. 295; Kahnweiler 1947, fig. 54; Cooper 1977, vol. II, pp. 106–7, no. 320; Kosinski 1991, p. 530; Ros de Barbero 2014, pp. 119 (ill.) and 208

EXHIBITIONS
Berlin 1930, no. 19; Zaragoza 2005–6; Madrid 2006, no. 20, pp. 73–74; Madrid 2014–15, no. 109

Using a variety of shapes and planes that alternate cool and warm colors, Gris brings considerable compositional balance to this still life. It is a representative work from his mature period, when the elements in his paintings broke down into flat geometric figures stripped of any sense of three dimensions.

This canvas reveals Juan Gris as an artist in constant evolution. Working continuously, he developed a personal philosophy of art on which he based a style that owed much to the cubism of Georges Braque (1882–1963) and Pablo Picasso (1881–1973). By this point in his career, however, he was his own master.

In Douglas Cooper's catalogue of Gris's oeuvre, this work was listed as destroyed in 1944. Apparently, in 1928, a collector of cubist art named Gottlieb Friedrich Reber deposited it in the German town of Wuppertal's Barmer Ruhmeshalle, which burned down in 1944. Happily, what Cooper thought was a donation had actually been a temporary loan, and in 1930, long before the unfortunate fire, Reber had already sold the work to a collector from that same town.

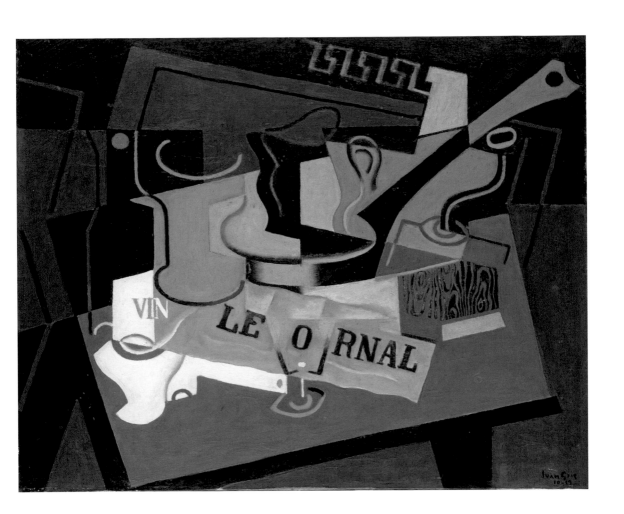

FERNAND LÉGER (1881–1955)

Nature morte (Still Life), 1919
Oil on canvas, 25 ⅜ x 19 ⅛ in. (64.5 x 48.5 cm)
Signed and dated: "F. LEGER / 19" (lower right corner)
P137

PROVENANCE
Oslo, Ragnar Moltzau Collection; London, Marlborough Fine Art, Ltd., 1959; New York, Sidney Janis
Gallery, 1959; Dallas, James H. and Lillian B. Clark Collection; Dallas, Museum of Art, on deposit from
February 1985 to July 1990; New York, Christie's

BIBLIOGRAPHY
Bauquier and Maillard 1990, pp. 322–23, no. 183; Ros de Barbero 2014, pp. 120 (ill.) and 208

EXHIBITIONS
Stockholm 1954, no. 185; Zurich and traveling 1957, no. 38 (Zurich), no. 39 (The Hague) and no. 40
(Edinburgh and London); New York 1959, no. 4; New York 1960–61, no. 4; Basel 1964, no. 13;
Houston 1978, no. 7; Paris-New York 1984–85, no. 8; Santander 1992, pp. 22–23; Madrid 2014–15, no. 110

In 1918, Fernand Léger signed a contract with art dealer Léonce Rosenberg and in February
of the following year, he presented his first important individual exhibition at the Galerie de
l'Effort Moderne, the showroom Rosenberg ran at number 19, rue de la Baume in Paris. The
Great War had just ended and Léger, who had been mobilized, was back.

Particularly curious and interested in the spectacular technological advances that
followed that war, and in the beginnings of "modern life," this artist had himself expressed
his predilection for forms imposed by industry. Therefore, having already experienced
the influence of impressionism and the painting of Paul Cézanne (1839–1906), as well
as the first cubist works of Pablo Picasso (1881–1973) and Georges Braque (1882–1963),
Léger began making works representative of that new era, including the present still life.

Line and shapes play the leading role in this work, bearing out this extraordinary
draftsman's opinion that when the drawing is finished, three quarters of the canvas are
completed.

The artist uses shading to generate relief, which he reinforces by setting the elements
against a background of geometric shapes. Léger hated discrete painting; for him, a painting
should take charge of the wall on which it hangs. Here, in his own style, he has generated a
powerful painting that uses shapes inspired by industry, concentrating on aluminum and its
attractive reflections.

151

74

MARÍA BLANCHARD (1881–1932)

Naturaleza muerta (Still Life), 1917–18
Oil on canvas, 28 ¾ x 23 ⅝ in. (73 x 60 cm)
Signed: "M BLANCHARD" (lower right corner)
P11

PROVENANCE
France, private collection; Versailles, Palais des Congrès, auctioned by P. and J. Martin, lot no. 422;
Madrid, Galería Gavar

BIBLIOGRAPHY
Campoy 1980, p. 87; Caffin-Madaule 1992–94, vol. 1 (1992), p. 226; Salazar 2004, no. 76; Ros de Barbero
2014, pp. 121 (ill.) and 209

EXHIBITIONS
Madrid 1980–81; Zaragoza 1981, p. 54 (ill.); Madrid 1982b, no. 44, p. 141; Santander 1992, pp. 16–17;
Santander-Madrid 2012–13, p. 159 (ill.); Madrid 2014–15, no. 111

75

BENJAMÍN PALENCIA (1894–1980)

Bodegón cubista (*Cubist Still Life*), 1923
Oil on canvas, 20 ⅞ x 28 ⅜ in. (53 x 72 cm)
Signed and dated: "Benjamín Palencia / -23-" (upper left corner)
P19

PROVENANCE
Barcelona, Galería Ignacio de Lassaletta

BIBLIOGRAPHY
Ros de Barbero 2014, pp. 122 (ill.) and 209

EXHIBITIONS
Santander 1992, pp. 26–27; Valencia and traveling 1994–95, no. 7; Madrid 1996–97, p. 129; Madrid 1998, no. 62; Murcia-Alicante-Madrid 2007, no. 44; Madrid-Seville 2009–10, p. 265; Madrid 2014–15, no. 112

PABLO PICASSO (1881–1973)

Nu assis (*Seated Nude*), winter 1922–23
Oil and charcoal on canvas, 51 ¼ x 38 ¼ in. (130 x 97 cm)
P66

PROVENANCE
Mougins, Pablo Picasso Collection; Picasso legacy (no. 12354); Paris, Maya Widmaier Collection;
Basel, Galerie Beyeler

BIBLIOGRAPHY
Zervos 1951, no. 454, p. 191 (ill.); Duncan 1961, p. 241 (ill.); Giménez 2012, no. 17 (ill.); Ros de Barbero 2014,
pp. 123 (ill.) and 209

EXHIBITIONS
Santander 1992, pp. 24–25; Málaga 1992–93, no. 41; Madrid 1995–96b, no. 1; Venice 1998; New York-Houston
2012–13, no. 17 (ill.); Madrid 2014–15, no. 113

Like *Baigneuses* (Bathers), a drawing from 1920 that is also in the Abelló Collection [pen and black ink on paper, 10 ¾ x 10 ¼ in. (273 x 260 mm)], this painting from the winter of 1922–23 was made during Pablo Picasso's return to classicism following his direct contact with the art of Antiquity. In 1917 he traveled to Rome, Pompeii, Naples and Florence with Serge Diaghilev's (1872–1929) Ballets Russes, for which he made costumes and sets. A year later, in 1918, he married Olga Koklova (1891–1954), a Russian ballerina with whom he fell in love on that trip.

In fact, classicism had accompanied Picasso on and off since his first works, with longer or shorter gaps that included his cubist period. Francisco Calvo Serraller has even considered this artist biographically oriented toward classicism, among other reasons, because he had grown up in Mediterranean cities such as Málaga and Barcelona and was the son of an academic painter.[1] To counterbalance this tendency, Calvo Serraller adds that he belonged to the Spanish school, which was traditionally anticlassicist, and that he began his artistic career in Barcelona in a cultural setting dominated by southern neo-romantic symbolism.

Both the forms and iconography of this *Nu assis* correspond perfectly to his return to classicism as representations of *Venus at her Toilette* or *Venus before the Mirror*. The figure is bare-chested here, but her legs are covered by a white cloth and her hands hide the most feminine part of her body, like a chaste Aphrodite.

With antecedents in the work of Giovanni Bellini (*ca.* 1433–1516)—*Young Woman with a Mirror*, 1515, Kunsthistorisches Museum, Vienna, GG 97—and Titian (*ca.* 1489–1576)—*Young Venus with a Mirror, ca.* 1555, National Gallery, Washington D. C., 1937.1.34—this subject was addressed by other great painters as well, including Peter Paul Rubens (1577–1640) and Diego Velázquez (1599–1660). The nude figure contemplates herself in the mirror, which reflects her face, offering two versions of the model from different angles, almost like a sculpture. Equally sculptural is the woman's nude body. Monumental and solid, her appearance speaks more of stone than of flesh.

Besides the contemplation of beauty, this image depicts intimacy and serenity. The pleasure of one's own beauty has faded, leaving what may be a melancholy awareness of passing time, as in a moral allegory.

This interesting work's perfect state of conservation allows us to observe the confident linear charcoal lines that define the figure's profile. Its volume is modeled with thick impastos of white oil paint in what is practically a monochromatic palette.

1 Francisco Calvo Serraller in *Picasso clásico* 1992, pp. 49–50.

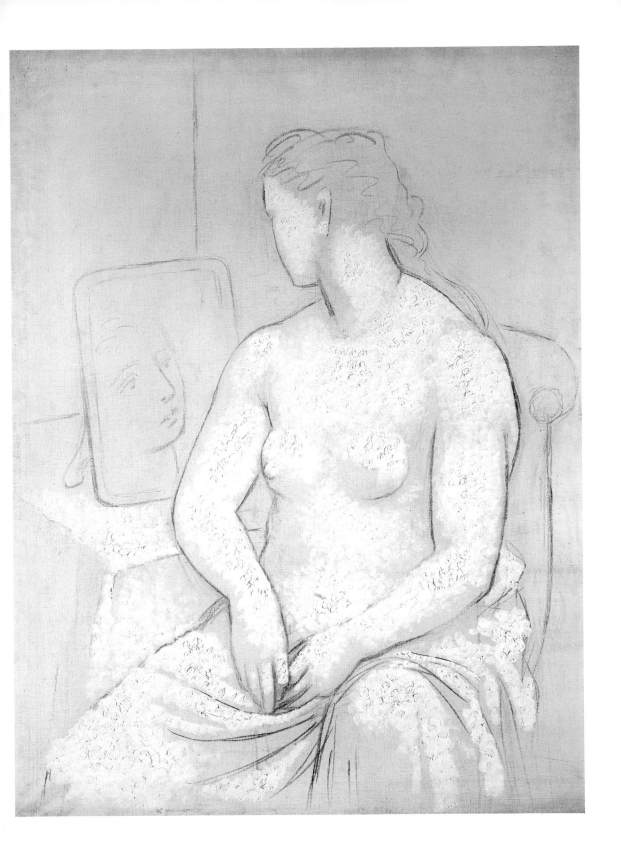

PABLO PICASSO (1881–1973)

Buste (*Bust*), June 30, 1971
Oil on canvas, 36 ¼ x 28 ¾ in. (92 x 73 cm)
P1

PROVENANCE
Picasso legacy, 1973 (no. 13746); Bernard Ruiz Picasso Collection; Paris, Galerie Claude Bernard, 1981; Barcelona, Ibetsa, 1981; Barcelona, Galería Trece

BIBLIOGRAPHY
Zervos 1978, p. 28, no. 81; Ros de Barbero 2014, pp. 125 (ill.) and 210

EXHIBITIONS
Avignon 1973, no. 67; Paris 1980, no. 46; Santander 1992, pp. 46–47; Madrid 1993b, pp. 206–7 (ill.); Madrid 2014–15, no. 115

In 1971, Pablo Picasso celebrated his ninetieth birthday. Since June 1961, he had spent most of his time at Notre-Dame-de-Vie, the villa near Mougins in the mountains by Cannes that became his last residence. There, he lived with his wife, Jacqueline Roque (1927–1986), whom he had married in 1961. Already a legendary figure, Picasso became the first living painter to exhibit at the Musée du Louvre in Paris, in a show inaugurated by President Georges Pompidou in October 1971.

At that point in his life, this artist who had invented many of the formal media of the art of his time continued to work prolifically. That production reveals a will to survive as well as a formidable vitality, and what we first notice in this late work is the great force with which it is painted.

The face of the man depicted here with a hat occupies practically the entire canvas, giving it a certain monumentality. The subject of the painting has not been identified, but Picasso himself said that when he painted a male figure he always had his father in mind, "which is why [his] men are so frequently bearded."[1] Broken into cubist facets, the face offers both a frontal and a profile view. The painter eschews intermediate tones in favor of very marked black lines that delimit the grayish whites, the green background and the touches of yellow.

John Richardson stressed Picasso's admiration of Vincent van Gogh (1853–1890), whom he called his "patron saint." And while the Dutch painter's influence is not evident in Picasso's style or compositions, it runs deep in his work from the very start, emerging in a clearer way in late paintings such as this one.[2] Here, the freedom and plasticity in Picasso's use of paint recall Vincent van Gogh's work, allowing us to relate it to the latter's self-portrait with a straw hat from 1887 (Detroit Institute of Arts, 22.13).

1 Javier Barón in *Picasso, tradición y vanguardia* 2006, p. 343.
2 John Richardson in *Late Picasso* 1988, p. 32.

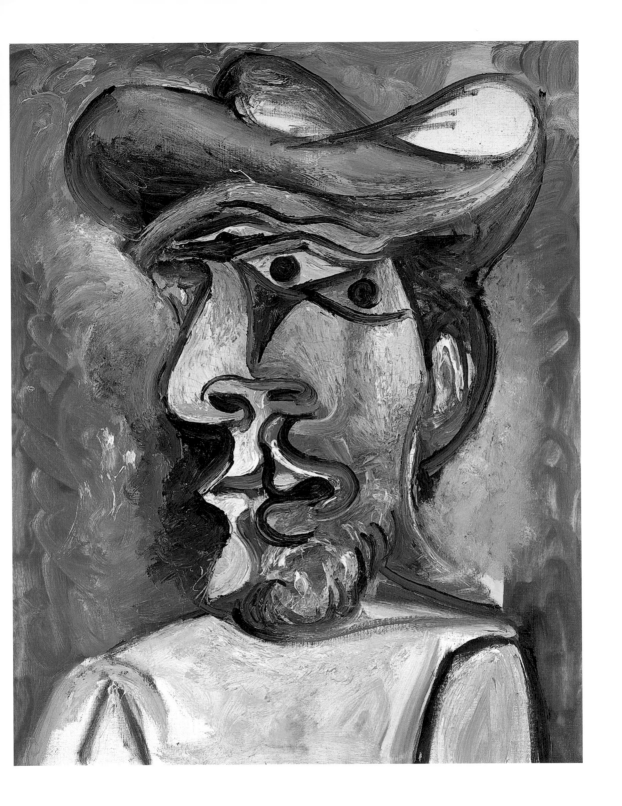

78

PABLO PICASSO (1881–1973)

Danseuses et profil (*Dancers and Profile*), 1902
Colored crayons on paper, 4 ¾ x 6 ⅛ in. (120 x 155 mm)
Signed: "–P ruiz Picasso–" (lower right corner)
Verso, charcoal drawing of the same subject
D394

PROVENANCE
Paris, Galerie E. Sassi; London, Christie's

BIBLIOGRAPHY
Ros de Barbero 2014, pp. 132 (ill.) and 213

EXHIBITIONS
Santander 1994, p. 39; Madrid 2007–8a, pp. 72 and 133; Málaga 2008,
pp. 118–19; Valencia 2009b, p. 80; Madrid 2014–15, no. 124

79

PABLO PICASSO (1881–1973)

Femme nue (Female Nude), ca. 1903
Pen and ink and colored pencil on card, 5 ¼ x 3 ½ in. (133 x 89 mm)
Inscription: "Picasso" (upper left corner)
D681

PROVENANCE
Boris Yaffe Collection, 1950s; New York, Sotheby's

BIBLIOGRAPHY
Ros de Barbero 2014, pp. 133 (ill.) and 213

EXHIBITIONS
La Coruña 2002–3, no. 132; Madrid 2007–8a, pp. 73 and 133; Málaga 2008,
pp. 124–25; Valencia 2009b, p. 81; Madrid 2014–15, no. 126

80

PABLO PICASSO (1881–1973)

Jeune saltimbanque (*Young Acrobat*), 1905
Pen and ink and red crayon on paper, 6 ⅜ x 4 ⅜ in. (161 x 110 mm)
Signed: "–Picasso–" (upper left corner)
D2301

PROVENANCE
Paris, Galerie M. Rousso; Monsieur et Madame François Collection, February 7, 1950;
London, Christie's

BIBLIOGRAPHY
Ros de Barbero 2014, pp. 133 (ill.) and 213

EXHIBITIONS
Geneva 1999–2000, p. 58 (ill.) and p. 183; Madrid 2014–15, no. 125

81

PABLO PICASSO (1881–1973)

La coiffure (*The Hairdo*), 1906
Pen and India ink on paper, 12 ¼ x 9 ¼ in. (313 x 235 mm)
D2356

PROVENANCE
Berlin, Willy Hahn Collection; Hessen, private collection

BIBLIOGRAPHY
Zervos 1970, no. 436; Ros de Barbero 2014, pp. 134 (ill.) and 213

EXHIBITIONS
Madrid 2014–15, no. 127

82

PABLO PICASSO (1881–1973)

Mandoline (*Mandolin*), *ca.* 1911
Wash on paper, 9 ½ x 12 ⅜ in. (240 x 315 mm)
Inscription: "Picasso" (verso)
D448

PROVENANCE
Paris, Galerie Simon (Louise Leiris); New York, Buchholz Gallery (Curt Valentin);
Washington D. C., Mr. and Mrs. Oscar Cox Collection; London, Christie's

BIBLIOGRAPHY
Zervos 1954, p. 135 (ill.), no. 1124; Ros de Barbero 2014, pp. 135 (ill.) and 214, no. 131

EXHIBITIONS
Santander 1994, p. 40; Las Palmas-Oviedo 2000, pp. 56–57; Madrid 2007–8a, pp. 74 and 133;
Málaga 2008, pp. 130–31; Valencia 2009b, p. 82; Madrid 2014–15, no. 131

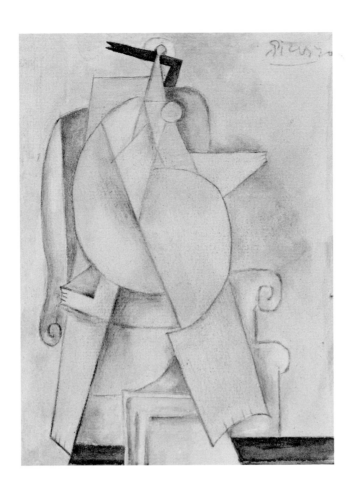

83

PABLO PICASSO (1881–1973)

Personaje cubista (*Cubist Figure*), ca. 1914–15
Watercolor and pencil on paper, 6 ⅛ x 4 ⅜ in. (155 x 110 mm)
Signed: "Picasso" (upper right corner)
D423

PROVENANCE
Paris, Paul Guillaume, June 1919; Oslo, Walter Halvorsen; London, Christie's

BIBLIOGRAPHY
Ros de Barbero 2014, pp. 135 (ill.) and 214

EXHIBITIONS
Santander 1994, p. 41; Las Palmas-Oviedo 2000, pp. 58–59; Madrid 2007–8a, pp. 75 and 133;
Málaga 2008, pp. 132–33; Valencia 2009b, p. 83; Madrid 2014–15, no. 129

84

PABLO PICASSO (1881–1973)

Self-portrait, 1915
Pen and ink on buff envelope, 5 ⅞ x 4 ⅜ in. (150 x 110 mm)
Signed: "Picasso" (upper right corner)
D1053

PROVENANCE
Paris, gift of the artist to Gaby Depeyre; Paris, Galerie Heinz Berggruen; Toronto, Dunkelman Gallery
(no. 155002); Basel, Galerie Beyeler (no. 5501); Barcelona, Sala Gaspar; private collection; London,
Christie's

BIBLIOGRAPHY
Palau i Fabre 1970, p. 153; Zervos 1975, p. 72 (ill.), no. 163; Warncke and Walther 1992, p. 691 (ill.);
Richardson 1996, p. 367 (ill.); Ros de Barbero 2014, pp. 134 (ill.) and 214

EXHIBITIONS
Frankfurt 1965, no. 54; Basel 1971–72, no. 13; Buenos Aires 2006, pp. 34–35 (ill.); Madrid 2007–8a,
pp. 76–77 and 133; Málaga 2008, pp. 114–15; Valencia 2009b, pp. 84–85; Madrid 2014–15, no. 128

RENOIR PICASSO PICASSO PICASSO RENOIR

ZIEM

MODIGLIANI DERAIN DERAIN DERAIN MODIGLIANI

85

PABLO PICASSO (1881–1973)

11 Miniature Drawings, 1916, after:
Pierre-Auguste Renoir, *Femme à sa toilette (Woman at her Toilet)*
Pablo Picasso, *L'Arlequin (Harlequin)*
Pablo Picasso, *Nature morte (Still Life)*
Pablo Picasso, *Autoportrait (Self-portrait)*
Pierre-Auguste Renoir, *Femme se lavant les pieds (Woman Washing her Feet)*
Félix Ziem, *Vue de Venise (A View of Venice)*
Amedeo Modigliani, *Tête d'homme (Head of a Man)*
André Derain, *Paysage de l'Estaque (Landscape at L'Estaque)*
André Derain, *Nature morte (Still Life)*
André Derain, *Paysage du Midi (Landscape of the Midi)*
Amedeo Modigliani, *Femme assise (Seated Woman)*
Pencil on wooden matchboxes, 2 ¼ x 1 ½ in. (57 x 37 mm approx.) ea.
D1861

PROVENANCE
Paris, private collection; given to another collector, 1981; London, Christie's

EXHIBITIONS
Málaga 2008, pp. 112–13

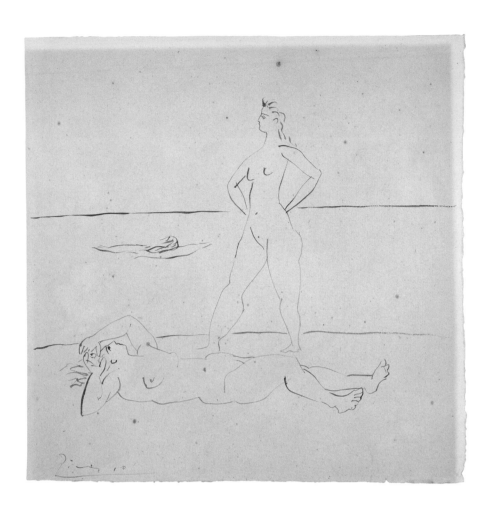

86

PABLO PICASSO (1881–1973)

Baigneuses (*Bathers*), 1920
Pen and black ink on paper, 10 ¾ x 10 ¼ in. (273 x 260 mm)
Signed: "Picasso" (lower left corner)
D396

PROVENANCE
Paris, Galerie Simon; New York, Buchholz Gallery; New York, Karl Nathan; New York,
Margaret Bresch; London, Christie's

BIBLIOGRAPHY
Zervos 1954, p. 162 (ill.), no. 1365; Ros de Barbero 2014, pp. 136 (ill.) and 214

EXHIBITIONS
Málaga 1992–93, no. 18; Santander 1994, p. 43; Las Palmas-Oviedo 2000, pp. 70–71; Segovia 2000–1,
no. 38; Madrid 2007–8a, pp. 78–79 and 133; Málaga 2008, pp. 116–17; Valencia 2009b, pp. 86–87;
Madrid 2014–15, no. 132

87

PABLO PICASSO (1881–1973)

De la guerre au Sénat (*From War to the Senate*), 1921
Collage, wash and ink on cardboard, 15 ³⁄₈ x 11 ³⁄₈ in. (390 x 290 mm)
Signed and dedicated: "Picasso / à / Jean Cocteau" (bottom center)
D290

PROVENANCE
Paris, Jean Cocteau Collection; Édouard Dermit; New York, Sotheby's

BIBLIOGRAPHY
Zervos 1951, p. 191 (ill.), no. 454; Duncan 1961, p. 241 (ill.); Ros de Barbero 2014,
pp. 135 (ill.) and 214

EXHIBITIONS
Las Palmas-Oviedo 2000, pp. 78–79; Madrid 2002a, p. 136; Madrid 2007–8a, pp. 80–81
and 133; Málaga 2008, pp. 120–21; Valencia 2009b, pp. 88–89; Madrid 2014–15, no. 130

PABLO PICASSO (1881–1973)

Têtes de chevaux (*Horse Heads*), December 5, 1933
India ink and pencil on paper, 16 x 20 in. (406 x 507 mm)
Signed: "Picasso" (upper left corner)
Dated: "5 decembre / XXXIII" (lower left corner)
Inscription: "Mr Maupoil / A decouper / et fixer sur papier blanc" (verso)
D1306

PROVENANCE
Paris, Galerie Louise Leiris; London, Sotheby's, December 1, 1965; private collection; London, Christie's

BIBLIOGRAPHY
Ros de Barbero 2014, pp. 137 (ill.) and 215

EXHIBITIONS
Buenos Aires 2006, p. 37; Madrid 2007–8a, pp. 82 and 134; Málaga 2008, pp. 136–37; Valencia 2009b, p. 90; Málaga 2010, pp. 136–37; Madrid 2014–15, no. 134

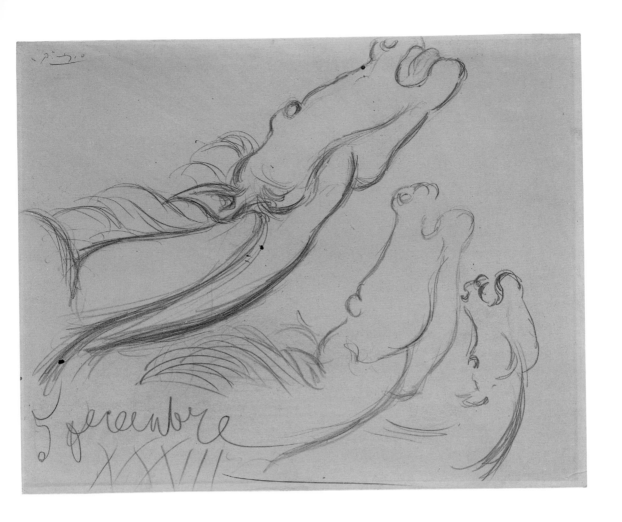

5 decembre
XXXIII

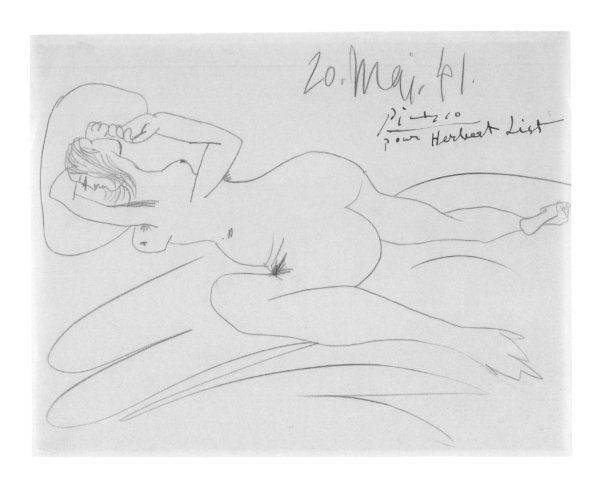

89

PABLO PICASSO (1881–1973)

La Jeune Fille qui ne dort pas (*The Young Woman Who Doesn't Sleep*), May 20, 1941
Pencil on paper, 8 ¼ x 10 ½ in. (210 x 267 mm)
Signed, dated and dedicated: "20.Mai.41. / Picasso / pour Herbert List"
(upper right corner)
D1054

PROVENANCE
Gift from the painter to Herbert List, 1944; Herbert List Collection; London, Christie's

BIBLIOGRAPHY
Zervos 1960, p. 56 (ill.), no. 142; Ros de Barbero 2014, pp. 136 (ill.) and 214

EXHIBITIONS
Buenos Aires 2006; Madrid 2007–8a, pp. 83 and 134; Málaga 2008, pp. 126–27;
Valencia 2009b, p. 91; Madrid 2014–15, no. 133

90

PABLO PICASSO (1881–1973)

Bullfighting Scene, February 25, 1960
Preparatory drawing to illustrate Luis Miguel Dominguín's book,
Toros y toreros (Paris, 1961)
Brush and black ink on paper, 7 ⅛ x 9 ½ in. (182 x 242 mm)
Signed: "Picasso" (upper left corner)
Dated: "25. / 2. / 60. / V" (lower left corner)
D294

PROVENANCE
London, Christie's

BIBLIOGRAPHY
Sabartés 1961, no. 34, pl. 34; Zervos 1968, no. 187, pl. 50; Ros de Barbero 2014, pp. 137 (ill.) and 215

EXHIBITIONS
Salamanca 1999; Las Palmas-Oviedo 2000, pp. 106–7; Madrid 2007–8a, pp. 84–85 and 134;
Málaga 2008, pp. 134–35; Valencia 2009b, pp. 92–93; Madrid 2014–15, no. 135

HENRI MATISSE (1869–1954)

Liseuse accoudée à une table, devant une tenture relevée
(*Reader Leaning on a Table in front of a Gathered Curtain*), 1923–24
Oil on canvas, 23 ⅝ x 19 ¼ in. (60 x 49 cm)
Signed: "henri matisse" (lower left corner)
P68

PROVENANCE
Paris, Galerie Bernheim-Jeune; Paris, Paul Rosenberg Collection; Paris, Coutot Collection; New York, Ganowitz Collection; A. Bellanger Collection, 1938; London, Alex Reid & Lefevre Ltd.; New York, Kraushaar Gallery; New York, Edwin C. Vogel Collection; New York, Sam Salz Collection; Henry Ford II Collection, March 14, 1957; New York, Acquavella Galleries

BIBLIOGRAPHY
Ros de Barbero 2014, pp. 126 (ill.) and 211

EXHIBITIONS
Paris 1924, no. 36; Oslo-Copenhagen-Stockholm 1938, no. 9; Washington 1986–87, no. 138; Santander 1992, pp. 28–29; Madrid 2009b; Madrid 2014–15, no. 116

In the early 1920s, Henri Matisse settled at 1, Place Charles Felix, near, Place Charles Felix, near the Cours Saleya Market in the city of Nice. There, he rented a third-floor space where he painted this work. In fact, the domestic interior depicted here corresponds to that apartment, which was decorated with bright wallpaper, carpets and textiles.

A woman reads at a table in the center of the room. The space, which leads into the following room, is bathed in the abundant light that enters from the large window on the left. Windows are a recurrent theme in Matisse's work; indeed, another appears in the background, visible because the curtain that separates the two rooms has been gathered, endowing the composition with a sense of depth and perspective.

In this canvas, spaces and defined volumes have not disappeared and the accumulated decorative elements play a major role. The painting is fluid and the palette extremely varied, revealing Matisse's search for a balance of colors and shapes. During his stay in Nice, Matisse painted numerous indoor scenes with female figures, including his famous *Odalisques*.

For this artist, creation began with vision. He considered seeing a creative act unto itself because it demanded effort. In his opinion one should always view life with a child's eye in order to depict it in an original way. Those words speak directly to the present work: Matisse paints the woman reading because he sees her in front of him. His practically childlike style in this colorist and personal work stems from his manner of exercising his creativity from the moment he first sees her.

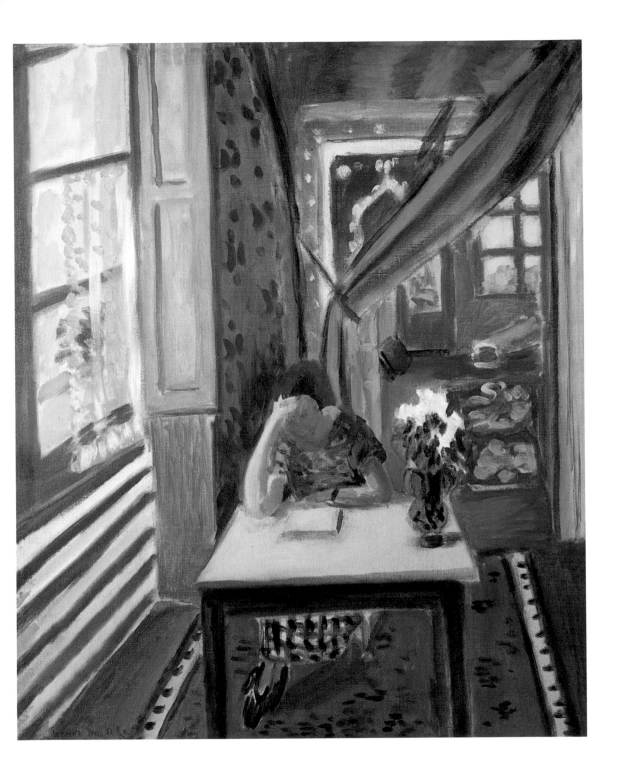

EDVARD MUNCH (1863–1944)

Johan Martin og Sten Stenersen (*Johan Martin and Sten Stenersen*), 1935
Oil and wax crayons on paper mounted on canvas, 30 ¼ x 17 ⅜ in. (770 x 440 mm)
Signed: "E. Munch" (upper right corner)
D1628

PROVENANCE
Rolf Stenersen Collection (purchased directly from the artist); Sten Stenersen Collection;
London, Sotheby's

BIBLIOGRAPHY
Stenersen 2001; Jensen 2003; Wandrup 2003; Ros de Barbero 2014, pp. 145 (ill.) and 217

EXHIBITIONS
Oslo-Kragerø-Stavanger 1936, no. 34; Amsterdam 1937, no. 65; Stockholm 1937, no. 64; Copenhagen-
Stockholm 1946–47, no. 46 (Copenhagen), no. 43 (Stockholm); Oslo 1948, no. 77; Oslo 1994, no. 146;
Oslo 2003–4; Madrid 2007–8a, pp. 116–17 and 135; Dallas 2008, p. 50; Valencia 2009b, pp. 132–33;
Madrid 2014–15, no. 147

SALVADOR DALÍ (1904–1989)

Rostro invisible / Ruinas con cabeza de Medusa y paisaje
(*Invisible Face / Ruins with Medusa's Head and Landscape*), 1942
Oil on canvas, 15 x 9 ⅝ in. (38 x 24.5 cm)
Signed, dated and dedicated: "Pour Mrs. CHASE / affectuesement Gala (?)
Salvador Dalí / 1942" (lower left corner)
P24

PROVENANCE
Madrid, Galería Trece

BIBLIOGRAPHY
Dalí and Pla 1981, p. 151 (ill.); Descharnes 1984, p. 271 (ill.); Brunius 1989, p. 18 (ill.); Kolberg 2006;
Ros de Barbero 2014, pp. 128 (ill.) and 211–12

EXHIBITIONS
Stuttgart-Zurich 1989, no. 222; Humlebæk 1989–90, no. 42, p. 18; Montreal 1990, no. 59; Santander
1992, pp. 38–39; Los Angeles-Montreal-Berlin 1997–98, no. 27, p. 153, fig. 132; Segovia 2001–2,
no. 21; Venice-Philadelphia 2004–5, no. 199; Madrid 2014–15, no. 118

This work was a gift from Salvador Dalí to Mrs. Edna Woolman Chase (1877–1957), who
became editor-in-chief of *Vogue* magazine in 1914 and turned it into the uncontested
leader among fashion magazines and the publishing phenomenon we know today.
It was her idea to set in motion collaborations between the worlds of contemporary
art and fashion, an enterprise in which Dalí himself participated, with spectacular
surrealist photographs for some issues and even a cover design for the April 1,
1944 issue. In 1942, Dalí gave Chase this work, barely a year after the retrospective
exhibition Dalí shared with Miró at New York's Museum of Modern Art, a show that
eventually traveled to eight cities in the United States.

As almost always with Dalí, the terrain plays an important role. Here it is the
plains of the Ampurdán in northern Catalonia under clear skies. This background
is "masked" by the face-shaped ruin in the foreground. It is as though two different
paintings had been overlapped. Dalí plays with the images suggesting others that are
not immediately visible but emerge after careful viewing. Here, ruins become a face.

Dalí's two favorite colors are in evidence here: Naples yellow in the earth and the
ruin's brickwork and blue in the sky. In the composition, one's eye is drawn to
the head of Medusa and to the crutch that holds up the ruin. The first is an element
of Classical mythology, which was a source of inspiration to Dalí throughout his
career. The crutch is omnipresent in his oeuvre, constituting one of his most
recurrent fantasies as a symbol of death and resurrection. In his biography, Dalí
himself wrote it would take "quantities of crutches to give a semblance of solidity to
all that."[1] Thus, the crutch appears here in place of a column.

This optical illusion, which includes tiny people sketched silhouette-like with
wavy lines, is a highly imaginative dream image constructed with elements of reality
barring the head of Medusa, which is the only truly fantastic motif in the work.

1 Dalí 1993, p. 261.

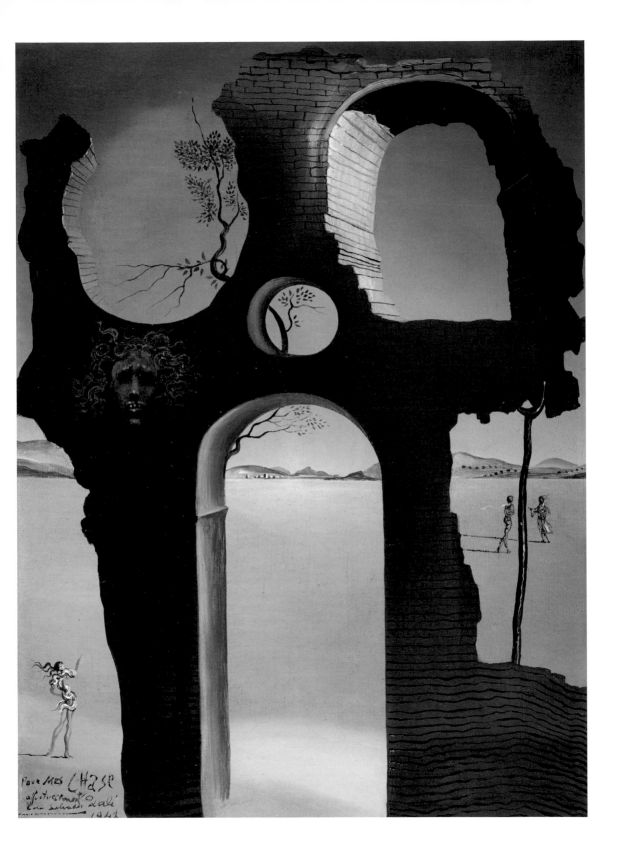

SALVADOR DALÍ (1904–1989)

Portrait of the Artist's Father and Sister, 1925
Graphite and ink on medium-weight transverse-laid paper,
no watermark, 19 ⅝ x 13 in. (500 x 330 mm)
Signed and dated: "Salvador Dalí / 1925" (lower right corner)
D442

PROVENANCE
Monserrat Dalí de Bas Collection, 1976; Madrid, Edmund Peel-Sotheby's

BIBLIOGRAPHY
Gaya Nuño 1950, pl. 42; Larco 1964, vol. III, pl. 372; Descharnes 1976, p. 54, fig. 57; Descharnes 1984,
p. 51 (ill.); Romero 2003, p. 33 (ill.); Meisler 2005, p. 75 (ill.); Ros de Barbero 2014, pp. 139 (ill.) and 215

EXHIBITIONS
Barcelona 1925; Tokyo-Nagoya-Kyoto 1964; Rotterdam 1970–71, no. 89; Madrid-Barcelona 1983,
pp. 62–63, no. 97; Madrid 1989a, pp. 24–25; London 1990; Santander 1994, p. 47; Madrid-Barcelona
1994–95, no. 98, p. 170; Basel 1996, no. 32, pp. 213 and 461; Vigo 1996–97, p. 31; Las Palmas-Oviedo 2000,
pp. 82–83; Madrid 2001–2a, no. 46, p. 133; Venice-Philadelphia 2004–5, no. 39; Madrid 2007–8a,
pp. 112–13; Dallas 2008, pp. 93–94; Valencia 2009b, pp. 128–29; Madrid 2014–15, no. 138

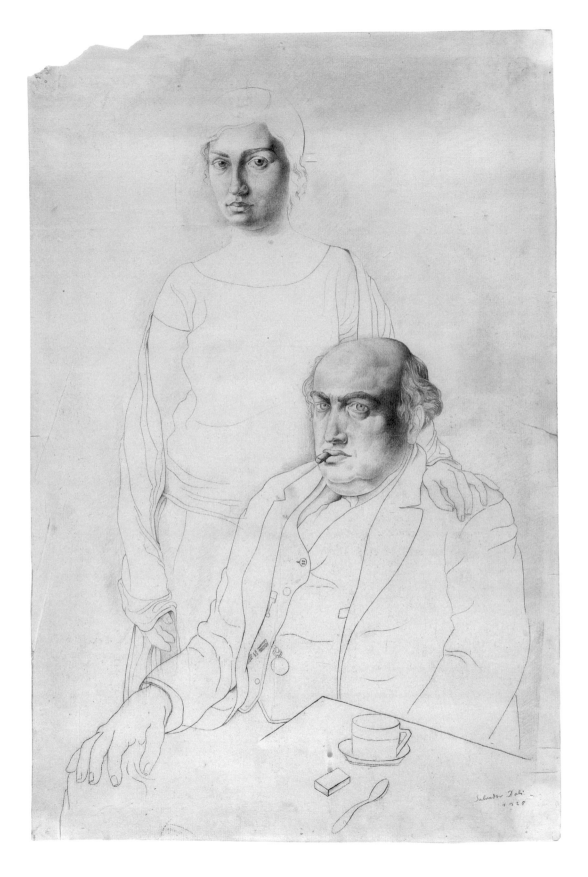

MARC CHAGALL (1887–1985)

Maternité a la chevre d'or (*Maternity with Golden Goat*), 1954–63
Oil on canvas, 28 ¾ x 21 ¼ in. (73 x 54 cm)
Signed: "Marc chagall" (lower right corner)
P42

PROVENANCE
Paris, Adrien Maeght Collection; private collection; Barcelona, Xavier Vila

BIBLIOGRAPHY
Ros de Barbero 2014, pp. 129 (ill.) and 212

EXHIBITIONS
Santander 1992, pp. 44–45; Madrid 2014–15, no. 119

A Russian painter, Marc Chagall lived in Vence from 1950 through 1966, when he moved to the neighboring village of Saint-Paul de Vence. The town visible on the horizon recalls the latter, with its square church tower and fortified walls. An enigmatic woman holding a child in her arms seems to be floating in the sky over the village, seated on a golden goat. Below, a man rests under what may be an olive tree.

As Chagall wanted his figures to be interpreted freely, we have turned to Classical mythology to identify the child as a young Zeus in the arms of the nymph that protected him from the fury of his father, Chronos. The goat could be Amaltea, also known as Aix, who nursed him. Her descent from the Sun would explain her golden color here, and the presence of that star in the sky. According to that same mythology, this animal lived in a cave in Crete. When she died, she became the constellation Capricorn. Perhaps that is why she appears in mid-air over Saint-Paul de Vence.

A gifted colorist influenced by Byzantine art and Russian icons, Chagall was famous for transforming the visible world into lyrical and colorful paintings such as this one.

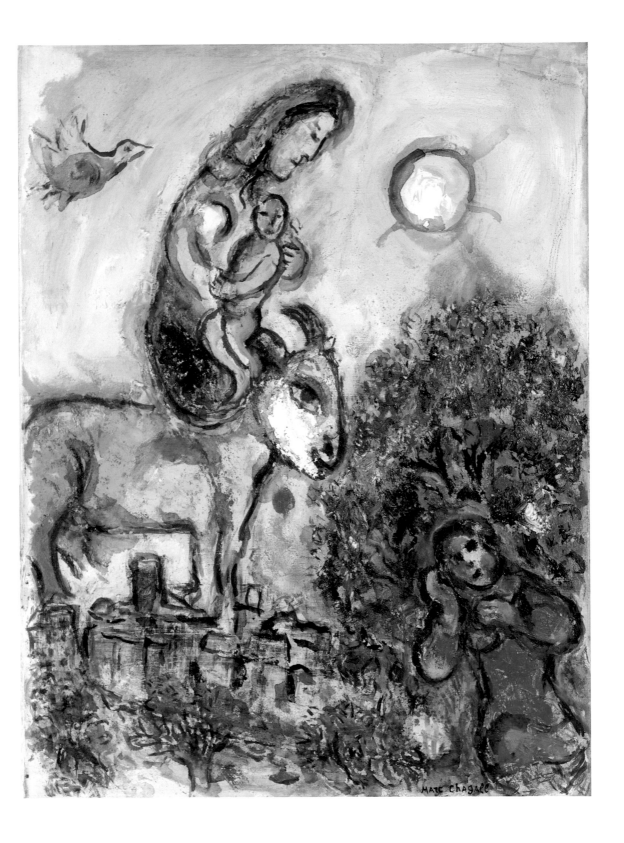

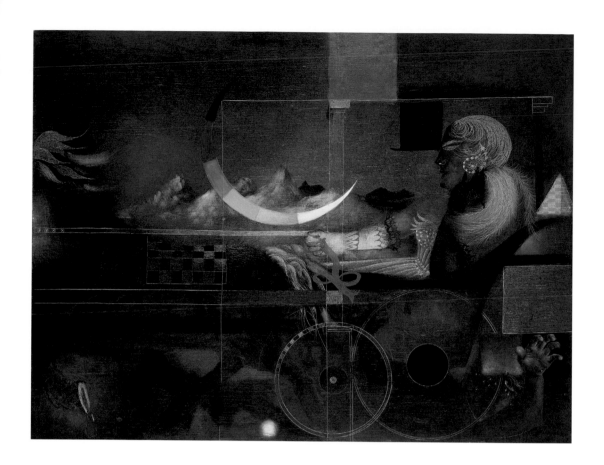

96

ANTONI TÀPIES (1923–2012)

El accidente (*The Accident*), 1951
Oil on canvas, 35 ¼ x 45 ¾ in. (89.5 x 116 cm)
Signed: "Tàpies" (verso)
P1526

PROVENANCE
Barcelona, Sala Gaspar; Ohio, Mr. and Mrs. Frank H. Porter
Trust Estate Collection; London, Christie's; Spain, private collection;
London, Christie's

BIBLIOGRAPHY
Agustí 1988, p. 162, no. 360

EXHIBITIONS
Venice 1952; Chicago 1953, no. 9

97

ANTONIO LÓPEZ GARCÍA (1936)

Bodegón de la pistola (*Still Life with Pistol*), 1959
Oil on panel, 27 x 39 in. (68.5 x 99 cm)
Signed and dated: "Antonio López García. Año 1959"
(upper left corner)
P46

PROVENANCE
Madrid, Galería El Coleccionista

BIBLIOGRAPHY
Javier Viar in *Antonio López* 2011, pp. 68–69, fig. 14

EXHIBITIONS
Madrid 1993a, no. 30; Madrid-Bilbao 2011–12

98

JOAN MIRÓ (1893–1983)

Homenaje a Picasso (*Homage to Picasso*), December 1971
India ink and pencil on fine cloth, 38 ¼ x 24 in. (970 x 610 mm)
Signed: "Miró" (lower right corner)
Signed, dated and dedicated: "Amb an gran / abrac a PABLO /
PICASSO. / XII / 71 / Miró" (verso)
P57

PROVENANCE
Madrid, Galería Sen

BIBLIOGRAPHY
Ros de Barbero 2014, pp. 149 (ill.) and 218

EXHIBITIONS
Madrid 2007–8a, pp. 109 and 135; Dallas 2008, p. 83; Valencia 2009b, p. 125; Madrid 2014–15, no. 152

99

MANUEL RIVERA (1928–1995)

Espejo naciendo IV (Birth of a Mirror IV), 1974
Mixed media on wood, 51 ¼ x 35 in. (130 x 89 cm)
Signed: "–M. Rivera–" (lower center)
P13

PROVENANCE
Madrid, Galería Juana Mordó

BIBLIOGRAPHY
García Viñolas 1976, n.p. (ill.); Logroño 1976, n.p. (ill.); Marisa Rivera in Manuel Rivera 1997,
p. 196; Torre 2009, p. 347 (ill.), no. [582] p-74-9; Ros de Barbero 2014, pp. 151 (ill.) and 218

EXHIBITIONS
Madrid 1975–76; Paris 1976, no. 44; Madrid 1981, p. 121; Madrid 2014–15, no. 155

MIQUEL BARCELÓ (1957)

536 Kilos, 1990
Mixed media on canvas, 64 ⅝ x 53 ⅛ in. (164 x 135 cm)
P143

PROVENANCE
St. Moritz, Galerie Bruno Bischofberger

EXHIBITIONS
Santander 1992, pp. 56–57; Barcelona 1998, p. 111; Salamanca 1999; Saint-Paul de Vence 2002;
Toledo 2003

In 1990 Miquel Barceló began to make a series of paintings on the subject of bullfighting.
They are some of his finest works, and the present canvas is one of them. It was made
in Mallorca in the summer of 1990. Barceló was attracted to bullfighting from an early
age. The image of the bullring is ever present in his memory, and he has linked it to the
Mediterranean Sea and even to the dome of the United Nations building, his most recent
major work, which he defined as "a bullring upside down." He has also created various
bullfighting posters for the bullrings of Nîmes (1988), Ronda (2003), Céret (2004),
La Monumental in Barcelona (2007) and *La Maestranza* in Seville (2008).

This work is characterized by an abundance of paint that runs off the sides of the canvas,
giving it a special texture. With his original and personal technique, Barceló imbues
the image of the bull entering the bullring with a power and potency that are further
reinforced by the title, *563 Kilos*. The bullring becomes a whirlpool that spins at the same
time as the moving bull.

PABLO PALAZUELO (1916–2007)

De Somnis LXII, 2000
Oil on canvas, 94 ½ x 61 ⅞ in. (240 x 157 cm)
Initialed: "P" (lower right corner)
P371

PROVENANCE
Madrid, Galería Soledad Lorenzo

BIBLIOGRAPHY
Ros de Barbero 2014, pp. 152 (ill.) and 218; Torre (forthcoming)

EXHIBITIONS
Madrid 2005–6b, p. 85; Madrid 2014 15, no. 156

102

FRANCIS BACON (1909–1992)

Composition, 1933
Gouache, pastel, pen and ink on paper, 21 x 15 ¾ in. (535 x 400 mm)
Signed and dated: "F. Bacon / 33" (lower right corner)
D1525

PROVENANCE
London, Miss Diana Watson; London, Sotheby's; London, Peter Cochrane Collection; private collection;
London, Christie's

BIBLIOGRAPHY
Alley and Rothenstein 1964, no. 9 (ill.); Domino 1996, p. 13 (ill.); Schmied 1996, fig. 99 (ill.); Olivier
Berggruen in Seipel and Steffen 2003, p. 73, fig. 3; Harrison 2005, no. 14 (ill.); Stephens 2012, p. 157 (ill.);
Ros de Barbero 2014, pp. 154 (ill.) and 219

EXHIBITIONS
London 1934; Cardiff 1962, no. 108; London 1979–80, no. 6.47; Paris-Munich 1996–97, no. 89; New York
2000, no. 7; Vienna-Basel 2003–4, no. 42, pp. 168, 169, 360 (ill.); Paris 2005, no. 115; Madrid 2007–8a,
pp. 123 and 135; Dallas 2008, pp. 101–2; Valencia 2009b, p. 139; London-Edinburgh 2012, no. 94 (ill.);
Madrid 2014–15, no. 158

103

FRANCIS BACON (1909–1992)

Étude d'un portrait (*Study for a Portrait*), 1978
Oil on canvas, 14 x 12 in. (35.5 x 30.5 cm)
P2

PROVENANCE
Paris, gift to the chauffeur of gallery owner Claude Bernard, August 29, 1978; France,
private collection; Barcelona, Galería Trece

BIBLIOGRAPHY
Ros de Barbero 2014, pp. 155 (ill.) and 219

EXHIBITIONS
Barcelona 1987; Santander 1992, pp. 50–51; Madrid 2014–15, no. 159

This portrait embodies Francis Bacon's concept of painting. For him, what matters is the image that appears on the canvas and its passage directly to the nervous system. Here, Bacon achieves an "anti-realist figuration" in which, despite its distortion, the portrait succeeds in transmitting the model's appearance.

Bacon did not want his work to be interpreted. For him, painting was an accident and the canvas changed by itself as it was being painted. As he put it: "painting will only catch the mystery of reality if the painter doesn't know how to do it." And he added: "I am always trying through chance or accident to find a way by which appearance can be there, but remade out of other shapes."[1] It is as though, in the presence of his model, the artist applied the paint to the canvas in a fortuitous manner. The result is even stronger and more intense than reality: the model's features emerge as if by magic, reconstructed on the basis of other shapes.

1 For all quotes by Francis Bacon see Sylvester 1977.

104

FRANCIS BACON (1909–1992)

Three Studies for a Portrait of Peter Beard, June 1975
Oil on canvas, 14 x 12 in. (35.5 x 30.5 cm) ea.
Signed and dated (verso of each canvas)
P64

PROVENANCE
Paris, Galerie Claude Bernard; United States, private collection; Basel, Galerie Beyeler

BIBLIOGRAPHY
Sylvester 1977, p. 127 (ill.), no. 95; Russell 1979, pp. 172–73 (ill.), no. 99; Peppiatt 1981, p. 50 (ill.); Leiris 1983, no. 100 (ill.); Borel 1996, pp. 130–33 (ill.); Hilarie M. Sheets in *The New York Times* (August 22, 1999), p. 18 (ill.); García 2007, pp. 82–83 (ill.); Ros de Barbero 2014, pp. 156–57 (ill.) and 220

EXHIBITIONS
Marseille 1976, no. 15 (ill.); London-Stuttgart-Berlin 1985–86, no. 91 (London) and no. 92 (Stuttgart and Berlin) (ill.); Basel 1987, no. 32 (ill.); Oslo and traveling 1987–88, no. 29, p. 50 (ill.); Santander 1992, pp. 48–49; New Haven and traveling 1999, no. 56, pp. 168–69 (ill.); London 2006, n.p. (ill.); Madrid 2007, no. 129, p. 263; Zaragoza 2008–9, no. 237; Milan 2010, no. 167; Madrid 2014–15, no. 160

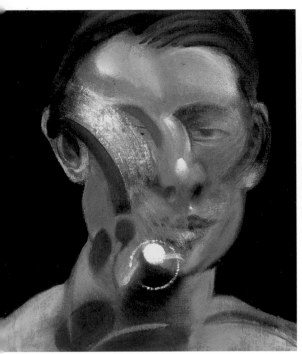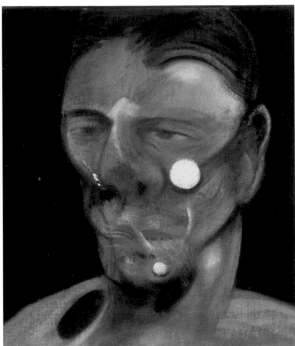

Portraits were a constant in Francis Bacon's oeuvre. According to the artist, "art is an obsession with life and [...] as we are human beings, our greatest obsession is with ourselves." He therefore made innumerable self-portraits as well as portraying friends and models when they were around.

Here we see a likeness of Peter Beard, a photographer famous for his images of Africa. Bacon particularly enjoyed his work and welcomed him to his studio, where the present triptych was painted. According to Beard, "Bacon was a visionary, but in addition he had an extraordinary gift: common sense. We were great friends. We shared a belief in fatalism. We were joined by the same mistrust of the human species: man is small, like a cancer cell, and cancer grows at an amazing speed."[1]

Bacon's fondness of photography is palpable in all his work, especially the influence of Eadweard Muybridge's (1830–1904) photographic series, which inspired the painter's triptychs and series. It must be noted, however, that for Bacon these successions of images are never narrative. In his paintings, Bacon is not telling us something—his works are not stories, but rather pure images designed to be felt.

As he himself put it, "in trying to do a portrait, my ideal would really be just to pick up a handful of paint and throw it at the canvas and hope that the portrait was there." Here, we can see the triple likeness of Peter Beard as "a kind of tightrope walk between what is called figurative painting and abstraction."[2]

1 http://www.elmundo.es/larevista/num191/textos/peter1.html.
2 For the painter's quotes see Sylvester 1977.

FRANCIS BACON (1909–1992)

Triptych, 1983
Oil and pastel on canvas, 78 x 58 in. (198 x 147.5 cm) ea.
Signed, dated and titled: "Tryptich 1983 / Francis Bacon" (verso of each canvas)
Inscriptions by the artist: "Left Panel", "Center Panel", "Right panel"
(verso of each panel)
P1630

PROVENANCE
The artist's legacy; Vaduz (Liechtenstein), Marlborough International Fine Art; Zurich, Sotheby's

BIBLIOGRAPHY
Deleuze 1984, fig. 96; Trucchi 1984, fig. 199; Ades and Forge 1985, fig. 123; Schmied 1985, fig. 23; Schmied 1996, fig. 40; Ros de Barbero 2014, pp. 158–59 (ill.) and 220–21

EXHIBITIONS
New York 1984, no. 10; Paris 1984, no. 16; London-Stuttgart-Berlin 1985–86, no. 123; New York 1987, no. 4; Tokyo 1988–89, no. 9; Madrid-New York 1992–93, no. 3; Saint-Étienne 1994–95; Edinburgh and traveling 1995–96, no. 3; Paris-Munich 1996–97, no. 80; Paris 1998–99; Düsseldorf 2000, no. 7; New York 2002; Valencia-Paris 2003–4, n.p., p. 129 (ill.); Venice 2005, no. 4; Madrid 2009a, pp. 252–53; Madrid 2014–15, no. 161

Considering art to be "an obsession with life,"[1] Francis Bacon justified his concentration on the human figure because, being men, our obsession is with ourselves. As such, here he paints a single figure with almost no accessory elements except for a chair. He also excludes spatial references, depicting only a man alone in a closed room, an image that transmits disquiet and claustrophobia. The figure's shadow is present in all three canvases and serves to anchor it to an imaginary floor. This sobriety is in keeping with the fact that Bacon did not seek to tell stories through his paintings.

The man's body appears nude, painted like flesh, whose color fascinated him. The treatment of the musculature recalls that of Michelangelo (1475–1564), whom Bacon admired for his breadth and monumentality. The face in all three canvases is disfigured and incomplete, but in all cases it has a mouth. Indeed, this Irish painter was obsessed with the mouth and even with its diseases, and he inevitably assigned it a preponderant place in his works.

Given the intimate character of this triptych, the figure on the three canvases could well be John Edwards (1949–2003), who became the painter's inseparable friend in 1976. They met at the Colony Room, a cocktail lounge in London's Soho quarter. Despite being forty years younger than the artist, Edwards became his constant companion and was his only heir when Bacon died in 1992. The figure and composition of a portrait of Edwards from 1988 could be related to this work.

The final result is a painting somewhere between abstraction and figuration with a spectacular orange background. Bacon conceived of painting as an accident. In his creative process, he threw paint at the canvas and observed the results. He painted with his hands, rags and brushes in an irrational manner that generated the intensity and distortion he sought in his images. As Guillermo da Costa Palacios writes, "Returning to the human image by suspending its apparent form through lines other than representative, and yet, almost prodigiously, remaking that image and depicting it in an authentic manner."[2]

The triple format reflects Bacon's interest in film and photography, which have influenced our manner of viewing the world ever since they were invented. He particularly recognized the influence of Eadweard Muybridge's (1830–1904) photographic studies of human movement and considered the triptych or series of three works to be "a more balanced unit." Hence, he painted triptychs, as we see here, or series of paintings, but always free of any narrative content.

1 For quotes by the painter see Sylvester 1977.
2 Costa Palacios 2006.

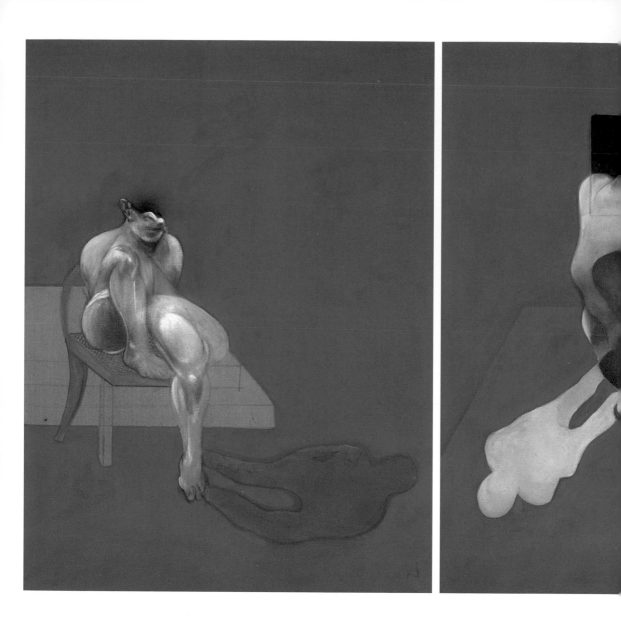

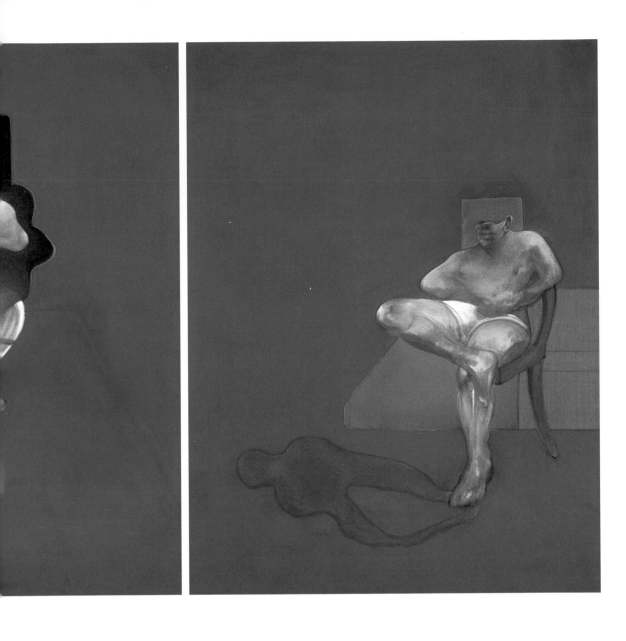

2010 Recent Acquisitions
2010 Recent Acquisitions. London: Rafael Valls, 2010.

Ades and Forge 1985
Ades, Dawn, and Andrew Forge. *Francis Bacon* [exh. cat. London, Tate Gallery]. London: Tate Gallery/Thames & Hudson; New York: Abrams, 1985.

Águeda 1982
Águeda Villar, Mercedes. "La colección de pinturas del Infante Don Sebastián Gabriel." *Boletín del Museo del Prado*, vol. III, no. 8 (1982): pp. 102–17.

Agustí 1988
Agustí, Anna. *Tàpies: The Complete Works*, vol. I: *1943–1960*. Barcelona: Fundació Antoni Tàpies/Polígrafa, 1988.

Alexandre 1993a
Alexandre, Noël. *Modigliani inconnu: témoignages, documents et dessins inédits de l'ancienne collection de Paul Alexandre*. Paris: Albin Michel/Fonds Mercator, 1993.

Alexandre 1993b
Alexandre, Noël. *The Unknown Modigliani: Drawings from the Collection of Paul Alexandre*. New York: Abrams/Fonds Mercator, 1993.

Alley and Rothenstein 1964
Alley, Ronald, and John Rothenstein. *Francis Bacon: Catalogue Raisonné*. London: Thames & Hudson, 1964.

Alonso Berruguete 1961
Alonso Berruguete: guía de la exposición [exh. cat. Madrid, Casón del Buen Retiro]. Madrid: Dirección General de Bellas Artes, 1961.

Álvarez Cervela 1968
Álvarez Cervela, José María. *A pintura mitológica e alegórica nos tectos e abóbadas do Escorial e do Palácio Real de Madrid*. Lisbon: Imperio, 1968.

Álvarez Lopera 1993
Álvarez Lopera, José. *El Greco: la obra esencial*. Madrid: Sílex, 1993.

Angelis 1974
Angelis, Rita de. *L'opera pittorica completa di Goya*. Classici dell'Arte 74. Milan: Rizzoli, 1974.

Angulo 1940–41
Angulo Íñiguez, Diego. "Primitivos valencianos en Madrid." *Archivo Español de Arte*, vol. XIV, no. 41 (1940–41): pp. 85–87.

Angulo 1943
Angulo Íñiguez, Diego. "La Virgen con el Niño, de Berruguete, de la colección del Vizconde de Roda." *Archivo Español de Arte*, vol. XVI, no. 56 (1943): pp. 111–15.

Angulo 1945
Angulo Íñiguez, Diego. "Varios pintores de Palencia. El Maestro de Astorga." *Archivo Español de Arte*, vol. XVIII, no. 70 (1945): pp. 229–35.

Angulo 1954
Angulo Íñiguez, Diego. *Ars Hispaniae*, vol. XII: *Pintura del Renacimiento*. Madrid: Plus Ultra, 1954.

Ansón Navarro, Gutiérrez Pastor and Mano 2007
Ansón Navarro, Arturo, Ismael Gutiérrez Pastor, and José Manuel de la Mano. *Francisco Bayeu y sus discípulos* [exh. cat. Zaragoza, Caja Rural de Aragón]. Zaragoza: Cajalón, 2007.

Antigüedad del Castillo-Olivares 1989
Antigüedad del Castillo-Olivares, María Dolores. "Arte y coleccionismo en Burgos durante la ocupación francesa." *Espacio, tiempo y forma*, series VII: *Historia del arte*, vol. 2, pp. 329–42. Madrid: UNED, 1989.

Antonio López 2011
Antonio López [exh. cat. Madrid, Museo Thyssen-Bornemisza; Bilbao, Museo de Bellas Artes]. Madrid: Museo Thyssen-Bornemisza, 2011.

Araujo 1896
Araujo Sánchez, Ceferino. *Goya*. Madrid: La España Moderna, 1896.

Arias de Miranda 1843
Arias de Miranda, Juan. *Apuntes históricos sobre la Cartuja de Miraflores de Burgos*. Burgos: Pascual Polo, 1843.

Arnáez 1975
Arnáez, Rocío. *Museo del Prado. Catálogo de dibujos II. Dibujos españoles del siglo XVIII. A-B*. Madrid: Museo del Prado, 1975.

Arnáiz 1981
Arnáiz, José Manuel. *Eugenio Lucas, su vida y su obra*. Madrid: M. Montal, 1981.

Arnason 1986
Arnason, H. Harvard. *History of Modern Art: Painting, Sculpture, Architecture, Photography*. 3rd ed. revised by Daniel Wheeler. New York: Abrams, 1986.

Arte y cultura 1992
Arte y cultura en torno a 1492 [exh. cat. Seville, Cartuja de Santa María de las Cuevas]. Seville: Sociedad Estatal para la Exposición Universal Sevilla '92, 1992.

Aterido 2002
Aterido, Ángel. *El bodegón en la España del Siglo de Oro*. Madrid: Edilupa, 2002.

Aterido and Alba 2013
Aterido, Ángel, and Laura Alba. "Juan Fernández el Labrador, Miguel de Pret y la 'construcción' de la naturaleza muerta." *Boletín del Museo del Prado*, vol. XXXI, no. 49 (2013): pp. 34–53.

Aureliano de Beruete 1983
Aureliano de Beruete, 1845–1912 [exh. cat. Madrid, Centro Cultural de la Caja de Pensiones]. Madrid: Caja de Pensiones, Obra Cultural, 1983.

Backsbacka 1962
Backsbacka, Ingjald. *Luis de Morales*. Helsinki: Paavo Heinon Kirjapaino, 1962.

Bartolomé 1996
Bartolomé, Belén. "Francisco Bayeu, decorador, en los Reales Sitios." In *Francisco Bayeu, 1734–1795* [exh. cat. Zaragoza, Museo e Instituto de Humanidades Camón Aznar], pp. 29–49. Zaragoza: Ibercaja, 1996.

Bartolomé Bermejo 2003
La pintura gótica hispanoflamenca: Bartolomé Bermejo y su época [exh. cat.]. Barcelona: Museu Nacional d'Art de Catalunya; Bilbao: Museo de Bellas Artes, 2003.

Baticle 1995
Baticle, Jeannine. *Goya*. Barcelona: Crítica, 1995.

Baticle and Marinas 1981
Baticle, Jeannine, and Cristina Marinas. *La galerie espagnole de Louis-Philippe au Louvre, 1838–1848*. Paris: Éditions de la Réunion des musées nationaux, 1981.

Bauquier and Maillard 1990
Bauquier, Georges, and Nelly Maillard. *Fernand Léger. Catalogue raisonné de l'oeuvre peint, 1903–1919*. Paris: Maeght, 1990.

Benezit Dictionary of Artists 2006
Benezit Dictionary of Artists. 14 vols. Paris: Gründ, 2006.

Benito Doménech 1991
Benito Doménech, Fernando. *Ribera 1591–1652*. Madrid: Bancaja, 1991.

Benito Doménech 1998
Benito Doménech, Fernando. *Los Hernandos. Pintores hispanos del entorno de Leonardo* [exh. cat. Valencia, Museo de Bellas Artes]. Valencia: Consorci de Museus de la Comunitat Valenciana, 1998.

Benito Doménech and Gómez Frechina 2001
Benito Doménech, Fernando, and José Gómez Frechina, eds. *La clave flamenca en los primitivos valencianos* [exh. cat. Valencia, Museo de Bellas Artes]. Valencia: Generalitat Valenciana, 2001.

Benito Doménech et al. 2009
Benito Doménech, Fernando, et al. *La Edad de Oro del arte valenciano. Rememoración de un centenario* [exh. cat. Valencia, Museo de Bellas Artes], Valencia: Generalitat Valenciana, 2009.

Berjano Escobar 1917
Berjano Escobar, Daniel. *El pintor Luis de Morales (El Divino)* [exh. cat. Madrid, Museo del Prado]. Madrid: Mateu, 1917.

Bermejo 1962
Bermejo, Elisa. *Juan de Flandes*. Madrid: Consejo Superior de Investigaciones Científicas, Instituto Diego Velázquez, 1962.

Bermejo and Portús 1988
Bermejo, Elisa, and Javier Portús. *Juan de Flandes*. Los genios de la pintura española 17. Madrid: Axel Springer, 1988.

Beruete 1919
Beruete y Moret, Aureliano de. *Goya, pintor de retratos*. 2nd ed. Madrid: Blass, 1919.

Beruete 1928
Beruete y Moret, Aureliano de. *Goya*. Edited by Francisco Javier Sánchez Cantón. Madrid: Blass, 1928.

Blanco Mozo and Martínez (forthcoming)
Blanco Mozo, Juan Luis, and Alejandro Martínez. "Pares desiguales. Dualidad moral y libertinaje en el proceso al infante don Luis Antonio de Borbón y Farnesio." In *Actas del XVI Encuentro de la Ilustración al Romanticismo*, Cádiz, October 16–18, 2013 (forthcoming).

Boix 1922
Boix, Félix. *Exposición de dibujos originales 1750–1860* [exh. cat. Madrid, Sociedad Española de Amigos del Arte]. Madrid: Blass, 1922.

Borel 1996
Borel, France. *Bacon: Portraits and Self-Portraits*. London-New York: Thames & Hudson, 1996.

Bottineau 1993
Bottineau, Yves. *Les Bourbons d'Espagne 1700–1808*. Paris: Fayard, 1993.

Brunius 1989
Brunius, Teddy. "Katakresernes mester." *Louisiana Revy*, vol. XXX (December 1989): pp. 16–22.

Caffin-Madaule 1992–94
Caffin-Madaule, Liliane. *Catalogue raisonné des oeuvres de María Blanchard*. 2 vols. London: Caffin-Madaule, 1992–94.

Calvert 1908
Calvert, Albert F. *Goya: An Account of his Life and Works, with 612 Reproductions from his Pictures, Etchings and Lithographs*. London: Bodley Head, 1908.

Calvo Serraller 1996
Calvo Serraller, Francisco. *Luis Paret y Alcázar 1746–1799: un retrato melancólico*. Madrid: Fundación Amigos del Museo del Prado, 1996.

Calvo Serraller et al. 2001
Calvo Serraller, Francisco, et al. *Goya: la imagen de la mujer* [exh. cat. Madrid, Museo Nacional del Prado]. Madrid: Fundación Amigos del Museo del Prado, 2001.

Calvo Serraller et al. 2002
Calvo Serraller, Francisco, et al. *Goya: Images of Women* [exh. cat. Washington D. C., National Gallery of Art]. Edited by Janis A. Tomlinson. Washington D. C.: National Gallery of Art; New Haven: Yale University Press, 2002.

Camón Aznar 1950
Camón Aznar, José. *Dominico Greco*. Madrid: Espasa-Calpe, 1950.

Camón Aznar 1959
Camón Aznar, José. *Goya en los años de la Guerra de la Independencia*. Zaragoza: Institución Fernando el Católico, 1959.

Camón Aznar 1970a
Camón Aznar, José. *Summa Artis, vol. XXIV: La pintura española del siglo XVI*. Madrid: Espasa-Calpe, 1970.

Camón Aznar 1970b
Camón Aznar, José. *Dominico Greco*. 2 vols. Madrid: Espasa-Calpe, 1970.

Campoy 1980
Campoy, Antonio Manuel. *María Blanchard*. Madrid: Gavar, 1980.

Castellví 1989
Castellví, Miguel. "La exposición antológica de Francisco de Goya desembarca en los canales de Venecia." *ABC* (May 7, 1989): p. 69.

Cau 1975
Cau, Jean. *Degas, 1834–1917* [exh. cat.]. Paris: Galerie Schmit, 1975.

Ceán Bermúdez 1800
Ceán Bermúdez, Juan Agustín. *Diccionario histórico de los más ilustres profesores de las Bellas Artes en España*. 6 vols. Madrid: Viuda de Ibarra, 1800.

Ceán Bermúdez 1998
Ceán Bermúdez, Juan Agustín. *Diccionario histórico de los más ilustres profesores de las Bellas Artes en España*. 6 vols. Valencia: Librerías París-Valencia, 1998.

Ceroni 1958
Ceroni, Ambrogio. *Amedeo Modigliani: peintre*. Milan: Edizioni del Milione, 1958.

Ceroni 1965
Ceroni, Ambrogio. *Amedeo Modigliani, dessins et sculptures*. Milan: Edizioni del Milione, 1965.

Ceroni 1970a
Ceroni, Ambrogio. *I dipinti di Modigliani.* Introduction by Leone Piccioni. Milan: Rizzoli, 1970.

Ceroni 1970b
Ceroni, Ambrogio. *Das gemalte Werk von Modigliani.* Introduction by Leone Piccioni. Luzern: Kunstkreis, 1970.

Ceroni 1972
Ceroni, Ambrogio. *Tout l'oeuvre peint de Modigliani.* Introduction by Françoise Cachin. Paris: Flammarion, 1972.

Cherry 1999
Cherry, Peter. *Arte y naturaleza. El bodegón español en el Siglo de Oro.* Madrid: Fundación de Apoyo a la Historia del Arte Hispánico, 1999.

Cherry 2006
Cherry, Peter. *Luis Meléndez: Still-life Painter.* Madrid: Fundación de Apoyo a la Historia del Arte Hispánico, 2006.

Cherry 2008
Cherry, Peter. "Miguel de Pret (1595–1644), documentos y un cuadro nuevo." *Archivo Español de Arte*, vol. LXXXI, no. 324 (2008): pp. 415–17.

Cherry, Loughman and Stevenson 2010
Cherry, Peter, John Loughman, and Lesley Stevenson. *In the Presence of Things: Four Centuries of European Still-life Painting,* part I: *17th and 18th centuries* [exh. cat. Lisbon, Museu Calouste Gulbenkian]. Lisbon: Calouste Gulbenkian Foundation, 2010.

Christiansen 1987
Christiansen, Keith. "New York: Old Master Paintings." *Burlington Magazine*, vol. CXXIX, no. 1008 (March 1987): pp. 211–12.

Company 1986
Company, Ximo. "La pintura valenciana de Jacomart a Pau de Sant Leocadi: el corrent hispanoflamenc i els inicis del Renaixement." 3 vols. Master's degree. Universidad de Barcelona, 1986.

Company and Garín 1988
Company, Ximo, and Felipe Vicente Garín Llombart. "Valencia y la pintura flamenca." In *Historia del Arte Valenciano*, vol. II: *La Edad Media: el gótico*, pp. 236–71. Valencia: Biblioteca Valenciana, 1988.

Confines 2000
Confines: miradas, discursos, figuras en los extremos del siglo XX [exh. cat. Madrid, Sala de Exposiciones Plaza de España]. Madrid: Consejería de Cultura, Dirección General de Archivos, Museos y Bibliotecas, 2000.

Constable 1962
Constable, William George. *Canaletto: Giovanni Antonio Canal 1697–1768.* 2 vols. Oxford: Clarendon Press, 1962.

Coo and Reynaud 1979
Coo, Jozef de, and Nicole Reynaud. "Origen del retablo de San Juan Bautista atribuido a Juan de Flandes." *Archivo Español de Arte y Arqueología*, vol. LII, no. 206 (1979): pp. 125–44.

Cooper 1977
Cooper, Douglas. *Juan Gris.* 2 vols. [exh. cat. Paris, Galerie Berggruen]. Paris: Berggruen, 1977.

Corboz 1985
Corboz, André. *Canaletto: una Venezia immaginaria.* 2 vols. Milan: Alfieri Electa, 1985.

Cossío 1908
Cossío, Manuel B. *El Greco.* 2 vols. Madrid: V. Suárez, 1908.

Cossío 1981
Cossío, Manuel B. *Domenico Theotocopuli El Greco.* Madrid: Espasa-Calpe, 1981.

Costa Palacios 2006
Costa Palacios, Guillermo da. "Francis Bacon: radiografías de la distorsión." *Enfocarte*, no. 27 (2006), online: http://www.enfocarte.com/6.27/bacon.html

Dalí 1993
Dalí, Salvador. *The Secret Life of Salvador Dalí.* Trans. Haakon Chevalier. New York: Dover, 1993.

Dalí and Pla 1981
Dalí, Salvador, and Josep Pla. *Obres de Museu.* Barcelona: Dasa, 1981.

Dauberville and Dauberville 1968
Dauberville, Jean and Henry. *Bonnard: Catalogue raisonné de l'oeuvre peint*, vol. II: *1906–1919.* Paris: Bernheim-Jeune, 1968.

Dauberville and Dauberville 1974
Dauberville, Jean and Henry. *Bonnard: Catalogue raisonné de l'oeuvre peint*, vol. IV: *1940–1947 et supplément 1887–1939.* Paris: Bernheim-Jeune, 1974.

Degas inédit 1989
Degas inédit. Actes du colloque Degas (Paris, Musée d'Orsay, April 18–21, 1988). Paris: Documentation Française, 1989.

Delenda 2010
Delenda, Odile, in collaboration with Almudena Ros de Barbero. *Zurbarán. Catálogo razonado y crítico*, vol. II: *Los conjuntos y el obrador.* Madrid: Fundación de Apoyo a la Historia del Arte Hispánico, 2010.

Deleuze 1984
Deleuze, Gilles. *Francis Bacon. Logique de la sensation.* 2nd ed. Paris: La Différence, 1984.

Delgado 1957
Delgado, Osiris. *Luis Paret y Alcázar: pintor español.* Madrid: Universidad de Puerto Rico, Instituto Diego Velázquez del CSIC and Universidad de Madrid, 1957.

Descalzo 2014
Descalzo, Amalia. "El traje masculino español en la época de los Austrias." In *Vestir a la española en las cortes europeas (siglos XVI y XVII)*, vol. I, pp. 15–38. Edited by José Luis Colomer and Amalia Descalzo. Madrid: Centro de Estudios Europa Hispánica, 2014.

Descharnes 1976
Descharnes, Robert. *Salvador Dalí.* New York: Abrams, 1976.

Descharnes 1984
Descharnes, Robert. *Dalí, la obra y el hombre.* Barcelona: Tusquets, 1984.

Desparmet-Fitzgerald 1928–50
Desparmet-Fitzgerald, Xavière. *L'Oeuvre peint de Goya. Catalogue raisonné.* 4 vols. Paris: F. de Nobele, 1928–50.

Domino 1997
Domino, Cristophe. *Francis Bacon: Taking Reality by Surprise.* London: Thames & Hudson, 1997.

Dortu 1971
G. Dortu, Madeleine. *Toulouse-Lautrec et son oeuvre.* 6 vols. New York: Collectors Editions, 1971.

Duncan 1961
Duncan, David Douglas. *Picasso's Picassos.* New York: Harper, 1961.

Durán, González López and Martí Ayxelà 1998
Durán, Dolores, Carlos González López, and Montserrat Martí Ayxelà. *Fortuny* [exh. cat. Zaragoza, Centro de Exposiciones y Congresos]. Zaragoza: Ibercaja, 1998.

Edad Media 1993
De la Edad Media al Romanticismo 1993–1994 [exh. cat.]. Madrid: Galería Caylus, 1993.

Einstein 1926
Einstein, Carl. *Die Kunst des 20. Jahrhunderts*. Propyläen-Kunstgeschichte 16. Berlin: Propyläen-Verlag, 1926.

Einstein 1934
Einstein, Carl. *Georges Braque*. Paris: Chroniques du Jour, 1934.

Esplendores de Espanha 2000
Esplendores de Espanha: de El Greco a Velázquez [exh. cat. Rio de Janeiro, Museu Nacional de Belas Artes]. Madrid: Ministerio de Educación, Cultura y Deporte, 2000.

Fabre 1828
Fabre, Francisco José. *Descripción de las alegorías pintadas en las bóvedas del Real Palacio de Madrid, hechas por orden de S. M.* Madrid: Eusebio Aguado, 1829.

Faraldo n.d.
Faraldo, Ramón D. *Aureliano de Beruete, pintor*. Barcelona: Omega, n.d. [1949?].

Felton 1969
Felton, Craig. "The Earliest Paintings of Jusepe de Ribera." *Wadsworth Atheneum Bulletin*, vol. V, no. 3 (1969): pp. 2–29.

Felton 1991a
Felton, Craig. "Marcantonio Doria and Jusepe de Ribera's Early Commissions in Naples." *Ricerche sul '600 napoletano*, vol. X (1991): pp. 121–37.

Felton 1991b
Felton, Craig. "Ribera's Early Years in Italy: the 'Martyrdom of St Lawrence' and the 'Five Senses'." *Burlington Magazine*, vol. CXXXIII, no. 1055 (February 1991): pp. 71–81.

Fernández 1996
Fernández, Pedro J. *Quién es quién en la pintura de Goya*. 2nd ed. Madrid: Celeste, 1996.

Flores españolas 2002
Flores españolas del Siglo de Oro [exh. cat. Haarlem, Frans Hals Museum; Madrid, Museo Nacional del Prado]. Madrid: Fundación Amigos del Museo del Prado, 2002.

Fol 1875
Fol, Walther. "Fortuny." *Gazette des Beaux-Arts*, ser. II, no. 11 (April 1875): pp. 267–81 and 350–66.

Fontbona and Miralles 1981
Fontbona, Francesc, and Francesc Miralles. *Anglada-Camarasa*. Barcelona: Polígrafa, 1981.

Franchi 1946
Franchi, Raffaello. *Modigliani*. Florence: Arnaud, 1946.

Francisco Bayeu 1996
Francisco Bayeu, 1735–1795 [exh. cat. Zaragoza, Museo e Instituto de Humanidades Camón Aznar]. Zaragoza: Ibercaja, 1996.

García 2007
García, Ángeles. "La mirada enmascarada." *El País Semanal*, no. 1589 (March 11, 2007): pp. 82–83.

García Viñolas 1976
García Viñolas, Manuel. "Manuel Rivera." *Pueblo* January 21, 1976, n.p.

Garfias 1972
Garfias, Francisco. *Vida y obra de Daniel Vázquez Díaz*. Madrid: Ibérico-Europea, 1972.

Garín 1954
Garín Ortiz de Taranco, Felipe M. *Yáñez de la Almedina: pintor español*. Valencia: Instituto Alfonso el Magnánimo, 1954.

Garín 1978
Garín Ortiz de Taranco, Felipe M. *Yáñez de la Almedina*. 2nd ed. Ciudad Real: Instituto de Estudios Manchegos, 1978.

Garín 1979
Garín Ortiz de Taranco, Felipe M. "Las pequeñas tablas de devoción privada de Yáñez y su escuela." In *Estudios sobre literatura y arte dedicados al profesor Emilio Orozco Díaz*, vol. II, pp. 87–90. Granada: Universidad de Granada, 1979.

Garín and Ros de Barbero 2014
Garín Llombart, Felipe Vicente, and Almudena Ros de Barbero. *Colección Abelló* [exh. cat. Madrid, Centrocentro Cibeles]. Madrid: Centrocentro Cibeles de Cultura y Ciudadanía, 2014.

Garrido 1995
Garrido, María del Carmen. "Le processus créatif chez Juan de Flandes." In *Le dessin sous-jacent dans la peinture, colloque X* (September 5–7, 1993), pp. 21–29. Edited by Hélène Verougstraete and Roger van Schoute. Louvain-la-Neuve: Université Catholique de Louvain, 1995.

Gassier and Wilson 1970
Gassier, Pierre, and Juliet Wilson. *Vie et oeuvre de Francisco de Goya, comprenant l'oeuvre complet illustré*. Freiburg: Office du Livre, 1970.

Gassier and Wilson 1994
Gassier, Pierre, and Juliet Wilson. *Goya: his Life and Work*. Cologne: Taschen, 1994.

Gaya Nuño 1950
Gaya Nuño, Juan Antonio. *Salvador Dalí*. Barcelona: Omega, 1950.

Gaya Nuño 1958
Gaya Nuño, Juan Antonio. "Actualidad de Luis Paret: bibliografía reciente, datos nuevos y obras inéditas." *Goya*, vol. 58, no. 22 (1958): pp. 206–12.

Gerard and Ressort 2002
Gerard Powell, Véronique, and Claudie Ressort, in collaboration with Jeannine Baticle, Philippe Lorentz, and Almudena Ros de Barbero. *Musée du Louvre. Département des Peintures. Catalogue. Écoles espagnole et portugaise*. Paris: Réunion des musées nationaux, 2002.

Giménez 2012
Giménez, Carmen, ed. *Picasso Black and White* [exh. cat. New York, Solomon R. Guggenheim Museum; Houston, The Museum of Fine Arts]. Munich: Prestel; New York: DelMonico Books, 2012.

Gindertael 1969
Gindertael, Roger van. *Modigliani e Montparnasse*. Milan: Fabbri, 1969.

Gleizes 1926
Gleizes, Albert. "Cubisme (Vers une conscience plastique)." *Bulletin de l'Effort Moderne*, no. 24 (April 1926).

González López and Martí Ayxelá 1989
González López, Carlos, and Montse Martí Ayxelá. *Mariano Fortuny Marsal.* 2 vols. Maestros del arte de los siglos XIX y XX 2. Barcelona: Ediciones Catalanas, 1989.

González-Doria 1986
González-Doria, Fernando. *Las reinas de España.* 5th ed. San Fernando de Henares (Madrid): Cometa, 1986.

Gordon 1974
Gordon, Donald E. *Modern Art Exhibitions 1900–1916.* 2 vols. Munich: Prestel, 1974.

Gordon and Forge 1988
Gordon, Robert, and Andrew Forge. *Degas.* New York: Abrams, 1988.

Goya and Zapater 1924
Goya, Francisco de, and Francisco Zapater. *Colección de cuatrocientas cuarenta y nueve reproducciones de cuadros, dibujos y aguafuertes de Don Francisco de Goya, precedidos de un epistolario del gran pintor y de las noticias biográficas publicadas por Don Francisco Zapater y Gómez en 1860.* Madrid: Saturnino Calleja, 1924.

Green 2012
Green, Christopher. "Francis Bacon and Picasso." In *Picasso and Modern British Art* [exh. cat. London, Tate Britain; Edinburgh, The Scottish National Gallery of Modern Art]. Edited by James Beechey and Chris Stephens. London: Tate, 2012.

Gudiol 1970
Gudiol, José. *Goya. 1746–1828. Biografía, estudio analítico y catálogo de sus pinturas.* 4 vols. Barcelona: Polígrafa, 1970.

Gudiol 1982
Gudiol, José. *Doménikos Theotokópoulos, El Greco, 1541–1614.* Barcelona: Polígrafa, 1982.

Gurdjian 1991
Gurdjian, Philippe. *Femmes chefs-d'oeuvre.* Paris: Vecteurs, 1991.

Harrison 2005
Harrison, Martin. *In Camera: Francis Bacon; Photography, Film and the Practice of Painting.* London: Thames & Hudson, 2005.

Held 1971
Held, Jutta. *Die Genrebilder der Madrider Teppichmanufaktur und die Anfänge Goyas.* Berlin: Mann, 1971.

Huyghe 1935
Huyghe, René, ed. *Histoire de l'art contemporain: La peinture.* Paris: Alcan, 1935.

Ibáñez Martínez 1993
Ibáñez Martínez, Pedro Miguel. *Pintura conquense del siglo XVI.* 3 vols. Cuenca: Diputación Provincial de Cuenca, 1993.

Ibáñez Martínez 1999
Ibáñez Martínez, Pedro Miguel. *Fernando Yáñez de Almedina (La incógnita Yáñez).* Cuenca: Universidad de Castilla-La Mancha, 1999.

Ibáñez Martínez 2011
Ibáñez Martínez, Pedro Miguel. *La huella de Leonardo en España: los Hernandos y Leonardo* [exh. cat. Madrid, Canal de Isabel II]. Madrid: Palacios y Museos, 2011.

Isarlov 1932
Isarlov, Georges. "Georges Braque." *Orbes* 3 (Spring 1932).

Ishikawa 2004
Ishikawa, Chiyo. *The "Retablo de Isabel la Católica" by Juan de Flandes and Michel Sittow.* Turnhout: Brepols, 2004.

Jardot and Martin 1948
Jardot, Maurice, and Kurt Martin. *Die Meister französischer Malerei der Gegenwart.* Baden-Baden: Woldemar Klein, 1948.

Jensen 2003
Jensen, Finn Robert. "Stenersen og geniet." *Aftenposten* April 16, 2003.

Jordan 1985
Jordan, William B. *Spanish Still Life in the Golden Age, 1600–1650* [exh. cat.]. Fort Worth: Kimbell Museum of Art, 1985.

Jordan 1997
Jordan, William B. *An Eye on Nature: Spanish Still-life Paintings from Sánchez Cotán to Goya* [exh. cat.]. London: Matthiesen Fine Art, 1997.

Jordan 2005
Jordan, William B. *Juan van der Hamen y León y la Corte de Madrid* [exh. cat. Madrid, Palacio Real]. Madrid: Patrimonio Nacional, 2005.

Jordan 2006
Jordan, William B. *Juan van der Hamen y León and the Court of Madrid* [exh. cat. Dallas, Meadows Museum]. New Haven: Yale University Press, 2006.

Jordan 2009
Jordan, William B. "El Pseudo-Hiepes es Bernardo Polo." *Archivo Español de Arte,* vol. LXXXII, no. 328 (October-December 2009): pp. 393–424.

Juan de Flandes 2010
Juan de Flandes en het Miraflorestabel, gesignaleerd en opgespoord [exh. cat. Antwerp, Museum Mayer van den Bergh]. Antwerp: Ludion, 2010.

Kahnweiler 1947
Kahnweiler, Daniel-Henry. *Juan Gris: His Life and Work.* London: Lund Humphries; New York: Valentin, 1947.

Kasl 2014
Kasl, Ronda. *The Making of Hispano-Flemish Style: Art, Commerce, and Politics in Fifteenth-Century Castile.* Turnhout: Brepols, 2014.

Kasl and Stratton 1997
Kasl, Ronda, and Suzanne L. Stratton, eds. *Painting in Spain in the Age of Enlightenment: Goya and his Contemporaries* [exh. cat. Indianapolis, Indianapolis Museum of Art; New York, Spanish Institute]. Seattle: University of Washington Press, 1997.

Klingender 1968
Klingender, Francis D. *Goya in the Democratic Tradition.* London: Sidgwick and Jackson; New York: Schoken Books, 1968.

Kolberg 2006
Kolberg, Gerhard, ed. *Salvador Dalí. La gare de Perpignan. Pop, Op, Yes-yes, Pompier* [exh. cat. Cologne, Museum Ludwig]. Ostfildern: Hatje Cantz, 2006.

Kosinski 1991
Kosinski, Dorothy. "G. F. Reber: Collector of Cubism." *The Burlington Magazine,* vol. CXXXIII, no. 1061 (August 1991): pp. 519–31.

Kusche 1964
Kusche, Maria. *Juan Pantoja de la Cruz.* Madrid: Castalia, 1964.

Kusche 2003
Kusche, Maria. *Retratos y retratadores. Alonso Sánchez Coello y sus competidores Sofonisba Anguissola, Jorge de la Rúa y Rolán de Moys.* Madrid: Fundación de Apoyo a la Historia del Arte Hispánico, 2003.

Pantorba 1970
Pantorba, Bernardino de [José López Jiménez]. *La vida y la obra de Joaquín Sorolla. Estudio biográfico y crítico*. Madrid: Extensa, 1970.

Papi 2002
Papi, Gianni. "Jusepe de Ribera a Roma e il Maestro del Giudizio di Salomone." *Paragone*, vol. LIII, no. 44, 629 (2002): pp. 21–43.

Papi 2007
Papi, Gianni. *Ribera a Roma*. Soncino: Edizioni del Soncino, 2007.

Parisot 1991
Parisot, Christian. *Modigliani Catalogue Raisonné*, vol. II: *Peintures, dessins, aquarelles*. Livorno: Edizioni Graphis Arte, 1991.

Patani 1992
Patani, Osvaldo. *Amedeo Modigliani: catalogo generale: sculture e disegni 1909–1914*. Milan: Leonardo, 1992.

Patani 1994
Patani, Osvaldo. *Amedeo Modigliani, catalogo generale. Disegni 1906–1920. Con i disegni provenienti dalla collezione Paul Alexandre (1906–1914)*. Milan: Leonardo, 1994.

Peppiatt 1981
Peppiatt, Michael. "Les Rêves décomposés de Francis Bacon." *Connaissance des Arts*, no. 351 (May 1981): pp. 48–57.

Pérez Sánchez 1987
Pérez Sánchez, Alfonso E. *La Nature morte espagnole du XVIIème siècle à Goya*. Freiburg: Office du Livre, 1987.

Pérez Sánchez 1996
Pérez Sánchez, Alfonso E. *Pintura española recuperada por el coleccionismo privado* [exh. cat. Seville, Hospital de los Venerables; Madrid, Real Academia de Bellas Artes de San Fernando]. Seville: Fundación Focus-Abengoa, 1996.

Pérez Sánchez 1997
Pérez Sánchez, Alfonso E. *Pinturas recuperadas* [exh. cat. Oviedo, Museo de Bellas Artes de Asturias]. Seville: Fundación Focus-Abengoa, 1997.

Pérez Sánchez and Spinosa 1992a
Pérez Sánchez, Alfonso E., and Nicola Spinosa, eds. *Jusepe de Ribera 1591–1652* [exh. cat. Naples, Castel Sant'Elmo, Certosa di San Martino and Cappella del Tesoro di San Gennaro]. Naples: Electa Napoli, 1992.

Pérez Sánchez and Spinosa 1992b
Pérez Sánchez, Alfonso E., and Nicola Spinosa, eds. *Ribera 1591–1652* [exh. cat.]. Madrid: Museo Nacional del Prado, 1992.

Pérez Sánchez and Spinosa 1992c
Pérez Sánchez, Alfonso E., and Nicola Spinosa, eds. *Jusepe de Ribera 1591–1652* [exh. cat. New York, The Metropolitan Museum of Art]. New York: Abrams, 1992.

Pfannstiel 1929
Pfannstiel, Arthur. *L'art et la vie: Modigliani*. Paris: Marcel Seheur, 1929.

Pfannstiel 1956
Pfannstiel, Arthur. *Modigliani et son oeuvre. Étude critique et catalogue raisonné*. Paris: Bibliothèque des Arts, 1956.

Picasso clásico 1992
Picasso clásico [exh. cat. Málaga, Palacio Episcopal]. Málaga: Consejería de Cultura y Medio Ambiente, 1992.

Picasso, tradición y vanguardia 2006
Picasso, tradición y vanguardia [exh. cat. Madrid, Museo Nacional del Prado and Museo Nacional Centro de Arte Reina Sofía]. Madrid: El Viso, 2006.

Pita Andrade 1980
Pita Andrade, José Manuel. "Una miniatura de Goya." *Boletín del Museo del Prado*, vol. I, no. I (1980): pp. 12–16.

Ponz 1788
Ponz, Antonio. *Viaje de España*, vol. XIV. 2nd ed. Madrid: Viuda de Ibarra, Hijos y Cía., 1788.

Post 1933
Post, Chandler Rathfon. *A History of Spanish Painting*, vol. IV: *The Hispano-Flemish Style in North-Western Spain*. Cambridge, Mass.: Harvard University Press, 1933.

Post 1934
Post, Chandler Rathfon. *A History of Spanish Painting*, vol. V: *The Hispano-Flemish Style in Andalusia*. Cambridge, Mass.: Harvard University Press, 1934.

Post 1938
Post, Chandler Rathfon. *A History of Spanish Painting*, vol. VII: *The Catalan School in the Late Middle Ages*. Cambridge, Mass.: Harvard University Press, 1938.

Post 1941
Post, Chandler Rathfon. *A History of Spanish Painting*, vol. VIII: *The Aragonese School in the Late Middle Ages*. Cambridge, Mass.: Harvard University Press, 1941.

Post 1947
Post, Chandler Rathfon. *A History of Spanish Painting*, vol. IX: *The Beginning of the Renaissance in Castile and Leon*. Cambridge, Mass.: Harvard University Press, 1947.

Post 1953
Post, Chandler Rathfon. *A History of Spanish Painting*, vol. XI: *The Valencian School in the Early Renaissance*. Cambridge, Mass.: Harvard University Press, 1953.

Post 1958
Post, Chandler Rathfon. *A History of Spanish Painting*, vol. XII: *The Catalan School in the Early Renaissance*. Cambridge, Mass.: Harvard University Press, 1958.

Prelude to Spanish Modernism 2005
Prelude to Spanish Modernism. Fortuny to Picasso [exh. cat.]. Albuquerque, New Mexico: The Albuquerque Museum; Dallas: Meadows Museum, Southern Methodist University, 2005.

Private Collection of W. H. Vanderbilt 1879
The Private Collection of W. H. Vanderbilt. New York: G. P. Putnam's Sons, 1879.

Puppi and Berto 1968
Puppi, Lionello, and Giuseppe Berto. *L'opera completa del Canaletto*. Classici dell'arte 18. Milan: Rizzoli, 1968.

Raynal 1920
Raynal, Maurice. *Juan Gris* [exh. cat.]. Paris: Editions de l'Effort Moderne, 1920.

Raynal 1933
Raynal, Maurice. "Une Conferénce de Juan Gris." *Cahiers d'Art*, vol. 8, nos. 5–6 (1933): pp. 186–201.

Raynal 1951
Raynal, Maurice. *Modigliani*. Geneva-Paris-New York: Skira, 1951.

Renacimiento mediterráneo 2001
El Renacimiento mediterráneo. Viajes de artistas e itinerarios de obras entre Italia, Francia y España en el siglo XV [exh. cat. Madrid, Museo Thyssen-Bornemisza; Valencia, Museo de Bellas Artes]. Madrid: Fundación Colección Thyssen-Bornemisza, 2001.

Restellini 2003
Restellini, Marc. *Amedeo Modigliani, l'angelo dal volto severo* [exh. cat. Milan, Palazzo Reale]. Milan: Skira, 2003.

Revenga 1998
Revenga, Paula. "Noticias sobre el pintor Miguel Vicente." *Anales Toledanos*, no. 35 (1998): pp. 139–49.

Reyes y mecenas 1992
Reyes y mecenas. Los Reyes Católicos-Maximiliano I y los inicios de la casa de Austria en España [exh. cat. Toledo, Museo de Santa Cruz; Innsbruck, Schloss Ambras]. Madrid: Electa, 1992.

Ribera inedito 1989
Ribera inedito tra Roma e Napoli [exh. cat. Naples, Castel Sant'Elmo and Chiesa della Certosa di San Martino]. Naples: Piero Corsini, 1989.

Richardson 1996
Richardson, John. *A Life of Picasso*, vol. II: *1907–1917, The Painter of Modern Life*. New York: Random House, 1996.

Rincón 1990
Rincón, Wifredo. *Guía de Zaragoza*. Madrid: El País-Aguilar, 1990.

Romero 2003
Romero, Luis. *Todo Dalí en un rostro*. 2nd rev. ed. Barcelona: Polígrafa, 2003.

Romero Asenjo 2009
Romero Asenjo, Rafael. *El bodegón español en el siglo XVII: desvelando su naturaleza oculta*. Madrid: Icono I&R, 2009.

Romero Asenjo and Illán Gutiérrez 2008
Romero Asenjo, Rafael, and Adelina Illán Gutiérrez. "Procesos no destructivos de análisis aplicados al estudio de la técnica pictórica de Luis Paret y Alcázar (1746–1799)." In *Ciencia y Esencia. Cuadernos de conservación y tecnología del arte*, vol. 1 (2008): pp. 47–67.

Romero Asenjo and Illán Gutiérrez 2014
Romero Asenjo, Rafael, and Adelina Illán Gutiérrez. "La preciosista técnica de Paret." *Ars Magazine*, no. 23 (July-September 2014): pp. 108–9.

Ros de Barbero 2014
Ros de Barbero, Almudena. "Catalogación de obras." In *Colección Abelló* [exh. cat. Madrid, Centrocentro Cibeles], pp. 21–160 and 161–221. Texts by Felipe Vicente Garín Llombart and Almudena Ros de Barbero. Madrid: Centrocentro Cibeles de Cultura y Ciudadanía, 2014.

Rose Wagner 1983
Rose Wagner, Isadora Joan. "Manuel Godoy. Patrón de las artes y coleccionista." Master's degree. 2 vols., Universidad Complutense de Madrid, 1983.

Rossi Bortolatto 1974
Rossi Bortolatto, Luigina. *L'opera completa di Francesco Guardi*. Classici dell'arte 71. Milan: Rizzoli, 1974.

Roy 1958
Roy, Claude. *Modigliani*. Geneva: Skira, 1958.

Roy 1985
Roy, Claude. *Modigliani*. Geneva: Skira; New York: Rizzoli, 1985.

Russell 1979
Russell, John. *Francis Bacon*. Paris: Éditions du Chêne, 1979 (1st ed. London, 1971).

Russoli and Minervino 1970
Russoli, Franco, and Fiorella Minervino. *L'opera completa di Degas*. Classici dell'arte 45. Milan: Rizzoli, 1970.

Sabartés 1961
Sabartés, Jaime. *Picasso: Toreros*. New York: George Braziller, 1961.

Sala Parés 1978
Sala Parés 1877–1977. Barcelona: I. G. Viladot, 1978.

Salas 1977
Salas, Xavier de. "Inéditos de Luis Paret y otras notas sobre él mismo." *Archivo Español de Arte*, vol. 50, no. 199 (1977): pp. 253–78.

Salazar 2004
Salazar, María José. *María Blanchard. Pintura 1889–1932. Catálogo razonado*. Madrid: Museo Nacional Centro de Arte Reina Sofía/Fundación Telefónica, 2004.

Sánchez Cantón 1931
Sánchez Cantón, Francisco Javier. "El retablo de la Reina Católica (Addenda et corrigenda)." *Archivo Español de Arte y Arqueología*, no. 7 (1931): pp. 149–52.

Sánchez Cantón 1951
Sánchez Cantón, Francisco Javier. *Vida y obras de Goya*. Madrid: Peninsular, 1951.

Sánchez Cantón 1965
Sánchez Cantón, Francisco Javier. *Ars Hispaniae*, vol. XVII: *Escultura y pintura del s. XVIII. Francisco de Goya*. Madrid: Plus Ultra, 1965.

Sánchez Cantón and Allende Salazar 1919
Sánchez Cantón, Francisco Javier, and Juan Allende Salazar. *Retratos del Museo del Prado. Identificación y rectificaciones*. Madrid: Julio Casano, 1919.

Sánchez Cantón and Moreno Villa 1937
Sánchez Cantón, Francisco Javier, and José Moreno Villa. "Noventa y siete retratos de la familia de Felipe III por Bartolomé González." *Archivo Español de Arte y Arqueología*, no. 33 (1937): pp. 127–57.

Sánchez del Peral 2001
Sánchez del Peral y López, Juan Ramón. "Jan van Kessel II y la 'Joya Grande' de Mariana de Neoburgo: consideraciones sobre el retrato portátil en la época de Carlos II." *Reales Sitios*, no. 150 (2001): pp. 65–74.

Sánchez López 2008
Sánchez López, Andrés. *La pintura de bodegones y floreros en España en el siglo XVIII*. Madrid: Fundación de Apoyo a la Historia del Arte Hispánico, 2008.

Santiago Páez 1990
Santiago Páez, Elena. *Miguel Jacinto Meléndez (1679–1734)* [exh. cat. Madrid, Museo Municipal]. Madrid: Ayuntamiento de Madrid, 1990.

Santiago Páez 1995
Santiago Páez, Elena. "Miguel Jacinto Meléndez (1679–1734), pintor de Felipe V." In *Philippe V d'Espagne et l'art de son temps. Actes du colloque des 7, 8 et 9 juin 1993 à Sceaux*, pp. 179–88. Directed by Yves Bottineau. Sceaux: Musée de l'Île-de-France, 1995.

Saralegui 1942
Saralegui, Leandro de. "Pedro Nicolau." *Boletín de la Sociedad Española de Excursiones*, vol. XLVI (1942): pp. 98–152.

Saralegui 1954
Saralegui, Leandro de. *El Museo Provincial de Bellas Artes de San Carlos. Tablas de las salas 1ª y 2ª de primitivos valencianos*. Valencia: Institución Alfonso el Magnánimo, 1954.

Saralegui 1960
Saralegui, Leandro de. "De pintura valenciana medieval. El Maestro de Bonastre." *Archivo de Arte Valenciano*, no. 31 (1960): pp. 5–23.

Schmied 1985
Schmied, Wieland. *Francis Bacon: Vier Studien zu einem Porträt*. Berlin: Frölich und Kaufmann, 1985.

Schmied 1996
Schmied, Wieland. *Francis Bacon: Commitment and Conflict*. Munich-New York: Prestel, 1996.

Scholz-Hänsel 2000
Scholz-Hänsel, Michael. *Jusepe de Ribera 1591–1652*. Cologne: Könemann, 2000.

Seipel and Steffen 2003
Seipel, Wilfried, and Barbara Steffen, eds. *Francis Bacon und die Bildtradition* [exh. cat. Vienna, Kunsthistorisches Museum Wien; Basel, Fondation Beyeler]. Milan: Skira, 2003.

Shinn 1882
Shinn, Earl [Edward Strahan]. *The Art Treasures of America*. 3 vols. Philadelphia: George Barrie, 1882.

Silva Maroto 1990
Silva Maroto, Pilar. *Pintura hispanoflamenca castellana. Burgos y Palencia: obras en tabla y sarga*. 3 vols. Valladolid: Junta de Castilla y León, 1990.

Silva Maroto 1994
Silva Maroto, Pilar. "Juan de Flandes." In *Les Primitifs flamands et leur temps*, pp. 573–83. Edited by Brigitte de Patoul and Roger van Schoute. Louvain-la-Neuve: La Renaissance du Livre, 1994.

Silva Maroto 1998
Silva Maroto, Pilar. *Pedro Berruguete*. Valladolid: Junta de Castilla y León, 1998.

Silva Maroto 2006
Silva Maroto, Pilar. *Juan de Flandes*. Salamanca: Caja Duero, 2006.

Soby 1954
Soby, James Thrall. *Modigliani. Paintings, Drawings, Sculpture*. New York: Museum of Modern Art, 1954.

Soehner 1957
Soehner, Halldor. "Greco in Spanien. 1: Grecos Stilentwicklung in Spanien." *Münchner Jahrbuch der bildenden Kunst*, no. 8 (1957): pp. 123–94.

Soehner 1958–59
Soehner, Halldor. "Greco in Spanien." *Münchner Jahrbuch der bildenden Kunst*, nos. 9–10 (1958–59): pp. 147–242.

Spike 2003
Spike, John T. *Dissimilar Revelations. Essays on Neolithic Art, Fra Angelico, Velázquez, Goya, and Cézanne*. New York: Edgewise Press, 2003.

Spinosa 1978
Spinosa, Nicola. *L'opera completa del Ribera*. Introductory text by Alfonso E. Pérez Sánchez. Milan: Rizzoli, 1978.

Spinosa 2003
Spinosa, Nicola. *Ribera. L'opera completa*. Naples: Electa Napoli, 2003.

Spinosa 2005
Spinosa, Nicola, ed. *José de Ribera. Bajo el signo de Caravaggio (1613–1633)* [exh. cat. Salamanca, Sala de Exposiciones San Eloy; Valencia, Museo de Bellas Artes; Seville, Museo de Bellas Artes]. Salamanca: Caja Duero; Valencia, Generalitat Valenciana, 2005.

Spinosa 2006
Spinosa, Nicola. *Ribera. L'opera completa*. Naples: Electa Napoli, 2006.

Spinosa 2008
Spinosa, Nicola. *Ribera. La obra completa*. Madrid: Fundación de Apoyo a la Historia del Arte Hispánico, 2008.

Stenersen 2001
Stenersen, Rolf E. *Edvard Munch: Close-up of a Genius*. Oslo: Sem & Stenersen, 2001.

Sutherland and Maheux 1992
Sutherland Boggs, Jean, and Anne Maheux. *Degas Pastels*. London: George Braziller, 1992.

Syfer-d'Olne et al. 2006
Syfer-d'Olne, Pascale, Anne Dubois, Roel Slachmuylders, Bart Fransen, and Famke Peters. *The Flemish Primitives*, vol. IV: *Masters with Provisional Names*. Catalogue of Early Netherlandish Painting: Royal Museums of Fine Arts of Belgium 4. Turnhout: Brepols, 2006.

Sylvester 1977
Sylvester, David. *Entrevistas con Francis Bacon*. Barcelona: Polígrafa, 1977.

Taguchi 1936
Taguchi, Seigo. *Modigliani*. Tokyo: Atelier-Sha, 1936.

Tarín 1925
Tarín y Juaneda, Francisco. *La Real Cartuja de Miraflores (Burgos), su historia y descripción* (1896). 2nd ed. Burgos: Hijos de Santiago Rodríguez, 1925.

Tesoros 1987
Tesoros de las colecciones particulares madrileñas: Pintura desde el siglo XV a Goya [exh. cat. Madrid, Real Academia de Bellas Artes de San Fernando]. Madrid: Dirección General de Patrimonio Cultural, 1987.

Toledano 2006
Toledano, Ralph. *Antonio Joli, Modena 1700–1777 Napoli*. Turin: Artema, 2006.

Tormo 1902
Tormo y Monzó, Elías. *Las pinturas de Goya y su clasificación cronológica*. Madrid: Viuda e hijos de M. Tello, 1902.

Tormo 1913
Tormo y Monzó, Elías. *Jacomart y el arte hispano-flamenco cuatrocentista*. Madrid: Blass, 1913.

Tormo 1924
Tormo y Monzó, Elías. "Obras conocidas y desconocidas de Yáñez de la Almedina." *Boletín de la Sociedad Española de Excursiones*, no. XXXII (1924): pp. 32–39.

Tormo 1949
Tormo y Monzó, Elías. *Pintura, escultura y arquitectura en España. Estudios dispersos de Elías Tormo y Monzó*. Madrid: Instituto Diego Velázquez de Arte y Arqueología, Consejo Superior de Investigaciones Científicas, 1949.

Torre 2009
Torre, Alfonso de la, with the collaboration of Marisa Rivera. *Manuel Rivera: 1943–1994. Catálogo razonado de pinturas*. Madrid: Fundación Azcona, 2009.

Torre (forthcoming)
Torre, Alfonso de la. *Catálogo razonado de Pablo Palazuelo*. Museo Nacional Centro de Arte Reina Sofía, Museu d'Art Contemporani de Barcelona, Fundación Palazuelo and Fundación Azcona (forthcoming).

Trens 1947
Trens, Manuel. *María. Iconografía de la Virgen en el arte español*. Madrid: Plus Ultra, 1947.

Tres siglos de pintura 1995
Tres siglos de pintura [exh. cat.]. Madrid: Caylus, 1995.

Trucchi 1984
Trucchi, Lorenza. *Francis Bacon*. Milan: Fabbri, 1984.

Tufts 1982
Tufts, Eleanor. "Luis Meléndez, Still-Life Painter 'Sans Pareil'." *Gazette des Beaux-Arts*, vol. VI, no. 100 (November 1982): pp. 143–66.

Tufts 1985
Tufts, Eleanor. *Luis Meléndez. Eighteenth-Century Master of the Spanish Still Life, with a Catalogue Raisonné*. Columbia, Mo.: University of Missouri Press, 1985.

Tzeutschler 1976
Tzeutschler Lurie, Ann. "Birth and Naming of St. John the Baptist Attributed to Juan de Flandes. A Newly Discovered Panel from a Hypothetical Altarpiece." *Bulletin of the Cleveland Museum of Art*, vol. LXIII, no. 5 (May 1976): pp. 118–35.

Urbach 2001
Urbach, Susan. "An *Ecce Agnus Dei* Attributed to Juan de Flandes: a Lost Panel from a Hypothetical Altarpiece." *Jaarboek Koninklijk Museum voor Schone Kunsten* (2001): pp. 189–207.

Urrea 2012
Urrea, Jesús. *Antonio Joli en Madrid, 1749–1754*. Madrid: Fondo Cultural Villar Mir, 2012.

Vandevivere and Bermejo 1986
Vandevivere, Ignace, and Elisa Bermejo. *Juan de Flandes* [exh. cat. Madrid, Museo Nacional del Prado]. Madrid: Ministerio de Cultura, 1986.

Vauxcelles 1935
Vauxcelles, Louis. *Pierre Bonnard (Drogues et peintures)*. Album d'Art contemporain 40. Paris: Innothéra, *ca.* 1935.

Viñaza 1887
Viñaza, Conde de la (Cipriano Muñoz y Manzano). *Goya. Su tiempo, su vida, sus obras*. Madrid: Manuel G. Hernández, 1887.

Vischer 2005
Vischer, Bodo. *Goyas Stillleben. Das Auge der Natur*. Petersberg: Imhof, 2005.

W. H. Vanderbilt Collection 1884
W. H. Vanderbilt Collection of Paintings. New York: n.p., 1884.

Waagen 1854
Waagen, Gustav Friedrich. *Treasures of Art in Great Britain*. 3 vols. London: John Murray, 1854.

Wandrup 2003
Wandrup, Fredrik. "Geniet og visergutten." *Dagbladet* April 19, 2003.

Warncke and Walther 1992
Warncke, Carsten-Peter, and Ingo F. Walther. *Pablo Picasso 1881–1973*. 2 vols. Cologne: Taschen, 1992.

Werner 1960–61
Werner, Alfred. "Modigliani as a Sculptor." *Art Journal*, vol. XX, no. 2 (Winter 1960–61): pp. 70–78.

Werner 1962
Werner, Alfred. *Modigliani. The Sculptor*. New York: Arts Inc., 1962.

Werner 1968
Werner, Alfred. *Amedeo Modigliani*. Cologne: DuMont, 1968.

Werner 1985
Werner, Alfred. *Amedeo Modigliani*. New York: Abrams 1985.

Wethey 1962
Wethey, Harold E. *El Greco and his School*. 2 vols. Princeton: Princeton University Press, 1962.

Wethey 1967
Wethey, Harold E. *El Greco y su escuela*. 2 vols. Madrid: Guadarrama, 1967.

Yriarte 1875
Yriarte, Charles. "Fortuny." *L'Art. Revue Hebdomadaire Illustrée*, no. I (1875): pp. 361–72 and 385–94.

Zervos 1951
Zervos, Christian. *Pablo Picasso*, vol. 4: *Oeuvres de 1920 à 1922*. Paris: Cahiers d'art, 1951.

Zervos 1954
Zervos, Christian. *Pablo Picasso*, vol. 6: *Supplément aux volumes 1 à 5*. Paris: Cahiers d'art, 1954.

Zervos 1960
Zervos, Christian. *Pablo Picasso*, vol. 11: *Oeuvres de 1940 et 1941*. Paris: Cahiers d'art, 1960.

Zervos 1968
Zervos, Christian. *Pablo Picasso*, vol. 19: *1959 à 1961*. Paris: Cahiers d'art, 1968.

Zervos 1970
Zervos, Christian. *Pablo Picasso*, vol. 22: *Supplément aux années 1903–1906*. Paris: Cahiers d'art, 1970.

Zervos 1975
Zervos, Christian. *Pablo Picasso*, vol. 29: *Supplément aux années 1914–1919*. Paris: Cahiers d'art, 1975.

Zervos 1978
Zervos, Christian. *Pablo Picasso*, vol. 33: *Oeuvres de 1971 à 1972*. Paris: Cahiers d'art, 1978.

Amsterdam 1933
Het Stilleven, Amsterdam, J. Goudstikker Gallery, February 18–March 19, 1933.

Amsterdam 1937
Edvard Munch, Amsterdam, Stedelijk Museum, May 1–June 20, 1937.

Amsterdam 1947
Pierre Bonnard, Amsterdam, Stedelijk Museum, June–July 1947.

Amsterdam-Brussels 1947
Toulouse-Lautrec, Amsterdam, Stedelijk Museum, July–August 1947; Brussels, Palais des Beaux-Arts, September–November 1947.

Avignon 1973
Pablo Picasso 1970–1972, Avignon, Palais des Papes, May 23–September 23, 1973.

Barcelona 1912
Darío de Regoyos, Barcelona, Galerías del Fayans Català, January 18–February 3, 1912.

Barcelona 1925
Dalí, Barcelona, Galerías Dalmau, November 14–27, 1925.

Barcelona 1980–81
Gran mostra d'art antic i modern, Barcelona, Sala Parés, December 5, 1980–January 5, 1981.

Barcelona 1987
Coleccionistas de arte en Cataluña, Barcelona, Palau Robert and Palau de la Virreina, June 22–July 22, 1987.

Barcelona 1989
Fortuny, 1838–1874, Barcelona, Centre Cultural, Fundació Caixa de Pensions, January 18–March 12, 1989.

Barcelona 1996–97
El Greco. Su revalorización por el modernismo catalán, Barcelona, Museu Nacional d'Art de Catalunya, December 20, 1996–March 2, 1997.

Barcelona 1998
Miquel Barceló 1987–1997, Barcelona, Museu d'Art Contemporani de Barcelona, April 3–June 21, 1998.

Barcelona 2003–4
Fortuny, Barcelona, Museu Nacional d'Art de Catalunya, October 17, 2003–January 18, 2004.

Barcelona 2004
La condición humana: el sueño de una sombra, Barcelona, Museu d'Història de la Ciutat, May 10–September 26, 2004.

Barcelona-Bilbao 2009
Joaquín Mir. Antológica 1873–1940, Barcelona, CaixaForum, February 4–April 26, 2009; Bilbao, Museo de Bellas Artes, May 18, 2009–July 26, 2009.

Barcelona-Madrid 1986–87
Darío de Regoyos 1857–1913, Barcelona, Fundació Caixa de Pensions, September 26–November 9, 1986; Madrid, Fundación Caja de Pensiones, November 21, 1986–January 12, 1987.

Barcelona-Madrid 2000
Isidre Nonell 1872–1911, Barcelona, Museu Nacional d'Art de Catalunya, February–April 2000; Madrid, Fundación Cultural Mapfre Vida, April 18–June 18, 2000.

Barcelona-Madrid 2003–4
Surrealismos, Barcelona, Oriol Galeria d'Art, September 29–November 10, 2003; Madrid, Galería Guillermo de Osma, February 6–March 31, 2004.

Basel 1933
Georges Braque, Basel, Kunsthalle, April 9–May 14, 1933.

Basel 1955
Pierre Bonnard, Basel, Kunsthalle, May 28–July 17, 1955.

Basel 1964
Fernand Léger, Basel, Galerie Beyeler, May–June 1964.

Basel 1971–72
Picasso: 90 Zeichnungen und farbige Arbeiten, Basel, Galerie Beyeler, November 20, 1971–January 15, 1972.

Basel 1987
Francis Bacon: Retrospective, Basel, Galerie Beyeler, June 12–September 12, 1987.

Basel 1996
Canto d'amore: klassizistische Moderne in Musik und bildender Kunst, 1914–1935, Basel, Kunstmuseum Basel, April 27–August 11, 1996.

Basel 2008–9
Venice: From Canaletto and Turner to Monet, Basel, Fondation Beyeler, September 28, 2008–February 15, 2009.

Basel 2012–13
Edgar Degas: The Late Work, Basel, Fondation Beyeler, September 30, 2012–January 27, 2013.

Berlin 1930
In Memoriam Juan Gris, 1887–1927, Berlin, Galerie Alfred Flechtheim, February 1930.

Berlin-Vienna 2005–6
Goya: Prophet der Moderne, Berlin, Alte Nationalgalerie, July 13–October 3, 2005; Vienna, Kunsthistorisches Museum, October 18, 2005–January 8, 2006.

Bern 1955–56
Juan Gris, Bern, Kunstmuseum, October 1955–January 1956.

Bilbao 1991–92
Luis Paret y Alcázar 1746–1799, Bilbao, Museo de Bellas Artes, December 1991–January 1992.

Bilbao 1999–2000
El bodegón español. De Zurbarán a Picasso, Bilbao, Museo de Bellas Artes, December 13, 1999–April 19, 2000.

Bilbao 2004
La obra invitada (Dos vedutas de Canaletto), Bilbao, Museo de Bellas Artes de Bilbao, July 23–September 19, 2004.

Bilbao 2008–9
La obra invitada (El Bautismo de Cristo de Juan de Flandes), Bilbao, Museo de Bellas Artes de Bilbao, October 8, 2008–January 11, 2009.

Bilbao-Madrid-Málaga 2013–14
Darío de Regoyos (1857–1913): La aventura impresionista, Bilbao, Museo de Bellas Artes de Bilbao, October 7, 2013–January 26, 2014; Madrid, Museo Thyssen-Bornemisza, February 18–June 1, 2014; Málaga, Museo Carmen Thyssen, June 26–October 12, 2014.

Bordeaux 1951
Francisco de Goya, 1746–1828, Bordeaux, Musée des Beaux-Arts, May 16–June 30, 1951.

Boston 1928
Exhibition of Paintings Loaned by Governor Alvan T. Fuller, Boston, Art Club, 1928.

Boston 1935
Independent Painters of Nineteenth Century Paris, Boston, Museum of Fine Arts, March 15–April 28, 1935.

Boston 1937
Modern French Paintings from Boston Collections, Boston, Institute of Modern Art, 1937.

Boston 1939
Art in New England: Paintings, Drawings and Prints from Private Collections in New England, Boston, Museum of Fine Arts, June 9–September 10, 1939.

Bruges 2002
Jan van Eyck de Vlaamse Primitieven en het Zuiden, Bruges, Groeningemuseum, March 15–June 30, 2002.

Bruges-Louvaine La Neuve 1985
Juan de Flandes, Bruges, Europalia 85, Memlingmuseum, Sint-Janshospitaal, October 1–November 11, 1985; Louvaine La Neuve, Musée Universitaire, November 16–December 22, 1985.

Brussels 1933
Modigliani, Brussels, Palais des Beaux-Arts, November 1933.

Brussels 1985
Europalia. Exposición Goya, Brussels, Musée des Beaux-Arts, September 26–December 22, 1985.

Budapest 1910
Nemzetközi impresszionista kiállitás, Budapest, Müvészház, April–May 1910.

Buenos Aires 2006
Picasso, Buenos Aires, Centro Cultural Borges, June 7–July 26, 2006.

Caceres 1980
Premio Cáceres de Pintura, Caceres, Diputación Provincial, 1980.

Cardiff 1962
British Art and the Modern Movement 1930–1940, Cardiff, National Museum of Wales, October 13–November 25, 1962.

Castellón 2005
Luces del Barroco, Castellón, Fundación Caja Castellón, January 27–March 27, 2005.

Chicago 1953
Antonio Puig Tàpies, Chicago, Marshall Field & Company, April 1–May 1, 1953.

Cleveland-New York 1951
Modigliani-Soutine, Cleveland, The Cleveland Museum of Art, January 13–March 18, 1951; New York, The Museum of Modern Art, April 11–June 17, 1951.

Copenhagen-Stockholm 1946–47
Norsk Konst ur Samling, Copenhagen, Kunstforeningen; Stockholm, Riksförbundet för bildande konst, 1946–47.

Dallas 2008
From Manet to Miró: Modern Drawings from the Abelló Collection, Dallas, Meadows Museum, September 14–December 2, 2008.

Dortmund-Cologne 1965–66
Juan Gris, Dortmund, Museum am Ostwall, October 23–December 4, 1965; Cologne, Wallraf-Richartz-Museum, December 29, 1965–February 13, 1966.

Düsseldorf 2000
Ich ist etwas Anderes. Kunst am Ende des 20. Jahrhunderts, Düsseldorf, Kunstsammlung Nordrhein-Westfalen, February 19–June 18, 2000.

Edinburgh 1996
Velázquez in Seville, Edinburgh, National Gallery of Scotland, August 8–October 20, 1996.

Edinburgh and traveling 1995–96
From London: Bacon, Freud, Kossoff, Andrews, Auerbach, Kitaj, Edinburgh, Scottish National Gallery of Modern Art, July 1–September 5, 1995; Luxembourg, Musée National d'Histoire et d'Art, September 22–November 5, 1995; Lausanne, Musée Cantonal des Beaux-Arts, November 16, 1995–January 31, 1996; Barcelona, Fundació Caixa de Catalunya, La Pedrera, February 16–April 16, 1996.

Frankfurt 1965
Pablo Picasso: 150 Handzeichnungen aus sieben Jahrzehnten, Frankfurt, Frankfurter Kunstverein Steinernes Haus, May 29–July 4, 1965.

Freiburg 1947
Die Meister Französischer Malerei der Gegenwart, Freiburg, Friedrichsbau, October 20–November 23, 1947.

Geneva 1999–2000
Steinlen et l'époque 1900, Geneva, Musée Rath, September 23, 1999–January 30, 2000.

Gerona 2004
Llums del Barroc, Gerona, Fundació Caixa de Girona, April 2–May 23, 2004.

Ghent 1966
El Greco 1541–1614, Ghent, Musée des Beaux-Arts, September 10–November 1, 1966.

Granada 2000
Carlos V, las armas y las letras, Granada, Hospital Real, April 14–June 25, 2000.

Haarlem-Madrid 2002–3
Flores españolas del Siglo de Oro, Haarlem, Frans Hals Museum, August 16–October 27, 2002; Madrid, Museo Nacional del Prado, November 15, 2002–February 2, 2003.

Hartford 1946
The Nude in Art, Hartford, Wadsworth Atheneum Museum of Art, January 1–February 3, 1946.

Houston 1978
Léger, Our Contemporary, Houston, Rice Museum, April 14–June 11, 1978.

Humlebæk 1989–90
Salvador Dalí, Humlebæk, Louisiana Museum of Modern Art, December 1989–March 1990.

Indianapolis-New York 1996–97
Painting in Spain in the Age of Enlightenment: Goya and his Contemporaries, Indianapolis, Indianapolis Museum of Art, November 23, 1996–January 19, 1997; New York, The Spanish Institute, Spring 1997.

La Coruña 2002–3
Picasso joven, La Coruña, Fundación Pedro Barrié de la Maza, December 17, 2002–March 17, 2003.

Las Palmas-Oviedo 2000
Colección Abelló: obra sobre papel, Las Palmas de Gran Canaria, Centro Atlántico de Arte Moderno, August 1–August 27, 2000; Oviedo, Museo de Bellas Artes de Asturias, September 5–October 1, 2000.

Las Palmas-Santa Cruz de Tenerife-Madrid 1996
Óscar Domínguez 1926–1957. Antológica, Las Palmas de Gran Canaria, Centro Atlántico de Arte Moderno, January 23–March 31, 1996; Santa Cruz de Tenerife, Centro de Arte "La Granja," April 19–May 18, 1996; Madrid, Museo Nacional Centro de Arte Reina Sofía, June 25–September 16, 1996.

Leipzig 1922
Moderne Kunst aus Privatbesitz, Leipzig, Leipziger Kunstverein im Museum am Augustplatz, April 9–May 1922.

Lille-Philadelphia 1998–99
Goya, un regard libre, Lille, Palais des Beaux-Arts, December 12, 1998–March 14, 1999; Philadelphia, Philadelphia Museum of Art, April 17–July 11, 1999.

Lisbon 2010
In the Presence of Things: Four Centuries of European Still-Life Painting. Part I: 17th–18th Centuries, Lisbon, Museu Calouste Gulbenkian, February 12–May 2, 2010.

London 1905
A Selection from the Pictures by Boudin, Cézanne, Degas, Manet, Monet, Morisot, Pissarro, Renoir, Sisley, London, Grafton Galleries, January–February 1905.

London 1934
Paintings by Francis Bacon, London, Transition Gallery, February 1934.

London 1963–64
Goya and His Times, London, The Royal Academy of Arts, December 7, 1963–March 1, 1964.

London 1971
Old Masters. Recent Acquisitions, London, Thomas Agnew and Sons, Ltd., November 2–December 10, 1971.

London 1979–80
Thirties: British Art and Design before the War, London, Hayward Gallery, October 25, 1979–January 13, 1980.

London 1986
Baroque III 1620–1700, London, Matthiesen Fine Art Ltd., June 13–August 15, 1986.

London 1990
On Classic Ground: Picasso, Léger, De Chirico and the New Classicism, 1910–1930, London, Tate Gallery, June 6–September 2, 1990.

London 1995
Spanish Still Life from Velázquez to Goya, London, National Gallery, February 22–May 21, 1995.

London 1997
An Eye on Nature: Spanish Still-Life Paintings from Sánchez Cotán to Goya, London, The Matthiesen Gallery, 1997.

London 2006
Triptychs, London, Gagosian Gallery, June 20–August 4, 2006.

London-Edinburgh 2012
Picasso and Modern British Art, London, Tate Britain, February 15–July 15, 2012; Edinburgh, The Scottish National Gallery of Modern Art, August 4–November 4, 2012.

London-Madrid 2003–4
Spanish Still-Life Painting from the 17th to the 19th Century, London, Rafael Valls Gallery, December 1–19, 2003; *Naturalezas muertas españolas de los siglos XVII al XIX*, Madrid, Galería Caylus, January 19–February 13, 2004.

London-Stuttgart-Berlin 1985–86
Francis Bacon, London, Tate Gallery, May 22–August 18, 1985; Stuttgart, Staatsgalerie, October 19, 1985–January 5, 1986; Berlin, Nationalgalerie, February 7, 1985 March 31, 1986.

London-Stuttgart-Otterlo 1992–93
Juan Gris, London, Whitechapel Art Gallery, September 18–November 29, 1992; Stuttgart, Staatsgalerie Stuttgart, December 18, 1992–February 14, 1993; Otterlo, Rijksmuseum Kröller-Müller, March 6–May 2, 1993.

Los Angeles-Montreal-Berlin 1997–98
Exiles + Emigrés: The Flight of European Artists from Hitler, Los Angeles, County Museum of Art, February 23–May 11, 1997; Montreal, Musée des Beaux-Arts, June 19–September 7, 1997; Berlin, Neue Nationalgalerie, October 9, 1997–January 4, 1998.

Lugano 1986
Goya nelle collezioni private di Spagna, Lugano, Villa Favorita, Collezione Thyssen Bornemisza, June 15–October 15, 1986.

Madrid 1900
Obras de Goya, Madrid, Ministerio de Instrucción Pública y Bellas Artes, May 1900.

Madrid 1902
Exposición de las obras de Domenico Theotocupuli, llamado El Greco, Madrid, Museo Nacional de Pintura y Escultura, May–June 1902.

Madrid 1912
Aureliano de Beruete, Madrid, Museo Sorolla, April 17, 1912.

Madrid 1917
Obras del Divino Morales, Madrid, Museo Nacional del Prado, May 1–31, 1917.

Madrid 1918
Retratos de mujeres españolas por artistas españoles anteriores a 1850, Madrid, Sociedad Española de Amigos del Arte, May–June 1918.

Madrid 1922
Exposición de dibujos originales 1750 a 1860, Madrid, Sociedad Española de Amigos del Arte, May–June 1922.

Madrid 1925
Exposición de retratos de niño en España, Madrid, Sociedad Española de Amigos del Arte, May–June 1925.

Madrid 1928
Centenario de Goya. Exposición de pinturas, Madrid, Museo del Prado, April–May 1928.

Madrid 1951
Goya, Madrid, Museo del Prado, July 1951.

Madrid 1954–55
Exposición bibliográfica mariana, Madrid, Biblioteca Nacional, December 22, 1954–1955.

Madrid 1961–62
Alonso Berruguete. Exposición conmemorativa en el IV centenario de su muerte, Madrid, Casón del Buen Retiro, December 1961–March 1962.

Madrid 1971
50 años de pintura vasca (1885–1935), Madrid, Museo Español de Arte Contemporáneo, October–December 1971.

Madrid 1975–76
Manuel Rivera. Obras 1956-1975, Madrid, Galería Juana Mordó, December 16, 1975–January 25, 1976.

Madrid 1977
Juan Gris, Madrid, Galería Theo, May–June 1977.

Madrid 1980–81
Ante el centenario de María Blanchard 1881–1981, Madrid, Galería Gavar, December 19, 1980–January 1981.

Madrid 1981
Manuel Rivera, 1956-1981. Exposición retrospectiva, Madrid, Salas del Palacio de Bibliotecas y Museos, April 1981.

Madrid 1982a
Anglada Camarasa, Madrid, Sala de Exposiciones de la Caja de Pensiones, February 8, 1982.

Madrid 1982b
María Blanchard, Madrid, Museo Español de Arte Contemporáneo, January 15–March 31, 1982.

Madrid 1983
Goya en las colecciones madrileñas, Madrid, Museo del Prado, April 19–June 20, 1983.

Madrid 1986
Juan de Flandes, Madrid, Museo del Prado, February 21–March 31, 1986.

Madrid 1987
Tesoros de las colecciones particulares madrileñas: pintura desde el siglo XV a Goya, Madrid, Real Academia de Bellas Artes de San Fernando, May 13–June 1987.

Madrid 1989a
De Fortuny a Saura. Dibujos, acuarelas y pinturas sobre papel, Madrid, Galería Caylus in collaboration with Galería Guillermo de Osma, November 16–December 16, 1989.

Madrid 1989b
Tesoros de las colecciones particulares madrileñas: pintura y escultura contemporáneas, Madrid, Real Academia de Bellas Artes de San Fernando, February 2–March 31, 1989.

Madrid 1989c
Fortuny, 1838–1874, Madrid, Fundación Caja de Pensiones, April 4–May 14, 1989.

Madrid 1990
Tres grandes maestros del paisaje decimonónico español: Jenaro Pérez Villaamil, Carlos de Haes y Aureliano de Beruete, Madrid, Centro Cultural Conde Duque, October 16–December 1990.

Madrid 1991
Tesoros de las colecciones particulares madrileñas: pinturas españolas del romanticismo al modernismo, Madrid, Real Academia de Bellas Artes de San Fernando, October–November 1991.

Madrid 1992
Ribera 1591–1652, Madrid, Museo Nacional del Prado, June 2–August 16, 1992.

Madrid 1993a
Antonio López, pintura, escultura, dibujo, Madrid, Museo Nacional Centro de Arte Reina Sofía, May 4–July 19, 1993.

Madrid 1993b
7 pintores españoles de la Escuela de París (1900–1915), Madrid, Casa del Monte, Caja de Madrid, October–November 1993.

Madrid 1995–96a
Goya en las colecciones españolas, Madrid, Sala de Exposiciones del Banco Bilbao Vizcaya, December 14, 1995–February 17, 1996.

Madrid 1995–96b
Picasso 1923: Arlequín con espejo, Madrid, Fundación Colección Thyssen-Bornemisza, November 24, 1995–February 18, 1996.

Madrid 1996–97
Pintura fruta: La figuración lírica española 1926–1932, Madrid, Sala de Exposiciones Plaza de España, November 21, 1996–January 15, 1997.

Madrid 1997
Paisaje y figura del 98, Madrid, Fundación Central Hispano, May 28–July 13, 1997.

Madrid 1998
Istmos. Vanguardias españolas 1915–1936, Madrid, Casa de las Alhajas, Fundación Caja de Madrid, October 15–December 15, 1998.

Madrid 2000a
El modernismo catalán, un entusiasmo, Madrid, Fundación Santander Central Hispano, February 29–April 23, 2000.

Madrid 2000b
Confines: miradas, discursos, figuras en los extremos del siglo XX, Madrid, Sala de Exposiciones Plaza de España, May 4–July 2000.

Madrid 2001–2a
Forma: El ideal clásico en el arte moderno, Madrid, Museo Thyssen-Bornemisza, October 9, 2001–January 13, 2002.

Madrid 2001–2b
Goya: La imagen de la mujer, Madrid, Museo Nacional del Prado, October 30, 2001–February 10, 2002.

Madrid 2001–2c
A la playa: el mar como tema de la modernidad en la pintura española, 1870–1936, Madrid, Fundación Cultural Mapfre Vida, November 14, 2000–January 21, 2001.

Madrid 2002a
La generación del 14: entre el novecentismo y la vanguardia (1906–1926), Madrid, Fundación Cultural Mapfre Vida, April 26–June 16, 2002.

Madrid 2002b
Braque, Madrid, Museo Thyssen-Bornemisza, February 5–May 19, 2002.

Madrid 2004
Luis Meléndez: Bodegones, Madrid, Museo Nacional del Prado, February 17–May 16, 2004.

Madrid 2005–6a
Luz de gas. La noche y sus fantasmas en la pintura española 1880–1930, Madrid, Fundación Cultural Mapfre Vida, November 11, 2005–January 15, 2006.

Madrid 2005–6b
Pablo Palazuelo 1995–2005, Madrid, Museo Nacional Centro de Arte Reina Sofía, October 25, 2005–January 9, 2006.

Madrid 2006
Juan Gris, Madrid, Galería Elvira González, January 12–March 12, 2006.

Madrid 2007
El espejo y la máscara: el retrato en el siglo de Picasso, Madrid, Museo Thyssen-Bornemisza, February 6–May 20, 2007.

Madrid 2007–8a
Maestros modernos del dibujo. Colección Abelló, Madrid, Museo Thyssen-Bornemisza, November 27, 2007–February 17, 2008.

Madrid 2007–8b
Durero y Cranach: arte y humanismo en la Alemania del Renacimiento, Madrid, Museo Thyssen-Bornemisza and Fundación Caja Madrid, October 9, 2007–January 6, 2008.

Madrid 2008a
Goya en tiempos de guerra, Madrid, Museo Nacional del Prado, April 14–July 13, 2008.

Madrid 2008b
Modigliani y su tiempo, Madrid, Museo Thyssen-Bornemisza and Fundación Caja Madrid, February 5–May 18, 2008.

Madrid 2009a
Francis Bacon, Madrid, Museo Nacional del Prado, February 3–April 19, 2009.

Madrid 2009b
Matisse, 1917–1941, Madrid, Museo Thyssen-Bornemisza, June 9–September 20, 2009.

Madrid 2010a
Turner y los maestros, Madrid, Museo Nacional del Prado, June 22–September 19, 2010.

Madrid 2010b
Gregorio Marañón (1887–1960): médico, humanista y liberal, Madrid, Biblioteca Nacional, March 22–June 6, 2010.

Madrid 2011
El joven Ribera, Madrid, Museo Nacional del Prado, April 5–August 28, 2011.

Madrid 2011–12
Da Vinci, el genio, Madrid, Centro de Exposiciones Canal de Isabel II, December 2, 2011–May 2, 2012.

Madrid 2012–13
Goya y el infante don Luis. El exilio y el reino: Arte y ciencia en la época de la Ilustración española, Madrid, Palacio Real, October 30, 2012–January 20, 2013.

Madrid 2014–15
Colección Abelló, Madrid, Centrocentro Cibeles de Cultura y Ciudadanía, October 2, 2014–March 1, 2015.

Madrid-Barcelona 1983
400 obras de Salvador Dalí de 1914 a 1983: exposición en homenaje a Salvador Dalí, Madrid, Museo Español de Arte Contemporáneo, April 15–May 29, 1983; Barcelona, Palau Reial de Pedralbes, June 10–July 31, 1983.

Madrid-Barcelona 1994–95
Dalí joven (1918–1930) = Dalí, els anys joves, 1918–1930, Madrid, Museo Nacional Centro de Arte Reina Sofía, October 18, 1994–January 16, 1995; Barcelona, Palau Robert, February 15–April 9, 1995.

Madrid-Barcelona 1998
España fin de siglo 1898, Madrid, Sala de Exposiciones del Ministerio de Educación y Cultura, January 13–March 29, 1998; Barcelona, Centro Cultural Fundación La Caixa, May 20–July 26, 1989.

Madrid-Bilbao 2011–12
Antonio López, Madrid, Museo Thyssen-Bornemisza, June 28–September 25, 2011; Bilbao, Museo de Bellas Artes, October 10, 2011–January 22, 2012.

Madrid-New York 1992–93
Francis Bacon, Paintings 1981–1991, Madrid, Galería Marlborough, October 8–November 14, 1992; New York, Marlborough Gallery, April 1993.

Madrid-Rome-Athens 1999–2000
El Greco, identidad y transformación: Creta, Italia, España, 1560–1600, Madrid, Museo Thyssen-Bornemisza, February 3–May 16, 1999; Rome, Palazzo delle Esposizioni, June 2–September 19, 1999; Athens, National Gallery, October 18, 1999–January 17, 2000.

Madrid-Seville 2009–10
La Generación del 27. ¿Aquel momento ya es una leyenda?, Madrid, Residencia de Estudiantes, December 2, 2009–February 28, 2010; Seville, Convento de Santa Inés, March 18–June 20, 2010.

Madrid-Valencia 2001
El Renacimiento mediterráneo: viajes de artistas e itinerarios de obras entre Italia, Francia y España en el siglo XV, Madrid, Museo Thyssen-Bornemisza, January 31–May 6, 2001; Valencia, Museo de Bellas Artes, May 18–September 2, 2001.

Málaga 1992–93
Picasso clásico, Málaga, Palacio Episcopal, October 10, 1992–January 11, 1993.

Málaga 2008
Los caminos del trazo. Dibujando con Picasso, Málaga, Fundación Picasso, Museo Casa Natal, May 14–October 5, 2008.

Málaga 2010
Picasso. Caballos = Picasso. Horses, Málaga, Museo Picasso, May 17–September 5, 2010.

Manchester 1897
Exhibition of the Royal House of Tudor, Manchester, City Art Gallery, until August 2, 1897.

Marseille 1976
Francis Bacon, oeuvres récentes, Marseille, Musée Cantini, July 9–September 30, 1976.

Mexico City 1991–92
Presencia del Museo del Prado en México y otras colecciones, Mexico City, Centro Cultural de Arte Contemporáneo Fundación Televisa, December 1991–June 1992.

Milan 2010
Goya e il mondo moderno, Milan, Palazzo Reale, March 17–June 27, 2010.

Montreal 1990
Salvador Dalí, Montreal, Musée des Beaux-Arts, April 27–July 29, 1990.

Munich-Paris 1966–67
Pierre Bonnard, Munich, Haus der Kunst, October 8, 1966–January 1, 1967; Paris, Musée National de l'Orangerie des Tuileries, January 13–April 13, 1967.

Murcia-Alicante-Madrid 2007
Benjamín Palencia y el origen de la poética de Vallecas, Murcia, Palacio Almudí, January 25–March 1, 2007; Alicante, Museo de Bellas Artes Gravina, March 8–April 8, 2007; Madrid, Real Academia de Bellas Artes de San Fernando, April 13–May 20, 2007.

Naples 1992
Jusepe de Ribera 1591–1652, Naples, Castel Sant'Elmo, Certosa di San Martino and Cappella del Tesoro di San Gennaro, February 27–May 17, 1992.

Naples 2009–10
Ritorno al Barocco. Da Caravaggio a Vanvitelli, Naples, Museo di Capodimonte, Certosa e Museo di San Martino, Castel Sant'Elmo, Museo Pignatelli, Museo Duca di Martina and Palazzo Reale, December 12, 2009–April 11, 2010.

New Haven and travelling 1999
Francis Bacon: A Retrospective, New Haven, Yale Center for British Art, January 23–March 21, 1999; Minneapolis, Minneapolis Institute of Arts, April 8–May 27, 1999; San Francisco, Fine Arts Museums of San Francisco, June 13–August 2, 1999; Fort Worth, Modern Art Museum of Fort Worth, August 20–October 15, 1999.

New York 1959
New Acquisitions, New York, Sidney Janis Gallery, October 26–November 28, 1959.

New York 1960–61
Fernand Léger: Selected works from the Years 1918–1954, New York, Sidney Janis Gallery, December 5, 1960–January 7, 1961.

New York 1984
Francis Bacon: Recent Paintings, New York, Marlborough Gallery, May 5–June 5, 1984.

New York 1986
Important Old Master Paintings and Discoveries of the Past Year, New York, Piero Corsini Inc., November 1986.

New York 1987
Francis Bacon, Paintings of the Eighties, New York, Marlborough Gallery, May 7–July 31, 1987.

New York 1992
Jusepe de Ribera 1591–1652, New York, The Metropolitan Museum of Art, September 18–November 29, 1992.

New York 2000
On Paper: Selected Drawings of the 19th and 20th Century, New York, Marlborough Gallery, January 18–February 19, 2000.

New York 2002
Francis Bacon: Paintings, New York, Marlborough Gallery, November 4–December 7, 2002.

New York-Buffalo-Boston 1909
Paintings by Joaquín Sorolla y Bastida Exhibited by The Hispanic Society of America, New York, The Hispanic Society of America, February 8–March 8, 1909; Buffalo, Fine Arts Academy, March 20–April 10, 1909; Boston, Copley Society, April 20–May 11, 1909.

New York-Houston 2012–13
Picasso Black and White, New York, Solomon R. Guggenheim Museum, October 5, 2012–January 23, 2013; Houston, The Museum of Fine Arts, February 20–May 28, 2013.

Oslo 1948
Rolf Sternersens samling, Oslo, Kunstnernes Hus, 1948.

Oslo 1994
Edvard Munch Portretter, Oslo, Munch Museum, January 23–May 3, 1994.

Oslo 2003–4
Stenersens Munch, Oslo, Stenersenmuseet, June 25, 2003–January 18, 2004.

Oslo and travelling 1987–88
A School of London: Six Figurative Painters, Oslo, Kunstnernes Hus, May–June 1987; Humlebæk, Louisiana Museum for Moderne Kunst, June–August 1987; Venice, Ca'Pesaro, September–October 1987; Düsseldorf, Kunstmuseum, November 1987–January 1988.

Oslo-Copenhagen-Stockholm 1938
Matisse, Picasso, Braque, Laurens, Oslo, Kunstnernes Hus, January 1938; Copenhagen, Statens Museum for Kunst, February 1938; Stockholm, Liljevachs Konsthall, March 1938.

Oslo-Kragerø-Stavanger 1936
Munch fra Rolf Stenersen Samling, Oslo, Kunstnernes Hus; Kragerø, Kunstforening; Stavanger, Kunstforening, 1936.

Oviedo 1997
Pinturas recuperadas, Oviedo, Museo de Bellas Artes de Asturias, May–June 1997.

Paredes de Nava 2003
Pedro Berruguete. El primer pintor renacentista de la Corona de Castilla, Paredes de Nava (Palencia), Iglesia Parroquial de Santa Eulalia, April 4–June 8, 2003.

Paris 1907
Salon des Indépendants, Paris, March 20–April 30, 1907.

Paris 1910
Salon des Indépendants, Paris, March–April 1910.

Paris 1924
Exposition Henri Matisse, Paris, Galerie Bernheim-Jeune, May 1924.

Paris 1964
Collection Andrée Lefèvre, Paris, Musée National d'Art Moderne, March–April 1964.

Paris 1975
Degas 1834–1917, Paris, Galerie Schmit, May 15–June 21, 1975.

Paris 1976
Manuel Rivera, Paris, Musée d'Art Moderne de la Ville de Paris, February 11–March 21, 1976.

Paris 1980
Picasso: Peintures 1901–1971, Paris, Galerie Claude Bernard, June 1980.

Paris 1984
Francis Bacon, peintures récentes, Paris, Galerie Maeght Lelong, January 18–February 25, 1984.

Paris 1998–99
L'École de Londres: De Bacon à Bevan, Paris, Fondation Dina Vierny-Musée Maillol, October 10, 1998–January 20, 1999.

Paris 2005
Bacon-Picasso: la vie des images, Paris, Musée Picasso, March 2–May 30, 2005.

Paris-Houston 2013–14
Georges Braque, 1882–1963, Paris, Grand Palais, Galeries Nationales, September 16, 2013–January 6, 2014; Houston, The Museum of Fine Arts, February 16–May 11, 2014.

Paris-London 1952
L'Oeuvre du XXe siècle, Paris, Musée National d'Art Moderne, May–June 1952; London, Tate Gallery, July–August 1952.

Paris-Munich 1996–97
Francis Bacon, Paris, Centre Georges Pompidou, June 27–October 14, 1996; Munich, Haus der Kunst, November 4, 1996–January 31, 1997.

Paris-New York 1984–85
Exhibition of Paintings by Fernand Léger, Paris, Grand Palais, October 19–28, 1984; New York, Sidney Janis Gallery, December 6, 1984–January 5, 1985.

Paris-Ottawa-New York 1988–89
Degas, Paris, Galeries Nationales du Grand Palais, February 9–May 16, 1988; Ottawa, National Gallery of Canada, June 16–August 28, 1988; New York, The Metropolitan Museum of Art, September 27, 1988–January 8, 1989.

Pau 1876
Tableaux exposés dans les Salons de l'ancien asile de Pau appartenant aux héritiers de feu Mgr. L'Infant don Sébastien de Bourbon et Bragance, Pau, September 1876.

Recklinghausen 1956
Beginn und Reife. 10. Ruhrfestspiele, Recklinghausen, Kunsthalle Recklinghausen, June 17–July 30, 1956.

Reus 1989
Exposicio Fortuny, Reus, Museu Comarcal Salvador Vilaseca, June 1989.

Rio de Janeiro 2000
Esplendores de Espanha de El Greco a Velázquez, Rio de Janeiro, Museo Nacional de Bellas Artes, July 11–September 24, 2000.

Rio de Janeiro 2002
España Siglo XVIII: El Sueño de la Razón, Rio de Janeiro, Museo Nacional de Bellas Artes, July 4–August 25, 2002.

Rome 2005
Canaletto. Il trionfo della veduta, Rome, Senato della Repubblica, Palazzo Giustiniani, March 12–June 19, 2005.

Rome 2006
Amedeo Modigliani, Rome, Complesso del Vittoriano, February 24–June 20, 2006.

Roslyn Harbor 1993
Intimates and Confidants in Art: Husbands, Wives, Lovers and Friends, Roslyn Harbor (NY), Nassau County Museum of Art, February 28–May 23, 1993.

Roslyn Harbor 1994
From Botticelli to Matisse: Masterpieces of the Guccione Collection, Roslyn Harbor (NY), Nassau County Museum of Art, January 16–March 20, 1994.

Rotterdam 1928–29
Christmas Exhibition, Rotterdam, Museum Boijmans Van Beuningen, 1928–29.

Rotterdam 1933
Tentoonstelling 115 Stillevens 1480–1933 in het Museum Boymans, Rotterdam, Museum Boijmans Van Beuningen, April 1–23, 1933.

Rotterdam 1970–71
Dalí, Rotterdam, Museum Boijmans Van Beuningen, November 21, 1970–January 10, 1971.

Saint-Étienne 1994–95
Réalités Noires, Saint-Étienne, Musée d'Art Moderne, December 18, 1994–March 19, 1995.

Saint-Paul de Vence 2002
Mapamundi, Saint-Paul de Vence, Fondation Maeght, April 12–June 20, 2002.

Salamanca 1999
La Tauromaquia en la pintura española (de Fortuny a nuestros días), Salamanca, Sala de Exposiciones San Eloy Caja Duero, October–December 1999.

Salamanca 2005
Imágenes de un siglo: luces del Barroco, Salamanca, University, Patio de Escuelas, July–August 2005.

Santander 1992
Grandes maestros de las vanguardias históricas en la colección de Juan Abelló. De Picasso a Bacon, Santander, Museo de Bellas Artes, August 6–31, 1992.

Santander 1993
Obras maestras de arte antiguo en la Colección Juan Abelló, Santander, Museo Municipal de Bellas Artes, July 1–30, 1993.

Santander 1994
Obras sobre papel en la Colección Juan Abelló, Santander, Museo de Bellas Artes, August 3–September 5, 1994.

Santander-Madrid 2012–13
María Blanchard cubista, Santander, Fundación Botín, June 23–September 16, 2012; Madrid, Museo Nacional Centro de Arte Reina Sofía, October 17, 2012–February 25, 2013.

Segovia 2000–1
Picasso en las colecciones españolas, Segovia, Museo de Arte Contemporáneo Esteban Vicente, October 10, 2000–January 14, 2001.

Segovia 2001–2
Dalí en las colecciones españolas, Segovia, Museo de Arte Contemporáneo Esteban Vicente, October 9, 2001–January 6, 2002.

Segovia-Soria 2007
Antonio Machado en Castilla y León, Segovia, Torreón de Lozoya, February 15–April 8, 2007; Soria, Palacio de la Audiencia, April 17–June 15, 2007.

Seville 1992
Arte y cultura en torno a 1492, Seville, Monasterio de Santa María de las Cuevas, May 18–October 12, 1992.

Seville-Bilbao 2005–6
De Herrera a Velázquez. El primer naturalismo en Sevilla, Seville, Hospital de los Venerables, November 29, 2005–February 28, 2006; Bilbao, Museo de Bellas Artes, March 20–June 18, 2006.

Seville-Madrid 1996–97
Pintura española recuperada por el coleccionismo privado, Seville, Hospital de los Venerables, December 1996–February 1997; Madrid, Real Academia de Bellas Artes de San Fernando, February–April 1997.

Seville-Madrid-Oviedo 1998
El Greco conocido y redescubierto, Seville, Fundación Focus, Hospital de los Venerables, March–April 1998; Madrid, Fundación Central Hispano, May–June 1998; Oviedo, Museo de Bellas Artes de Asturias, June–July 1998.

Stockholm 1937
Edvard Munch, Stockholm, Konstakademien, 1937.

Stockholm 1954
Cézanne till Picasso, Stockholm, Liljevalchs Konsthall, September 1954.

Stuttgart-Zurich 1989
Salvador Dalí, 1904–1989, Stuttgart, Staatsgalerie, May 13–July 23, 1989; Zurich, Kunsthaus, August 18–October 22, 1989.

Tokyo 1988–89
Francis Bacon, Paintings, Tokyo, Marlborough Fine Art, October 18, 1988–January 21, 1989.

Tokyo-Nagoya-Kyoto 1964
Dalí, Tokyo, Prince Hotel Gallery, September 8–October 18, 1964; Nagoya, Prefectural Museum of Art, October 23–30, 1964; Kyoto, Municipal Art Gallery, November 3–29, 1964.

Toledo 2003
De Tàpies a Barceló, Toledo, Real Fundación de Toledo, June 7–September 15, 2003.

Toledo-Innsbruck 1992
Reyes y mecenas. Los Reyes Católicos, Maximiliano I y los inicios de la casa de Austria en España = Hispania-Austria: die katholischen Könige, Maximilian I. und die Anfänge der Casa de Austria in Spanien, Toledo, Museo de Santa Cruz, March 12–May 31, 1992; Innsbruck, Schloss Ambras, July 3–September 20, 1992.

Valencia 1994–95
El mundo de los Osona, ca. 1460–ca. 1540, Valencia, Museo de Bellas Artes San Pío V, November 29, 1994–February 23, 1995.

Valencia 2007
Reino y ciudad. Valencia en su historia, Valencia, Convento del Carmen, April 18–July 15, 2007.

Valencia 2009a
La Edad de Oro del arte valenciano. Rememoración de un centenario, Valencia, Museo de Bellas Artes, February 1, 2009–April 27, 2009.

Valencia 2009b
Maestros modernos del dibujo. Colección Abelló, Valencia, Centro del Carmen, January 13–March 29, 2009.

Valencia 2010
De Gaudí a Picasso. El modernismo catalán, Valencia, Instituto Valenciano de Arte Moderno, March 15–June 27, 2010.

Valencia and traveling 1994–95
Benjamín Palencia y el arte nuevo: obras 1919–1936, Valencia, Sala Bancaja, September–November 1994; Albacete, Museo de Albacete, November 1994–January 1995; Castellón; Murcia; Valladolid; Vigo; León; Santander; Madrid, Museo Nacional Centro de Arte Reina Sofía, September 20–November 27, 1995.

Valencia-Florence 1998
Los Hernandos, pintores hispanos del entorno de Leonardo / Ferrando Spagnuolo e altri maestri iberici nell'Italia di Leonardo e Michelangelo, Valencia, Museo de Bellas Artes San Pío V, March 5–May 5, 1998; Florence, Casa Buonarroti, May 19–July 30, 1998.

Valencia-Paris 2003–4
Francis Bacon: lo sagrado y lo profano = Francis Bacon: le sacré et le profane, Valencia, Instituto Valenciano de Arte Moderno, December 11, 2003–March 21, 2004; Paris, Fondation Dina Vierny – Musée Maillol, April 7–June 30, 2004.

Venice 1952
XXVI Biennale di Venezia, Venice, June 14–October 19, 1952.

Venice 1989
Goya, 1746–1828, Venice, Museo d'Arte Moderna Ca' Pesaro, May 7–July 30, 1989.

Venice 1998
Picasso 1917–1924: il viaggio in Italia, Venice, Palazzo Grassi, March 14–July 12, 1998.

Venice 2005
La Biennale di Venezia: 51 Esposizione Internazionale d'Arte. L'esperienza dell'arte, Venice, Padiglione Italia, June 10–November 6, 2005.

Venice and traveling 1993–96
The Unknown Modigliani. Drawings from the Collection of Paul Alexandre = Modigliani desconocido: dibujos de la antigua colección de Paul Alexandre, Venice, Palazzo Grassi, September 4, 1993–January 4, 1994; London, The Royal Academy of Arts, January 11–April 4, 1994; Cologne, Museum Ludwig, April 15–July 10, 1994; Bruges, Kunstcentrum Oud Sint-Jan, July 16–October 2, 1994; Tokyo, The Ueno Royal Museum, October 14–December 25, 1994; Lisbon, Culturgest, January 6–February 26, 1995; Madrid, Museo Nacional Centro de Arte Reina Sofía, October 3, 1995–January 9, 1996; Bilbao, BBV San Nicolás Building, December 5, 1995–January 6, 1996.

Venice-Philadelphia 2004–5
Salvador Dalí, Venice, Palazzo Grassi, September 12, 2004–January 16, 2005; Philadelphia, Philadelphia Museum of Art, February 16–May 30, 2005.

Vienna 2001
El Greco, Vienna, Kunsthistorisches Museum, May 4–September 2, 2001.

Vienna-Basel 2003–4
Francis Bacon und die Bildtradition, Vienna, Kunsthistorisches Museum Wien, October 15, 2003–January 18, 2004; Basel, Fondation Beyeler, February 8–June 20, 2004.

Vigo 1996–97
El Realismo en sus raíces, Vigo, Centro Cultural Caixavigo, December 1996–January 1997.

Washington 1986–87
Henri Matisse, The Early Years in Nice, 1916–1939, Washington D. C., National Gallery of Art, November 2, 1986–March 29, 1987.

Yokohama 1992
Joan Miró: Centennial Exhibition; the Pierre Matisse Collection, Yokohama, Yokohama Museum of Art, January 11–March 25, 1992.

Zaragoza 1981
María Blanchard (1881–1932), Zaragoza, Museo e Instituto de Humanidades Camón Aznar, February–March 1981.

Zaragoza 1996
Realidad e imagen: Goya 1746–1828, Zaragoza, Museo de Bellas Artes, October 3–December 1, 1996.

Zaragoza 2005–6
Juan Gris. Dibujos, Zaragoza, Museo Pablo Gargallo, October 9, 2005–January 8, 2006.

Zaragoza 2007
Francisco Bayeu y sus discípulos, Zaragoza, Sala de Exposiciones Cajalón, April 19–June 15, 2007.

Zaragoza 2008
Del Ebro a Iberia, Zaragoza, Museo Ibercaja Camón Aznar, May 30–September 28, 2008.

Zaragoza 2008–9
Goya y el mundo moderno, Zaragoza, Fundación Goya en Aragón, December 18, 2008–March 8, 2009.

Zurich and traveling 1957
The Moltzau Collection, from Cézanne to Picasso, Zurich, Kunsthaus, February 9–March 31, 1957; The Hague, Gemeentemuseum's Gravenhage, April 19–June 11, 1957; Edinburgh, Royal Scottish Academy, August 13–September 20, 1957; London, Tate Gallery, October 3–November 2, 1957.

Abelló Pascual, Juan, 15, 115

Alacuás, Master of, 22
Annunciation (Marquis of Mascarell's collection), 22

Alenza y Nieto, Leonardo, 98 (cat. 40), 99 (cat. 41–42)
Genre Scene, 98 (cat. 40)
Lady in a Landscape, 99 (cat. 42)
Lady on the Balcony, 99 (cat. 41)

Alexandre, Jean, 136

Alexandre, Paul Dr., 134–38, 140, 142

Alfonso the Magnanimous, King of Aragon, 23

Álvarez Collection, Villafranca del Penedés, 23

Ana Mauricia, Infanta of Spain, 42

Ana of Austria, Infanta of Spain, 42

Anglada Camarasa, Hermenegildo, 120 (cat. 56)
Mujer en un palco (*Woman in a Theater Box*), 120 (cat. 56)

Arellano, Juan de, 16, 56–57 (cat. 15–16)
Basket of Flowers on a Stone Cornice (P499), 56–57 (cat. 15)
Basket of Flowers on a Stone Cornice (P500), 56–57 (cat. 16)

Armagnac, General d', 26

Arteche, Julio de, 82

Artés, Master of (Pere Cabanes?), 30–31 (cat. 4)
Altarpiece of the Last Judgment (Museo de Bellas Artes, Valencia), 30
The Adoration of the Shepherds, 30–31 (cat. 4)

Arundel, Earl of, 40

Ault, Lee and Isabel, 139

Baço, Jaume, "Jacomart", 20–21 (cat. 1), 22–23
Adoration of the Kings (Álvarez Collection of Villafranca del Penedés), 23
Coronation of the Virgin (Museum of Fine Arts, Boston), 23
The Virgin and Child Enthroned among Musician Angels, 20–21 (cat. 1)

Bacon, Francis, 15–16, 190 (cat. 102), 191 (cat. 103), 194–97 (cat. 105)
Composition, 190 (cat. 102)
Étude d'un portrait (*Study for a Portrait*), 191 (cat. 103)

Three Studies for a Portrait of Peter Beard, 192–93 (cat. 104)
Triptych, 194–97 (cat. 105)

Barajas, Countess of, 42

Barbari, Jacopo de, 33

Barbate, Count of, 86

Barceló, Miquel, 186–87 (cat. 100)
536 Kilos, 186–87 (cat. 100)

Bayeu y Subías, Francisco, 86–87 (cat. 33–34)
Allegory of The Common Good, 86–87 (cat. 33)
Allegory of The Common Good, first sketches (Museo de Bellas Artes, Zaragoza), 87
Allegory of The Common Good, preparatory drawing (Museo Nacional del Prado, Madrid), 87
Allegory of Virtue and Honor, 86–87 (cat. 34)
Allegory of Virtue and Honor, first sketches (Museo de Bellas Artes, Zaragoza), 87
The Surrender of Granada (Musée du Louvre, Paris), 86

Bayeu, Josefa, 16, 95

Beard, Peter, 192–93

Bellanger, A. Collection, 172

Bellini, Giovanni, 154
Young Woman with a Mirror (Kunsthistorisches Museum, Vienna), 154

Bellotto, Bernardo, 73

Bernard, Claude, 156, 191–92

Berruguete, Pedro, 24–25 (cat. 2), 25
The Virgin Nursing the Child, 24–25 (cat. 2)
Virgin and Child (Cathedral, Palencia), 25

Beruete, Aureliano de, 108–9 (cat. 48), 110–11 (cat. 49)
View of the Guadarrama Mountain Range, 110–11 (cat. 49)
View of Toledo from Los Cigarrales, 108–9 (cat. 48)

Blanchard, María, 152 (cat. 74)
Naturaleza muerta (*Still Life*), 152 (cat. 74)

Blanco Soler Collection, 121

Boix, Félix, 82

Bonastre, Joan de, 23

Bonastre, Master of, 23
Transfiguration (chapel of Canon Joan de Bonastre at Valencia Cathedral), 23

Bonavia, Giacomo, 73

Bonnard, Pierre, 128–29 (cat. 61), 130–31 (cat. 62)
Misia au corsage rose (*Misia in a Pink Blouse*), 128–29 (cat. 61)
Nu sur fond bleu (*Nude on a Blue Background*), 130–31 (cat. 62)

Borbón, Francisco de, see Marchena, Duke of

Boucher, François, 82

Brancusi, Constantin, 16, 134, 136, 138, 139 (cat. 67), 140
Femme nue debout (*Standing Female Nude*), 139 (cat. 67)

Braque, Georges, 144 (cat. 70), 146, 148, 150
Rhum et guitare (*Rum and Guitar*), 144 (cat. 70)

Bresch, Margaret, 166

Broschi, Carlo, see Farinelli

Brugada, Antonio, 90, 100–1 (cat. 43)
Bullfight at the Plaza Mayor of Carabanchel Alto (*Madrid*) 100–1 (cat. 43)

Busquets Miró, Joan, 120

Cabanes, Pere, see Artés, Master of

Canal, Bernardo, 67

Canaletto, Giovanni Antonio Canal, 17, 66–69 (cat. 21–22), 70, 73
The Grand Canal of Venice from the Campo di San Vio, 66–69 (cat. 22)
Venice Docks near the Piazza di San Marco, 66–69 (cat. 21)

Caravaggio, Michelangelo Merisi da, 48

Carreño de Miranda, Juan, 63
Geometría práctica, 63
Principios para estudiar el nobilísimo y real arte de la pintura, 63

Casa Torres, Marquis of, 90, 95

Casas y Carbó, Ramón, 118 (cat. 54), 119 (cat. 55)
Señora en la biblioteca (*Lady in the Library*), 119 (cat. 55)
Teatro Novedades (*The Novedades Theater*), 118 (cat. 54)

Castillo, José del, 78–79 (cat. 28)
Still Life with Mallards, Wood Pigeons and Shotgun, 78–79 (cat. 28)

Catherine of Aragon, 40

Ceán Bermúdez, Juan Agustín, 52, 82

Celano, Tomasso da, 38
Vita Beati Francisci, 38

Cézanne, Paul, 135, 150
Boy in a Red Waistcoat (National Gallery of Art, Washington), 135

Chagall, Marc, 180–81 (cat. 95)
Maternité a la chevre d'or (*Maternity with Golden Goat*), 180–81 (cat. 95)

Champalimaud, António, 70

Chanel, "Coco" (Chanel, Gabrielle Bonheur), 128

Charles II, King of Spain, 58

Charles III, King of Spain, 62, 82, 84, 86

Charles IV, King of Spain, 76, 80, 86, 88

Charles IX, King of France, 40

Charles of Austria, 40

Chase, Mrs. Edna Woolman, 176

Chaus Collection, 66

Clark, James H. and Lillian B., 150

Cochrane, Peter, 190

Cocteau, Jean, 167

Corbelline Collection, 140

Corner, Giacomo, 67

Corsini, Piero, 46

Cosida, Juan, 46

Cosida, Juan Francisco, 46, 48

Cosida, Pedro, 46, 48

Cottreau, M., 62

Coutot, Maurice, 172

Cox, Mr. and Mrs. Oscar Collection, 162

Cranach the Elder, Lucas, 34–35 (cat. 6)
The Virgin Lactans, 34–35 (cat. 6)

Cranach the Younger, Lucas, 34

Cremer, Joseph, 32

Dal Borgo di Primo Collection, 38

Dalí de Bas, Monserrat, 178

Dalí, Salvador, 176–77 (cat. 93), 178–79 (cat. 94)
Portrait of the Artist's Father and Sister, 178–79 (cat. 94)
Rostro invisible / Ruinas con cabeza de Medusa y paisaje (*Invisible Face / Ruins with Medusa's Head and Landscape*), 176–77 (cat. 93)

Dalmau, Luis, 23

Degas, Edgar, 16, 124–27 (cat. 59–60)
Après le bain, femme nue s'essuyant (*After the Bath, Woman Drying Herself*) 124–26 (cat. 59)
La Sortie du bain (*After the Bath*), 124–25, 127 (cat. 60)

Depeyre, Gaby, 164

Derain, André, 165

Dermit, Édouard, 167

Diaghilev, Serge, 154

Dillon, Harold, 17th Viscount Dillon, 40

Dillon, Henry, 11th Viscount Dillon, 40

Dominguín, Luis Miguel, 171
Toros y toreros, 171

Dongen, Kees van, 132–33 (cat. 63), 136
Jeune fille au robe rouge (*Dolly van Dongen*) (*Girl in a Red Dress*), 132–33 (cat. 63)

Duveen, Joseph, 46

Edwards, Alfred, 128

Edwards, John, 195

Elizabeth I, Queen of Great Britain, 40

Elizabeth of Austria, 40, 42

Elizabeth of Valois, Queen of France, 40

Esche, Dr. Alfred, 132

Espinós, Benito, 80–81 (cat. 29–30)
Still Life with Flowers on a Cornice, 80–81 (cat. 29)
Still Life with Flowers and a Glass Vase on a Cornice, 80–81 (cat. 30)

Espinosa, Juan de, 52

Farinelli (Broschi, Carlo), 73

Farkas, George, 46

Feigen, Richard L., 46

Ferdinand III of Germany, Emperor, 42

Ferdinand VI, King of Spain, 72–74

Ferdinand VII, King of Spain, 88, 91

Fernández, Juan, "El Labrador", 54

Fiori, Mario dei, see Nuzzi, Mario, 56

Flandes, Juan de, 15, 26–27 (cat. 3), 28–29
Baptism: The Birth and Naming of John the Baptist (Cleveland Museum of Art, John L. Severance Fund), 29
Ecce Agnus Dei (Narodni Muzej, Belgrade) 29
Polyptych of Isabella the Catholic, 29
The Baptism of Christ, 15, 26–27 (cat. 3), 28
The Beheading of Saint John the Baptist (Musée d'art et d'histoire, Geneva) 29
The Feast of Herod (Museum Mayer van den Bergh, Antwerp), 29

Fol, Walther, 106

Ford II, Henry, 172

Fortuny Marsal, Mariano, 106–7 (cat. 47)
Arab Fantasia (Art Museum, Baltimore), 106
Arabian Fantasia, 106–7 (cat. 47)

Fourdinier, Micaela, 83

François, Monsieur et Madame, 162

Frenne, Ernest de, 140

Fuller, Peter, 124

Gabriel, Infante of Spain, 86

Gala (Elena Ivanovna Diakonova), 176

Galarza, Juana, 90–92

Galarza, Tomasa de, 90

Gamazo, Anna, 15

Gamazo, Count of, Collection, 56

Ganowitz, Morris, 172

García Hidalgo, José, 63

Giaquinto, Corrado, 78

Giner de los Ríos, Francisco, 110

Godoy, Manuel, 76

Gogh, Vincent van, 122, 156

Goicoechea, Esteban de, 90

Goicoechea, Gumersinda, 90–91, 94

Goicoechea, Manuela, 91

Goicoechea, Martín Miguel de, 90–91, 93–94

González Velázquez, Antonio, 82

González Velázquez, Zacarías, 88–89 (cat. 35–36)
Angels Bearing the Attributes of the Passion, 88–89 (cat. 36)
Eucharist (Royal Palace, Aranjuez), 88
Fresco decorations in the Queen's Casino (Instituto del Patrimonio Histórico Español), 88
The Eternal Father with Angels of the Passion, 88–89 (cat. 35)

González, Mariana, 87–88

González, Vicente, 88

Goupil, Adolphe, 106

Goya y Bayeu, Javier, 91

Goya y Lucientes, Francisco de, 16, 90–95, 98–100, 102, 110

Asamblea de la Compañía Real de las Filipinas (Musée Goya, Castres), 91
Caprichos (Caprices), 91, 98
Doña Josefa Bayeu, 95 (cat. 39)
La Tauromaquia (The Tauromachy), 102
Los desastres de la Guerra (The Disasters of War), 90
Majas on a Balcony (The Metropolitan Museum of Art, New York), 99
Pinturas Negras (Black Paintings), 102
Portrait of Gumersinda Goicoechea (private collection, France), 91
Portrait of Javier Goya (private collection, France), 91
Portrait of Juana Galarza de Goicoechea, 90–92 (cat. 38), 94
Portrait of Martín Miguel de Goicoechea, 90–91, 93 (cat. 37), 94

Goya, Mariano, 90, 94

Greco, El (Domenikos Theotokopoulos), 16, 38–39 (cat. 8)
The Disrobing of Christ, 38
The Stigmatization of Saint Francis, 38–39 (cat. 8)

Gris, Juan, 16, 146 (cat. 71), 148 (cat. 72)
La Casserole (The Pot), 148 (cat. 72)
Femme assise o L'Écossaise (Seated Woman or The Scotswoman), 146 (cat. 71)

Guardi, Francesco, 12–13, 16–17, 70–71 (cat. 24)
The Grand Canal of Venice, 12–13, 70–71 (cat. 24)
The Grand Canal with San Simenone Piccolo (The Akademie der Bildenden Künste, Vienna), 70
The Grand Canal with San Simeone Piccolo and Santa Lucia (Museo Thyssen-Bornemisza, Madrid), 70
The Grand Canal with San Simeone Piccolo and Santa Lucia, preparatory drawing (Académie des Beaux-Arts, Paris), 70
The Isle of San Cristoforo, near Murano, Venice, 12–13, 70–71 (cat. 23)
The Isle of San Cristoforo, preparatory drawing (Musée des Beaux-Arts, Dijon), 70

Guccione, Robert, 124

Gudin, Théodore, 100

Guillaume, Paul, 140, 163

Gussie, see Dongen, *Dolly van*

Gutiérrez de Calderón, Enrique, 82, 104

Guus, see Preitinger, Augusta

Hahn, Willy, 161

Halvorsen, Walter, 163

Hamen y León, Juan van der, 16, 50–51 (cat. 12), 52, 54, 56
Pears and Grapes in a Fruit Bowl, 50–51 (cat. 12)

Haye-Montbault, Count of, 62

Henriquet, Alec, 124

Henriquet, Alexandre, 124

Henry VIII, King of England, 40

Hohenlohe, Princess of, 102

Isabel of Farnesio, Queen of Spain, 73

Isabella the Catholic, Queen of Castile, 15, 28, 29

Jacomart, see Baço, Jaume

Játiva, Master of, 30

John II, King of Castile, 28

Joli de Dipi, Antonio, 16, 72–75 (cat. 25–26)
View of the Plaza of the Church of San Antonio of Aranjuez from the North, 72–75 (cat. 26)
View of the Royal Palace of Aranjuez from the Northeast, with King Ferdinand VI of Spain and Queen Maria Barbara of Bragança, 72–75 (cat. 25)

Kann, Alphonse, 146

Keeton, Kathy, 124

Kessel the Younger, Jan van, 58–59 (cat. 17–18)
Portrait of Charles II, 58–59 (cat. 17)
Portrait of Mariana of Neuburg, 58–59 (cat. 18)

Kleinmann, A. Collection, 140

Koenigs, Franz, 122

Koklova, Olga, 154

La Romana, Marquis of, 98

Labrador, El, see Fernández, Juan, "El Labrador"

Lee, Lady Charlotte, 40

Lee, Sir Eduard, Earl of Lichfield, 40

Lee, Sir Henry, 40

Lefèvre, André, 146

Léger, Fernand, 150 (cat. 73)
Nature morte (Still Life), 150 (cat. 73)

Leonardo da Vinci, 32, 33, 36
Christ as the *Salvator Mundi*, 32, 33

Lichfield, Earl of, 40

List, Herbert, 170

López García, Antonio, 183 (cat. 97)
Bodegón de la pistola (Still Life with Pistol), 183 (cat. 97)

Louis I, King of Spain, 63

Louis XIII, King of France, 42

Louis XIV, King of France, 42, 63

Louis-Philippe d'Orléans, King of France, 32

Lucas Velázquez, Eugenio, 102–3 (cat. 44), 104–5 (cat. 45–46)
The Goring, 102–3 (cat. 44)
Oriental Landscape (I), 104–5 (cat. 45)
Oriental Landscape (II), 104–5 (cat. 46)
Stagecoach in the Storm (Musée du Louvre, Paris, deposit at the Musée Goya, Castres), 102

Luis de Borbón, Infante of Spain, 82, 84

Macarrón Company, 108

Madrazo, José de, 98

Maeght, Adrien, 180

Maella, Mariano Salvador, 78

Mancini, Giulio, 48
Considerazioni sulla pittura, 48

Marchena, Duke of (Borbón, Francisco de), 76

Margaret of Austria, Queen of Spain, 42

Maria Barbara of Bragança, Queen of Spain, 72, 73, 74

Maria Isabel of Bragança, Queen of Spain, 88

María Luisa Gabriela of Savoy, Queen of Spain, 17, 62–63, 65

Maria Manuela, Princess of Portugal, 40

Maria of Austria, Infanta of Spain, 42

Mariana of Neuburg, Queen of Spain, 58

Mariana Victoria, Infanta of Spain, 86

Mariblanca (sculpture of Venus), 73

Marie Louise d'Orléans, Queen of Spain, 58

Martin, Paul, 140

Mary I, Queen of England, 40

Mary Tudor, Queen of England, 40

Matarazzo Sobrinho, Francisco, 66

Matisse, Henri, 172–73 (cat. 91)
Liseuse accoudée à une table, devant une tenture relevée (Reader Leaning on a Table in front of a Gathered Curtain), 172–73 (cat. 91)
Odalisques, 172

Maupoil, Mr., 168

Mazarin, Cardinal, 42

Meléndez, Francisco Antonio, 63

Meléndez, Luis Egidio, 76–77 (cat. 27)
Self-portrait (Musée du Louvre, Paris), 77
Still Life (Masaveu Collection, Oviedo), 77
Still Life with Partridges, Cloves of Garlic, Mug and Kitchen Utensils, 76–77 (cat. 27)
Still Life with Salmon, Oysters, Plates of Eggs, Garlic and Containers, 76

Meléndez, Miguel Jacinto, 17, 62–63, 64–65 (cat. 19–20)
Portrait of María Luisa Gabriela of Savoy, 17, 62–63, 65 (cat. 20)
Portrait of María Luisa Gabriela of Savoy (Meadows Museum, Southern Methodist University, Dallas), 17
Portrait of Philip V, 17, 62–64 (cat. 19)
Portrait of Philip V (Meadows Museum, Southern Methodist University, Dallas), 17

Menia, Il, see Rinaldi, Raffaello

Michelangelo Buonaroti, 195

Mir, Joaquín, 117 (cat. 53)
Mercado de pescado en la playa (Fish Market at the Beach), 117 (cat. 53)

Miraflores, Master of, 29
Baptism of Christ by the (Museo Nacional del Prado, Madrid), 29

Miró, Joan, 16, 176, 184 (cat. 98)
Homenaje a Picasso (Homage to Picasso), 184 (cat. 98)

Modigliani, Amedeo, 16, 134–35 (cat. 64), 137 (cat. 65), 138 (cat. 66), 140 (cat. 68), 142 (cat. 69), 165
Femme nue assise de trois quarts, incline vers l'avant, bras en tournant la jambe droite relevée (Seated Nude Bending Forward, Arms Hugging Raised Right Leg, in Three-quarter View), 142 (cat. 69)
Le Violoncelliste (The Cellist), 134–35 (cat. 64)
Le Violoncelliste (The Cellist), preparatory drawing, 16, 137, (cat. 65)
Portrait de Brancusi, sculpteur (Portrait of the Sculptor Brancusi), 138 (cat. 66)
Portrait of Constantin Brancusi, 136 (cat. 64 verso)
Tête (Head), 140 (cat. 68)

Moltzau, Ragnar, 150

Mor, Anthonis, 40
Bust of Philip II, 40

Morales, Luis de, "El Divino", 36–37 (cat. 7)
The Virgin of Silence, 36–37 (cat. 7)
Virgin with Child (Museo Nacional del Prado, Madrid), 36
The Virgin and Child (Ashmolean Museum of Art and Archaeology, Oxford), 36

Muguiro, José Francisco, 91

Munch, Edvard, 174 (cat. 92)
Johan Martin og Sten Stenersen (Johan Martin and Sten Stenersen), 174 (cat. 92)

Murillo, Bartolomé Esteban, 16, 17, 98
The Young Cock Fighter, 17
Young Beggar "The Lice-Ridden Boy" (Musée du Louvre, Paris), 98

Muybridge, Eadweard, 193, 195
Photographic studies of human movement, 193

Napier, Robert, 32

Napoleón Bonaparte, Emperor, 91

Napoleón III, Emperor, 91

Natanson, Thadée, 128

Nelson-Cottreau, Mme., 62

Nemes, Marcel, 132

Nonell, Isidro, 121 (cat. 57)
Gitana meditando (Gypsy Reflecting), 121 (cat. 57)

Nuzzi, Mario, "Mario dei Fiori" (Mario of the Flowers), 56

Ottoboni, Cardinal, 48

Ossun, Marquis of, 82

Palazuelo, Pablo, 188–89 (cat. 101)
De Somnis LXII, 188–89 (cat. 101)

Palencia, Benjamín, 153 (cat. 75)
Bodegón cubista (Cubist Still Life), 153 (cat. 75)

Palomino, Antonio Acisclo, 56

Panini, Giovanni Paolo, 73

Pantoja de la Cruz, Juan, 42–43 (cat. 10)
Portrait of the Infanta Doña Ana of Austria as a Girl, 42–43 (cat. 10)
Portrait of the Infanta Doña Ana of Austria (Ambras Castle, Innsbruck), 42

Parcent, Duchess of, 102

Paret y Alcázar, Luis, 17, 63, 82–83 (cat. 31), 84–85 (cat. 32)
Lady in a Garden, 83
Virgin and Child, 84–85 (cat. 32)
Self-portrait, 17, 82–83 (cat. 31)
Self-portrait (Museo Nacional del Prado, Madrid), 82
Self-portrait as a Jivaro, 82

Partridge, F. Collection, 72

Perea, Master of, 30

Philip II, King of Spain, 38, 40

Philip III, King of Spain, 42

Philip IV, King of Spain, 42

Philip V, King of Spain, 17, 62, 63, 64

Picasso, Pablo, 15–16, 132, 144, 146, 148, 150, 154–55 (cat. 76), 156–57 (cat. 77), 158 (cat. 78), 159 (cat. 79), 160 (cat. 80), 161 (cat. 81), 162 (cat. 82), 163 (cat. 83), 164 (cat. 84), 165 (cat. 85), 166 (cat. 86), 167 (cat. 87), 168–69 (cat. 88), 170 (cat. 89), 171 (cat. 90), 184
11 Miniature Drawings: 165 (cat. 85)
 After Pierre-Auguste Renoir, *Femme à sa toilette (Woman at her Toilet)*, 165 (cat. 85)
 Pablo Picasso, *L'Arlequin (Harlequin)*, 165 (cat. 85)
 Pablo Picasso, *Nature morte (Still Life)*, 165 (cat. 85)
 Pablo Picasso, *Autoportrait (Self-portrait)*, 165 (cat. 85)
 After Pierre-Auguste Renoir, *Femme se lavant les pieds (Woman Washing her Feet)*, 165 (cat. 85)
 After Félix Ziem, *Vue de Venise (A View of Venice)*, 165 (cat. 85)
 After Amedeo Modigliani, *Tête d'homme (Head of a Man)*, 165 (cat. 85)
 After André Derain, *Paysage de l'Estaque (Landscape at L'Estaque)*, 165 (cat. 85)
 After André Derain, *Nature morte (Still Life)*, 165 (cat. 85)
 André Derain, *Paysage du Midi (Landscape of the Midi)*, 165 (cat. 85)
 After Amedeo Modigliani, *Femme assise (Seated Woman)*, 165 (cat. 85)
 Autoportrait (Self-portrait), 165 (cat. 85)
 L'Arlequin (Harlequin), 165 (cat. 85)
Baigneuses (Bathers), 166 (cat. 86)
Bullfighting Scene, 171 (cat. 90)
Buste (Bust), 156–57 (cat. 77)
Danseuses et profil (Dancers and Profile), 158 (cat. 78)
De la guerre au Sénat (From War to the Senate), 167 (cat. 87)
Femme nue (Female Nude), 159 (cat. 79)
Jeune saltimbanque (Young Acrobat), 160 (cat. 80)
La coiffure (The Hairdo), 161 (cat. 81)
La Jeune Fille qui ne dort pas (The Young Woman Who Doesn't Sleep), 170 (cat. 89)
Mandoline (Mandolin), 162 (cat. 82)
Nature morte (Still Life), 165 (cat. 85)
Nu assis (Seated Nude), 154–55 (cat. 76)
Personaje cubista (Cubist Figure), 163 (cat. 83)
Self-portrait, 164 (cat. 84)
Têtes de chevaux (Horse Heads), 168–69 (cat. 88)

Pompidou, Georges, President of France, 156

Ponce, Antonio, 16, 54–55 (cat. 14), 56
Still Life with Artichokes and Talavera Urn with Flowers, 54–55 (cat. 14)

Pordy, Mrs. Alfred, 46

Porter Trust Estate, Nancy and Frank H., 182

Preitinger, Augusta, "Guus", 132

Ramonet, Julio Muñoz, 83

Raimondi, Marcantonio, 56

Reber, Gottlieb Friedrich, 148

Regoyos, Darío de, 17, 114 (cat. 50)
Peñas de Urquiola (Crags of Urquiola), 17, 114 (cat. 50)

Renoir, Pierre-Auguste, 165

Ribera, Juan Antonio, 98

Ribera, Jusepe de, "Lo Spagnoletto", 17, 46–49 (cat. 11)
Apostolate, 48
The Sense of Hearing, 48
The Sense of Smell, 17, 46–49 (cat. 11)
The Sense of Sight (Franz Mayer Museum, Mexico City), 48–49
The Sense of Taste (Wadsworth Athenaeum, Hartford), 48–49
The Sense of Touch (Norton Simon Foundation, Pasadena), 48–49

Richardson, John, 156

Rinaldi, Raffaello, "Il Menia", 73

Ripa, Cesare, 87
Iconologia, 87

Rivera, Manuel, 185 (cat. 99)
Espejo naciendo IV (Birth of a Mirror IV), 185 (cat. 99)

Robinson, Sir J. C., 32

Roda, Viscount of, 24, 26

Roque, Jacqueline, 156

Rosenberg, Léonce, 146, 150

Rosenberg, Paul, 172

Rúa, Jorge de la, see Straaten, Jooris van der

Rubens, Peter Paul, 154

Rubías, José Miguel, 94

Ruiz Picasso, Bernard, 156

Rusiñol, Santiago, 115 (cat. 51)
Jardines de Aranjuez (Gardens of Aranjuez), 115 (cat. 51)

Sabatini, Francesco, 78

Sabin, F. Collection, 72

Salz, Sam, 172

San Leocadio, Paolo da, 30

Sánchez, Apolinar, 82

Sánchez Coello, Alonso, 42

Sánchez Cotán, Juan, 50

Sansovino, Jacopo, 67

Scarlatti, Domenico, 73

Schempp, Theodore, 139

Sebastián Gabriel de Borbón, Infante of Spain, 76–77

Sert, José María, 128

Sert, Misia, 128

Severance, John L., 29

Silvan Kocher, Mr. and Mrs., 130

Singer, Herbert, 140

Singer, Nell, 140

Sittow, Michel, 29
Polyptych of Isabella the Catholic, 29

Sorolla y Bastida, Joaquín, 108, 116 (cat. 52)
Niños en el mar, playa de Valencia (Boys in the Sea, Valencia Beach), 116 (cat. 52)

Stenersen, Rolf, 174

Stewart, William H., 106

Straaten, Jooris van der, "Jorge de la Rúa", 40–41 (cat. 9)
Portrait of Philip II with the Order of the Garter, 40–41 (cat. 9)

Sweerts de Landas Wyborgh, Baron, 76

Tàpies, Antoni, 182 (cat. 96)
El accidente (The Accident), 182 (cat. 96)

Titian (Tiziano Vecellio), 154
Young Venus with a Mirror (National Gallery, Washington), 154

Toulouse-Lautrec, Henri de, 122–23 (cat. 58), 128
Femme au café (Woman in a Café), 122–23 (cat. 58)

Traverse, Charles François de la, 82

Trémouille de Noirmoutier, Marie-Anne de la, Princess of the Ursins, 63

Ullrich Collection, 34

Urban VIII, Pope (Maffeo Barberini), 48

Vanderbilt, William H., 106

Velázquez, Diego, 48, 110, 154

Vicente, Miguel, 52–53 (cat. 13), 88
Still Life with Chestnuts, Fruit, A Goblet of Wine and a Conch Shell with Flowers on a Table, 52–53 (cat. 13)

Vila, Xavier, 180

Vogel, Edwin C., 172

Waals-Könnigs, Madame C.L.E.H. van der, 122

Watson, Miss Diana, 190

Weber, J. B. Collection, 76

Weyden, Roger van der, 29
Triptych of Our Fair Lady (Gemäldegalerie, Berlin), 29

Widmaier, Maya, 154

Woolman Chase, Mrs. Edna, 176

Yaffe, Boris Collection, 159

Yáñez de la Almedina, Fernando, 32–33 (cat. 5)
The Salvator Mundi between Saints Peter and John, 32–33 (cat. 5)
Saint Cosme (Valencia Cathedral), 33

Youssoupov Collection, 46

Zenajda Godebska, Maria Zofia Olga, see Sert, Misia

Ziem, Félix, 165